KODAK
GUIDE TO 35mm
PHOTOGRAPHY

Techniques for Better Pictures

KODAK Guide to 35mm Photography

Cover photo ©Nancy Brown
Photos on pages 27, 28, 30, 31, 43, 64,
70 bottom, 86 top, 93, 141, 143 ©Steve Sint
Design by Mary McConnell
Printed in Belgium by Die Keure n.v. using Kodak materials.

ISBN 0-87985-801-X

Kodak
LICENSED PRODUCT

KODAK is a trademark of Eastman Kodak Company used under license.
KODAK PROFESSIONAL, EKTACHROME, ELITE, GOLD, KODACHROME, MAX,
PHOTO CD, PLUS-X, ROYAL, SELECT, SNAP-CAP, TECHNIDOL, T-GRAIN, T-MAX,
and TRI-X are trademarks of Eastman Kodak Company.
PHOTONET is a trademark of PictureVision, Inc.

The publisher acknowledges all other trademarks and registered trademarks of products
featured in this book as belonging to their respective owners.

Library of Congress Cataloging-in-Publication Data
Kodak guide to 35mm photography. -- 7th ed.
 p. cm. -- (Publication; AC-95)
 Includes index.
 "Cat. no. E112 0005"--T.p. verso.
 ISBN 0-87985-801-X (pbk.)
 1. 35mm cameras. 2. Photography--Handbooks, manuals, etc.
 I. Eastman Kodak Company. II. Series: Kodak publication; no. AC-95.
TR262.K62 1998
771. 3'2--dc21 98-25090
 CIP

KODAK Books are published under license
from Eastman Kodak Company by
Silver Pixel Press®
A Tiffen® Company
21 Jet View Drive
Rochester, NY 14624 USA
Fax: (716) 328-5078
www.silverpixelpress.com

KODAK Guide to 35mm Photography

Kodak wants to help you take really good pictures with your 35mm camera. This book was written with you in mind—whether you're just beginning in 35mm photography or just beginning to get serious about it. Even if you're an advanced photo hobbyist, you can use this book to brush up on the basics. This book will help you understand and use autofocusing, automatic cameras, as well as cameras with manual controls. You'll learn when, where, and how to capitalize on camera features such as fast lenses, interchangeable lenses, a wide range of shutter speeds and lens openings, exposure meters, and automatic exposure controls. The book presents picture-taking techniques, information on selecting films, discussions on outdoor and indoor lighting, guidelines for composition, how-to information for photographing many different kinds of subjects, and hundreds of colorful examples of good pictures—all of which will help you take better pictures. The results described in this book are possible with 35mm and other advanced cameras. There are dozens of camera models available today, each of which is unique in some way. So start by studying your instruction manual, with your camera in hand, before reading this book. Then practice the techniques the book describes one at a time. Take lots of pictures. Study the pictures you take, learn from them, and go on to new techniques. But above all, enjoy your pictures and share them with others. You'll find that photography can be a truly fulfilling hobby.

The Editors

CONTENTS

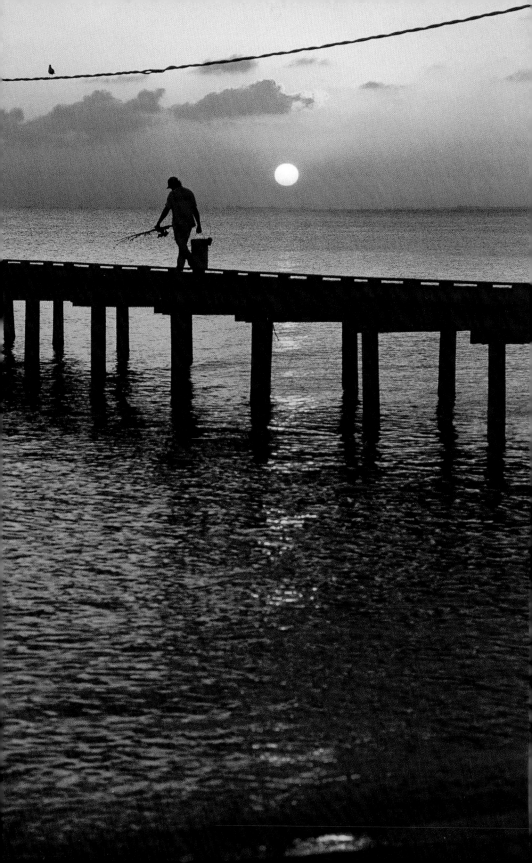

Camera Handling

Handling your 35mm camera with skill and ease can make the difference between getting the picture and being too late. It can also make the difference between getting a sharp picture and one that's blurry. The greatest photo opportunity in the world can quickly vanish if the photographer fumbles with the camera, sets exposure controls improperly, doesn't focus carefully, or jiggles the camera while depressing the shutter release. When camera handling becomes a natural action, the results are consistently better photographs.

In this opening chapter, we will describe and illustrate the fundamentals and habits of good camera handling to help you achieve greater success with every photo opportunity that comes your way.

CAMERA LENS MAINTENANCE

One of the most important factors in getting sharp, clear pictures is to have a clean camera lens. You've seen what the view is like when you look through a dirty window. Well, your pictures will have a similar hazy, unsharp appearance if you take them through a dirty camera lens. So before you start taking pictures, be sure your camera lens is clean.

If your camera lens needs cleaning, clean the front and back glass surfaces by first carefully blowing away any dust or

dirt. Then breathe on the surface of the lens to form a mist and gently wipe the mist away with a soft, clean, lintless cloth or use KODAK Lens Cleaning Paper moistened with KODAK Lens Cleaner.

CAUTION: Do not use solvents or solutions unless they are specifically designed for cleaning camera lenses. Don't use chemically treated tissues intended for eyeglasses.

Anne Aitchison

To consistently obtain pictures of high quality, you should develop good camera-handling habits. These include keeping your camera lens clean, adjusting your camera for sharp focus, and holding your camera steady.

By keeping a loaded camera handy at all times, you will be ready when good fortune strikes, as it did for this photographer. Photo by Carolyn Norwood.

LOADING AND UNLOADING 35mm CAMERAS

In this section we'll provide some general information that applies to most 35mm cameras. For specific instructions for your particular camera, see your camera manual.

Always load and unload your camera in subdued light—not bright sunlight. (This is especially important for very high speed films.) If there's no shade around, position your body so it casts a shadow over your camera for loading and unloading. This helps prevent bright light from entering the lip of the 35mm magazine and causing a streak on the first or second picture. If this happens, the streak is usually orange or clear on color slides or prints but dark on negatives. To avoid streaks, keep the film in its lighttight container before and after exposure.

Loading a 35mm camera is easy. However, it is possible to put a 35mm magazine into the camera the wrong way. The film slot of the magazine must face the take-up side of the camera; and the light-colored side of the film, the emulsion side, must face the camera lens. If the following loading summaries differ from the instructions in your camera manual, follow your manual.

With a manual-loading camera, thread the film onto the take-up spool. Make sure you've threaded the film correctly for the direction of rotation of the take-up spool. When the film is threaded, it should have enough tension to lie flat. If it doesn't, advance the film slowly until the rewind knob starts to turn. See that the sprocket teeth engage the film perforations before you close the camera back. After you close the back, advance the film three times so you are ready to take the

first picture. If you don't do this, you could make the first exposure on the fogged portion of the leader and not get the picture.

With an auto-loading camera, align the end of the film leader with the index mark along the bottom rail. Check that the advance gear engages the film perforations and that the film lies flat.

Close the back and press the shutter release. The camera will advance the film to the first frame.

Film in 35mm magazines is loaded in lengths for 12, 24, or 36 standard-format (2:3 ratio) exposures. (A half-frame camera yields twice as many exposures on the roll.) Extra film is included for a leader at the beginning of the roll and for a trailer at the end. The processing laboratory needs the leader as well as the trailer when processing the film. If you try to squeeze more than 24 exposures (or 12 or 36 depending on the roll) onto a roll of film, the extras may be lost in the processing.

How do you know if the film is advancing? Auto-loading cameras often have a film-running indicator atop the camera to indicate film is advancing. With a manual-loading camera, you can use the rewind knob to check the film. Turn the rewind knob carefully in the direction of the rewind arrow until you feel a slight tension. This takes up the slack in the film. Now when you advance the film, you should see the rewind knob rotate.

IMPORTANT: Be sure that you never turn the rewind knob the wrong way—opposite the direction for rewinding—when taking up the slack in the film. This could kink or jam the film. After you load the film, it's easy to forget how many exposures are in

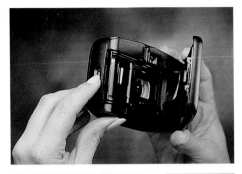
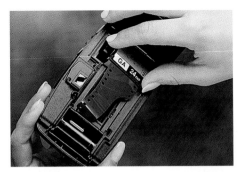
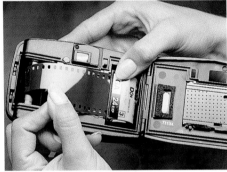
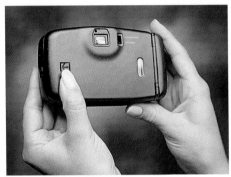

Many cameras offer automatic film loading. Typically, you align the film leader with an index mark on the bottom rail. Then you make sure the advance gear engages the film perforations. The film should be firmly secured to the take-up spool and the camera sprocket teeth should be catching the film perforations on both sides before closing the camera back. Next, close the camera back and press the shutter release— the film advances to the first frame. For specific loading instructions, see your camera instruction manual.

the magazine. Some cameras have a window on the film door to show the magazine surface that indicates the number of exposures. Other cameras have a memo holder on the film door into which you can insert the end flap of the film package; the end flap states the type of film and how many exposures. With a manual-advancing camera, if you think you have 36 exposures but actually have 24, you could damage the film by tearing the perforations or you could pull the film loose from the magazine by trying to advance the film. If you pull the film loose, you can't rewind it back into the magazine.

If you haven't used your camera for a while, you may be uncertain if it contains film. With most newer cameras, a window on the film door shows if film is in the camera. Or an LCD (liquid crystal display) panel may display the picture number, even when the camera is turned off.

With older cameras, it's sometimes difficult to determine whether or not the camera is loaded with film. If the film counter indicates an exposure number, there's probably film in the camera. With a manual-advancing camera, **gently** turn the rewind knob in the direction for rewinding without depressing the rewind button. If you feel resistance to turning the rewind knob, do not turn it any farther. Your camera is loaded with film. The film counter in most 35mm cameras has an S on it that resets when you open the back. If you see the S on the counter, this indicates that the camera back has been opened since the last exposure was made. Therefore, assuming the film has been rewound, it's safe to open the back again.

With some 35mm cameras, you must rewind the film from the camera take-up spool back into the original magazine before unloading. If you open the camera back before rewinding the film, the film will be completely exposed, or fogged, as it has no protection from the light. Fogging generally looks like a light, cloudy area covering part or all of a slide or print.

Cameras that load film automatically usually also rewind it automatically. The camera may automatically rewind the film at the end of the roll, or it may signal you to press a rewind button or switch that begins the rewind. Check your camera manual for specific instructions.

Because auto-load cameras require you to expose less leader film when loading, it is possible that you'll get more than the specified number of exposures on a given roll. But again, be aware that any shots past the specified number of exposures (i.e., 12, 24, or 36) may be lost in processing.

Each year several thousand magazines of 35mm film are returned for processing by photographers who have accidentally wound unexposed film back into the magazine. The most common reason for this happening is improper loading of 35mm cameras, which can cause the film not to advance through the camera as pictures are taken. After the photographer finishes what is thought to be the end of the roll, the film is rewound. Since the film didn't even go through the camera, no exposures were made and all the pictures are lost. Needless to say, this is a big disappointment.

To minimize the chances of winding the film leader into an unexposed magazine, load your camera according to the instructions in your camera manual. Also follow the tips given in this book about determining whether your film is advancing properly.

IMPORTANT: When using a camera with a manual rewind knob, do not turn the rewind knob in the direction opposite that of the rewind arrow. Such action can seriously bend the film and possibly tear it. To prevent torn perforations, keep the rewind button control firmly depressed in the rewind position until you have completely rewound the film. Check your camera manual for specific instructions.

Do not force the film advance lever; this might pull the film loose from the magazine, which would prevent the normal rewinding of the film back into the magazine, as mentioned before. Pulling the film loose usually results from a photographer's trying to make more exposures than 24 on a 24-exposure roll (or 12 or 36 depending on the roll) at the end of the film. Forcing the film advance lever can also cause overlapping pictures at the end of the roll. If you do pull the film loose from the magazine and open the camera back in the light, you'll fog the film.

The solution is to take your camera to a photofinishing lab or photo dealer that has a darkroom and ask to have the film transferred—in darkness—into a KODAK SNAP-CAP 135 Magazine. It is important to mark the film type and number of exposures on the magazine so that the processor can identify the film.

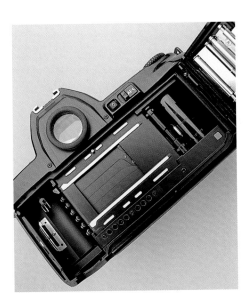

Electrical contacts in the film chamber enable many cameras to read DX-encoded films to automatically set film speed and determine the number of exposures on a roll.

NO FILM LEADER?

If you discover that you have accidentally wound unexposed film back into the magazine, all is not lost. You can still use the film by retrieving the film leader as demonstrated below.

1. Cut a strip about 1 inch wide and 5 inches long from a material such as sheet film or acetate.

2. Attach about 3 inches of double-coated cellophane tape to one side of the strip, covering one end. Round both corners of this end, which you will insert into the magazine, to reduce the chance of scratching your film.

3. Push 2 to 3 inches of the strip through the lips of the magazine. The sticky side of the strip should face the film core.

4. Pull the strip out gently. Usually the leader will attach itself to the sticky tape. If it doesn't, reinsert the strip. Then rotate the core of the magazine counterclockwise with the long end of the core facing you, and try again by pulling out the strip.

If you accidentally wind the leader of **unexposed** film into the magazine, you can save the use of the film by retrieving the leader. To retrieve the leader, purchase a leader retriever or use an acetate strip with double-sided cellophane tape on one side of the strip.

To obtain sharp pictures, you must hold your camera steady. As shown, stand with your feet about shoulder-width apart and your elbows close to your side. For normal and wide-angle lenses, grasp the camera with both hands.

What happens if you wind the leader of unexposed film back into the magazine? You have not lost the film, because your photo dealer can retrieve the leader. If that's not convenient, you can do it yourself.

CAMERA HOLDING

The way you hold your camera when you release the shutter is important for sharp pictures. Camera jiggle is the most common cause of unsharp pictures—not the obviously blurred pictures, but those lacking the needle sharpness that indicates the touch of a skilled photographer.

The best way for you to hold your camera is the way that's both comfortable and steady. Try to keep your arms against your body—not suspended in air. Place your feet firmly on the ground, slightly apart. Hold the camera tightly against your face. Take a breath, hold it, and gently squeeze the shutter release. Chances are excellent that you'll make a picture free of camera movement.

Golfers practice their swing. Target shooters practice squeezing the trigger. Photographers can practice their handling techniques.

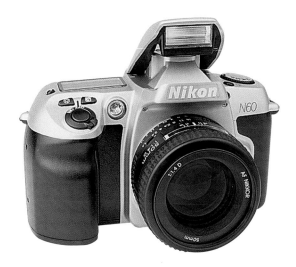

Many current SLR cameras combine ease of use with versatility by including features such as autofocus, auto-exposure, and a built-in flash unit.

CAMERA TYPES

The two basic types of 35mm cameras are single-lens-reflex (SLR) cameras and compact cameras. Compact 35mm cameras (also known as lens/shutter cameras) include non-SLR autofocus, fixed focus, rangefinder, and "bridge" (hybrid) cameras. With most of these, you view your subject through a viewfinder that is separate from the camera lens. These relatively small cameras have become increasingly popular, and they commonly include features such as automatic film advance and rewind, automatic exposure, and automatic focus. Having virtually point-and-shoot capability, a compact 35mm camera is an excellent choice for casual photography.

Single-lens-reflex cameras are also extremely popular. One of the major reasons for this is that they accept interchangeable lenses. When you look through the viewfinder of an SLR camera, you're actually looking at your subject through the camera's picture-taking lens. In this way, you can change from one lens to

another and immediately see in the viewfinder the image that will be recorded on your film. This also means that you'll see in the viewfinder some of the perspective changes we mention in the section on lenses. A direct optical viewfinder can be made to show approximately what will be included in the picture with various lenses. But it's more difficult to appraise the effect of the lenses on perspective.

One-time-use cameras are available with a variety of options, including built-in flash and waterproof housings. Cameras are usually loaded with either 200- or 400-speed color print film.

One-time-use cameras designed to produce elongated, panoramic images have become extremely popular in recent years.

Vincent Allin

Joanne Stramara

With a panoramic camera, you can create dramatic pictorial compositions. Be sure to keep the horizon level unless you're deliberately after bizarre results.

Another plus factor of a single-lens-reflex camera is that it's free of parallax—the difference between what the lens sees and what you see through a direct optical viewfinder, especially evident at close distances. We'll talk more about this in the section on close-up photography.

No matter what kind of viewfinder system you use, learn to use it with ease and with discernment. Before you shoot, look behind your subject to be sure you haven't included a distracting object. When possible, move around your subject to choose the best viewpoint. Although this may be like saying fire is hot, we can't overemphasize that your final picture will include everything that lies within the boundaries of your viewfinder. So before you snap the shutter, make sure you see in the viewfinder what you want to see in the resulting picture.

A good, simple 35mm camera makes picture taking easy—all you do is point and shoot!

Autofocus SLR cameras have all the convenience of point-and-shoot cameras and the flexibility of accepting a variety of interchangeable lenses and accessories.

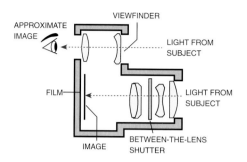

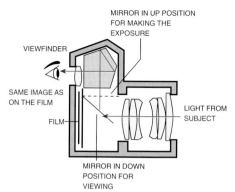

Camera with Direct Optical Viewfinder—In lens-shutter cameras, the viewfinder is separate from the camera lens. It shows approximately the same image as the image on the film.

Camera with SLR Viewfinder—A hinged mirror reflects the image through a pentaprism in the viewfinder to your eye. When you take a picture, the mirror flips up to let light reach the film and then returns to its original position.

Autofocus SLR Camera—Although almost completely automatic in operation, these cameras usually offer electronic or manual controls that allow you to change any of the exposure or focus settings. Such adjustability sets them apart from most snapshot cameras.

FOCUSING

The three types of focusing systems common in modern 35mm cameras are fixed focus, manual focus, and automatic focus. Fixed-focus lenses, common to the simplest compact cameras, are preset to provide sharp focus over a given distance range (typically from a minimum of about 4 feet to infinity). Fixed-focus lenses are fine for taking snapshots of family events or vacation scenics, but they do limit your flexibility and image control. The ability to focus your camera selectively allows you to concentrate attention on a particular area of a scene.

Manual-Focus Cameras

Many SLR cameras use manual focusing. To focus a manual SLR camera, you look through the viewfinder while turning the focusing collar on the lens until the area that you want to be sharp comes into focus. The viewfinder in an SLR camera usually contains a split-image rangefinder, a microprism, and a ground glass to help you in judging sharpest focus (see illustration). A split-image rangefinder does what it says—it splits the image. With split-image rangefinders, you look through the viewfinder at your subject and turn the focusing ring on your camera lens until the split images in the viewfinder line up. The subject is then in focus. Split-image finders work best when there is a prominent vertical line (for example, a telephone pole) in your composition to use as a focusing guide. One disadvantage of the split-image rangefinder is that it sometimes blacks out when you use it with telephoto lenses, obliterating part of the image area. If your camera has a microprism area (see illustration) or a ground

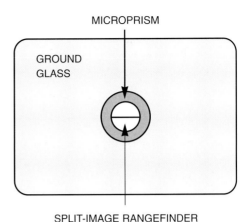

MICROPRISM

GROUND GLASS

SPLIT-IMAGE RANGEFINDER

Typical viewfinder in a manual-focusing SLR camera that has three focusing aids.

glass for focusing, you just turn the focusing ring until the subject looks sharp in the viewfinder. The microprism is a ring in the center of the viewfinder that exaggerates the unsharpness of out-of-focus subjects and, therefore, makes correct focusing easier to judge.

Each focusing aid works best in certain situations. For instance, you may prefer split-image focusing when you're photographing a building, because there are straight lines on which to focus. But if you're taking a picture of a crowd of people where prominent lines are hard to find, the microprism and ground glass systems of focusing are easier and faster. In addition, the ground glass offers the advantage of showing you what part of the picture is in the plane of sharpest focus relative to other parts of the picture. The ground glass also lets you preview depth of field over the entire image area if your camera has the feature that permits this. Practice focusing your camera until you do it naturally and don't have to give it a second thought.

Autofocus Cameras

Although the engineering behind an autofocus camera is complex, using one is easy. In both compact and SLR cameras, the viewfinder usually has a center target to show what the camera will automatically focus on. To get sharp pictures, aim your camera to superimpose this target on the main subject.

The obvious problem is that you won't always want to put your main subject in the center of the frame. To circumvent this, most autofocus cameras have a focus lock. With it, you focus on your subject in the center of the viewfinder and then lock the focus. Once you lock the focus, you can recompose the scene.

With most autofocus cameras, partially depressing the shutter button activates the focus. As long as you do not release the button (or take a picture), focus will remain locked on your chosen subject. Some cameras have a separate button that locks the focus until a picture has been taken. For the focus-lock technique to work, however, the camera-to-subject distance cannot change. If the distance does change, the subject will likely be out of focus. Refocusing is a simple matter of re-centering your subject and again partially pressing the shutter-release button.

More sophisticated SLR autofocus cameras may offer a choice of two autofocus modes: single shot and servo. The single-shot mode is better for photographing stationary subjects. The camera shutter will not fire until the camera has confirmed sharp focus. The servo mode works well for photographing moving subjects—a girl on a bicycle, for instance. It will continue to focus until the instant of exposure. One drawback of the servo

Data is transmitted between the camera and lens via electrical contacts on the camera's lens mount and on the lens. This enables the autofocus and auto-exposure systems to operate properly.

mode is that many cameras will fire even if the subject is not in sharp focus (if the subject has continued to move as the shutter is tripped, for example). Some very advanced SLR cameras are actually able to overcome even this problem by measuring the speed of a moving subject. The camera calculates how far the subject will move during the split second it takes to make an exposure and adjusts the focus accordingly. Consult your manual for advice on photographing moving subjects.

Some situations and subjects can cause focusing errors or failure. For instance, the camera cannot automatically focus on subjects behind other objects, such as a fence or a branch. If you are using a leafy tree limb to frame a barn, you must be certain that the focus area in the viewfinder is not seeing the limb, or it will cause the lens to focus on the limb and make your main subject, the barn, out of focus.

An autofocus camera will focus properly on the subject when you aim the camera so that the subject is positioned in the indicated focus area in the center of the viewfinder.

Even though you've framed the scene so that the subject is off-center for better composition, an autofocus camera will focus on whatever detail is in the center of the viewfinder. In this example, the background is sharp but the subject is fuzzy. Many autofocus cameras have a focus lock so you can prevent this kind of focusing error.

Because most autofocus systems work by comparing the tonal contrasts within a scene, they may balk in both low-light and low-contrast situations, such as a foggy scene.

Most cameras will beep or flash an indicator to indicate a focus problem. In dimly lit situations, the camera may tell you to use an accessory flash. Some flash units have infrared emitters that enable the camera to focus automatically in almost total darkness, and the flash provides enough light for picture taking. Brightly backlit scenes also trouble most SLR autofocus systems because the contrast in the scene is intense and changes rapidly if you move the camera even slightly.

In SLR autofocus cameras, the sensors are behind the lens. As long as you have an unobstructed view of your subject, the camera will focus. In compact autofocus cameras, however, the autofocus sensors are behind windows on the front of the camera. It's very important not to block these windows with a finger or camera strap, or focusing will be impaired.

Finally, some autofocus SLR cameras have trouble focusing on subjects that contain predominantly horizontal lines—clapboard shingles on a house, for example. You can get around this difficulty by turning the camera on a slight angle, locking in the focus, and then recomposing the scene.

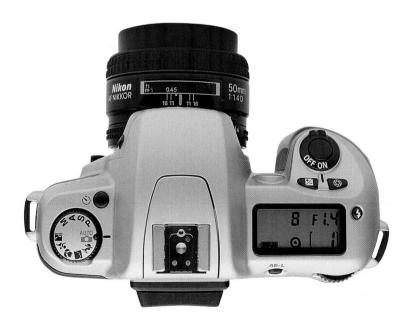

On many SLR cameras, you set exposure controls electronically, using push buttons. The camera then displays settings on an LCD panel. In the example, the panel shows that the shutter speed is 8 seconds and the lens opening is f/1.4.

Focus Assist

Most SLR autofocus cameras have an override that allows you to focus the lens manually. This can be an important feature if, for example, you want to manipulate focus for a special effect or to focus on a subject in a difficult situation, such as photographing a zoo animal through the bars of a cage. Many of these cameras have a feature called "focus assist" that will provide an audible or visible signal to tell when the subject is in focus.

EXPOSURE CONTROLS

The two controls on adjustable cameras that regulate the amount of light reaching the film are shutter speed and lens opening (also called aperture or f-stop). Setting these two controls correctly is necessary to take properly exposed pictures. With manual cameras, you adjust the shutter speed and aperture controls until the camera's meter indicates that you have chosen settings that will provide proper exposure.

Cameras that offer auto-exposure, on the other hand, adjust the shutter speed or the lens opening (or both) automatically, after the camera's meter has determined an optimum exposure setting. Cameras that are equipped to handle film with DX-encoding designations will automatically set the speed of the film that is loaded.

Whether your camera uses a built-in meter to guide you in setting aperture and shutter speed or sets them itself, you should understand the basic premise behind shutter speed and aperture to gain greater control over image quality.

The shutter speed controls the length of time the film is exposed to light. Shutter speeds are typically indicated by the numbers 1, 2, 4, 8, 15, 30, 60, 125, 250, 500, 1000, and 2000. The numbers represent fractions of a second (except 1 second) and mean 1/2, 1/4, 1/8, 1/15 second, and so on. The speeds may be marked on a dial or shown on an LCD panel atop the camera or in the viewfinder. Your camera may set shutter speeds in one-half or one-third stop increments and would therefore display shutter speeds that fall in between those listed above.

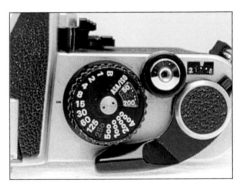

The shutter speed dial of a manual camera lists the shutter speeds in one-stop increments.

Camera's with a B or Bulb setting allow you to make time exposures—the shutter will stay open as long as you press the shutter release. For more precise control of time exposures, some advanced cameras allow you to set electronically timed shutter speeds several minutes.

Changing from one shutter speed to a speed that is twice as fast, for example 1/60 to 1/125 second, allows the light to strike the film for half as long; therefore, half as much light reaches the film. Changing to a shutter speed that holds the shutter open twice as long, for example 1/60 to 1/30 second, lets twice as much light strike the film.

The size of the lens opening on your camera is the other factor that controls the amount of light that reaches the film. The different sizes of lens openings are indicated by f-numbers. These numbers form a series, such as 1.4, 2, 2.8, 4, 5.6, 8, 11, 16, and 22, marked on the camera lens or shown on an LCD panel. The smallest f-number refers to the biggest opening. The largest f-number is the smallest lens opening.

When you change from one lens opening to the nearest number, you're adjusting the lens by 1 stop. If you move the setting to the next larger one, for example f/11 to f/8, the area of the opening is doubled, so you expose the film to twice as much light. Changing from one lens opening to the next smaller one, for example f/11 to f/16, cuts the light by half.

Automatic-exposure cameras dominate the camera market. Electronic sensors and microprocessors have not only taken the guesswork out of correct exposure, but the labor as well. The camera sets the shutter speed and aperture the

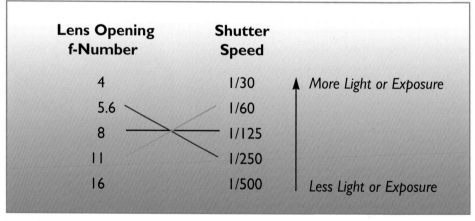

Using the settings going up each column exposes the film to more light. As the setting in one column is increased, the setting in the other column must be decreased to maintain the same exposure for the lighting conditions in the scene. For example, suppose the correct exposure setting is 1/125 second at f/8. To help stop fast action, you can change the shutter speed to 1/250 second, but you must also change the lens opening to f/5.6 to maintain the same exposure. If stopping fast action is not required but you want to increase the depth of field, you could use 1/60 second at f/11 to maintain the same exposure.

instant you press the shutter release. Cameras that measure the light reflecting off of the film itself can even adjust these settings as the exposure is occurring.

CHOOSING THE BEST COMBINATION OF SHUTTER SPEED AND LENS OPENING

There are many combinations of shutter speed and lens opening that will allow the same amount of light to reach the film for proper exposure. These are known as equivalent exposures. If you change from one shutter speed to the next higher speed, this lets half as much light expose the film. You should keep the total amount of light—the exposure—the same by opening the lens to the next larger lens opening. It also works the other way around. If you change to the next slower shutter speed, which lets in twice as much light, you should use the next smaller lens opening to let in the same amount of light as before.

Besides obtaining the proper exposure, you might want to use a particular combination of lens opening and shutter speed for three good reasons:

1. *To reduce the effects of camera motion.* A good, general-purpose shutter speed to achieve this is 1/125 second. A higher shutter speed of 1/250 second may produce even sharper pictures. With telephoto lenses, even higher shutter speeds may be necessary.

2. *To stop action.* A shutter speed of 1/125 second helps stop the action of someone walking, for instance. However, there may be times when you want to use a higher shutter speed to stop fast action, such as a person running.

3. *To control depth of field.* By using a small or a large lens opening with the appropriate shutter speed to maintain the correct exposure, you can increase or decrease the range of sharp focus, or the depth of field.

GUIDELINES FOR SELECTING THE BEST COMBINATION OF SHUTTER SPEED AND LENS OPENING

SELECTING THE LENS OPENING

Lens Opening	Guidelines	Example— 50mm *f*/2 Lens (Normal Focal Length)
Maximum for lens	Good for obtaining enough exposure in low lighting conditions. Minimum depth of field. Poorest image quality for specific lens.	*f*/2
One stop smaller than maximum lens opening	Good for exposures in dim lighting. Shallow depth of field. Helpful to put background purposely out of focus. Good image quality.	*f*/2.8
Two and three stops smaller than maximum lens opening	Best image quality for most lenses. Better depth of field than with larger lens openings. Good for obtaining proper exposure when lighting conditions are less than optimum such as on cloudy days or in shade.	*f*/4 and *f*/5.6
Two stops larger than minimum lens opening	Moderate depth of field. Good lens opening to use for most outdoor daylight pictures. Excellent image quality.	*f*/8
One stop larger than minimum lens opening	Great depth of field. Good lens opening to use for most daylight conditions. Excellent image quality.	*f*/11
Minimum for lens	Maximum depth of field. Very slight loss of sharpness due to optical effects. When maximum depth of field is important, benefits from increased depth of field outweigh disadvantages from almost imperceptible loss in sharpness.	*f*/16

SELECTING THE SHUTTER SPEED

Shutter Speed	Guidelines
B (Bulb)	Use a tripod. Shutter remains open as long as shutter release is. Good for obtaining great depth of field with small lens openings in dim light scenes. Also good for recording fire works, lightning, streak patterns from moving lights.
1 second and 1/2 second	Use a tripod. Good for obtaining great depth of field with small lens openings in dim light. Good for photographing stationary subjects.
1/4 second and 1/8 second	Use a tripod. Maximum slow shutter speed for portraits of adults. Good for obtaining great depth of field with small lens openings in dim light. Good for stationary objects.
1/15 second	Use a tripod. Some people can hand-hold camera using this speed with normal or wide-angle lens if camera is held very steady. Good for obtaining increased depth of field with small lens openings in dim light.
1/30 second	Slowest recommended shutter speed for hand-holding camera with normal or wide-angle lens. Hold camera very steady for sharp pictures. Good speed for most existing-light photography. Good for obtaining increased depth of field with small lens openings on cloudy days or in shade.
1/60 second	Good for daylight pictures outdoors on cloudy days, in shade, or for backlit subjects. Useful for increasing depth with smaller lens opening. Less chance of camera motion than with 1/30 second. Recommended* for electronic flash with many SLR cameras.
1/125 second	Best speed for most outdoor daylight pictures. Good depth of field with medium or small lens openings under bright light. Minimizes effects from slight camera motion. Stops moderate motion, such as people walking. Minimum speed for hand-holding camera with 105mm or shorter telephoto lenses. Recommended* for electronic flash with some SLR cameras.
1/250 second	Good for stopping moderate fast action, such as swimmers, parades, running children. Good for most daylight pictures when you don't need great depth of field and want to stop some action. Minimizes effects of camera motion. Good when hand-holding camera with telephoto lens up to 250mm.
1/500 second	Good for stopping fast action, such as divers, moving cars in traffic, or basketball players. Good to use for stopping all but the fastest kinds of action. Excellent to use with telephoto lenses. Good for lenses up to 400mm with handheld camera.
1/1000 second	Good for stopping fast action, such as race cars, motorcycles, track events, tennis players, skiers, and golfers. Excellent to use with long telephoto lenses up to 400mm with handheld camera.
1/2000 second	Best for stopping fast action, such as motor sports and racquet games. Requires largest lens opening and gives least depth of field. Outstanding for use with long telephoto lenses up to 400mm with handheld camera.

Note: Hold your camera steady for all shutter speeds recommended for hand-holding. You can also use slower shutter speeds than those mentioned for telephoto lenses when you put your camera on a firm support, such as a tripod. If in doubt about stopping the action, use the highest shutter speed you can for the conditions.

*See your camera manual for recommended shutter speeds for flash pictures.

DEPTH OF FIELD

Depth of field is the distance range within which objects in a picture look sharp. As you gain a sound understanding of depth of field, you can use it as a very effective control for making better pictures.

What are the primary factors affecting depth of field? Depth of field varies with the size of the lens opening, the distance of the subject focused upon, and the focal length of the lens. Depth of field becomes greater as

- the size of the lens opening decreases.
- the subject distance increases.

- the focal length of the lens decreases and subject distance remains unchanged.

An object at the distance focused upon will be the sharpest component in the picture. But image sharpness doesn't suddenly disappear at the limits shown. Points closer or farther away than the distance focused upon will be less sharp but will look acceptably sharp to the eye throughout the depth-of-field zone. Objects close to the depth-of field zone may appear almost sharp. But the farther an object is from this zone, the more out of focus it

How Lens Opening Affects Depth of Field
Same focal length, same subject distance
(Shaded area indicates depth of field — range of acceptably sharp focus)

LARGE LENS OPENING

SMALL LENS OPENING

How Subject Distance Affects Depth of Field
Same focal length, same f-stop

← 4 FT →

← 10 FT →

← 25 FT → INFINITY

How Focal Length Affects Depth of Field
Same f-stop, same subject distance

LONG FOCAL LENGTH — TELEPHOTO LENS

MEDIUM FOCAL LENGTH — NORMAL LENS

SHORT FOCAL LENGTH — WIDE-ANGLE LENS

INFINITY

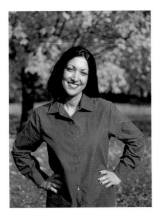

A small lens opening will give greater depth of field than a large lens opening at the same subject distance with the same focal length lens.

f/2.8 with a 50mm lens *f/11 with a 50mm lens*

Depth of field increases as the subject distance increases when the lens opening and focal length of the lens remain unchanged.

Subject distance 8 feet, f/11 with a 50mm lens

Subject distance 15 feet, f/11 with a 50mm lens

Depth of field decreases as focal length of the lens increases when the lens opening and subject distance remain unchanged.

50mm lens at f/11, subject distance 12 1/2 feet

105mm lens at f/11, subject distance 12 1/2 feet

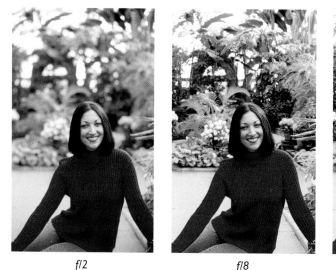

f/2	*f/8*	*f/16*

As this series shows, using a smaller aperture (larger f-number) increases the front-to-back sharpness (depth of field) in a picture. In the first picture, taken at f/2, only the foreground is sharp. In the last picture, taken at f/16, the whole picture is sharp from front to back.

will appear. In looking over these illustrations, you can see that there are times when accurate focusing is very important because depth of field is slight. These include times when you're using a long-focal-length lens or a large lens opening or when you are close to your subject. Of course, a combination of these factors makes accurate focusing even more important. For example, let's assume you're using a 135mm telephoto lens on your camera. (For more on lenses, see the chapter beginning on page 128.) If you're focused on a subject 14 feet away with a lens opening of *f/*4, your depth of field will extend from about 13-1/2 feet to 14-1/2 feet. This doesn't allow much room for focusing error!

You can use depth of field as a control in your pictures. In some shots you'll want as much depth of field as possible. For example, in shooting a scenic picture you may want to include tree branches in the foreground as an interesting frame. To get both the branches and the distant scene in sharp focus, you may use a wide-angle lens and a small lens opening for great depth of field.

In other situations you may not want so much depth of field. You may be photographing a very interesting subject. But what if the background is confusing? You can use a large lens opening, perhaps combined with a long-focal-length lens, to produce shallow depth of field. The disturbing background will be out of focus so as not to detract from your subject. The shallow depth of field will help focus attention on the main subject.

You'll probably want to have the foreground objects in sharp focus in most of your pictures. But you may want to make exceptions now and then to produce creative results. Sometimes an out-of-focus foreground can add interest, excitement, color, and intrigue to your photograph.

If you are using a manual-exposure camera, selecting the proper aperture for creative depth-of-field control is easy. Most auto-exposure cameras also provide a means to manipulate the aperture/shutter speed combination to achieve maximum or minimum depth of field. There are several options for accomplishing this.

To achieve extensive depth of field, for instance, some automatic cameras have a special depth-of-field program mode. Once set to this mode, the camera will select a shutter speed and aperture combination that gives priority to choosing the smallest possible aperture. Similarly, many auto-exposure cameras have an aperture-priority mode that enables you to control depth by allowing you to set the specific shooting aperture. Choose a large aperture such as $f/2.8$ for shallow depth or a small one such as $f/11$ for more depth. The camera will then choose a corresponding shutter speed for correct exposure. Or, if your auto camera allows, you can switch it to full manual and use it as a manual camera.

To get great depth of field in your scenic pictures, use a wide-angle lens and a small lens opening.

Marty Harris

• Depth-of-Field Scale / Hyperfocal Distance

What part of the scene will fall within the depth of field? You can find out by using the depth-of-field scale on your lens. If there's none on the camera or lens, see the depth-of-field tables in your camera or lens instruction manual.

The lens depth-of-field scale helps you put the depth of field **where** you want it and get the **amount** of depth of field you want. If you're taking a scenic picture, for example, you'll probably want all the depth of field you can get. If you simply focus on the distant scene, you'll be focused on infinity. But that's wasting a lot of depth of field. To have the most distant object in focus and also as much foreground as possible in focus as well, you can use a technique based on the **hyperfocal distance**.

To figure the hyperfocal distance, first set your lens to infinity. Then use the depth-of-field scale to read the nearest distance that will be in sharp focus at the aperture you are using. When you focus a lens on infinity, the near distance beyond which all objects are in acceptably sharp focus is the hyperfocal distance. For example, with a 50mm lens set at *f*/16 and focused on infinity, the near-limit indicator on the depth-of field scale shows that all objects from 15 feet to infinity will look sharp. The hyperfocal distance is 15 feet.

If you now refocus the lens to the hyperfocal distance (by setting the hyperfocal distance across from the focusing index), 15 feet in this example, objects from half the hyperfocal distance, 7-1/2

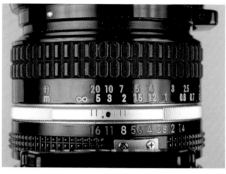

Most SLR camera lenses have depth-of-field scales printed on them so you can calculate the range of front-to-back sharpness. The most common type of scale is a double series of numbers representing the lens openings, on both sides of the focus indicator. Subjects within the distance range between the marks for the lens opening you're using will appear in sharp focus. Here the lens is set on *f*/11 and everything from about 7 feet to 17 feet will be in focus.

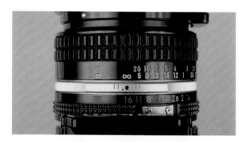

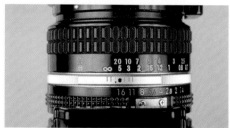

The same lens is set at *f*/16 in both pictures. On the top lens, the depth-of-field scale shows that objects from 15 feet to infinity will be in focus. To get maximum depth of field, the infinity mark for the lens on the bottom is set opposite the far depth-of-field limit. This focuses the lens on the hyperfocal distance. At this focus setting, everything from 7-1/2 feet to infinity will be in focus.

feet, to infinity will appear in sharp focus. Using the hyperfocal distance will always give you the greatest depth of field for that particular lens opening. As you open the lens aperture to larger openings, the hyperfocal distances get farther away and the depth of field decreases.

With an autofocus camera, you can either use the aperture that the camera has selected, or use an aperture-priority or full-manual exposure mode so that you can select a specific working aperture. Then with your lens focused on infinity, read the hyperfocal distance from the depth-of-field scale. Finally, switch your lens to manual focus and set it for the hyperfocal distance. Not all autofocus cameras have a depth-of-field scale or allow manual focusing.

Very often it's beneficial to know what distance to focus your camera on to get everything sharp within a range of medium distances. This is especially helpful when you're taking pictures rapidly without enough time to consult the depth of-field scale or if there is no such scale on your lens. As a general rule, approximately 1/3 of the depth of field is in front of the point of sharpest focus with 2/3 of the depth of field behind. As a result, you should focus on a distance 1/3 of the way from the nearest object you want sharp to the farthest. For example, for objects within a 5- to 20-foot range, you should focus on 10 feet and use the smallest lens opening that you can. This rule does not apply to very close subjects or to those at great distances from the camera, including those at infinity.

When you focus the lens on infinity, distant objects will be sharp, but the foreground may be fuzzy.

If you focus the lens on the foreground, objects in the distance may be fuzzy.

By focusing the lens on the hyperfocal distance, you may be able to make everything sharp. This is often desirable in photos of scenic views.

HELPFUL HANDLING HABITS

Here are some tips to help you work more efficiently. When you plan to shoot lots of pictures in a short time, take your film out of the cardboard cartons and put all of the unexposed film into one section of your camera bag. Keep exposed and unexposed film in separate parts of your bag so you don't waste time trying to find fresh film. (With several Kodak films, you can write "exposed" in special areas on the container lids and magazines to help make the task of handling easier. For more information on this easy-identification feature, see page 40.)

When you finish a roll of film, rewind it immediately. Then if you accidentally open the camera, you won't expose the film. Be sure to wind the end of the film all the way into the magazine so that you don't mistakenly reload it later, thinking it was unexposed film.

As you take your pictures, you'll probably have to adjust focus or exposure settings or modes for some unusual situations. Suppose you go from distant shots of a road race to a close-up of a car refueling nearby. For the distant action shots, you'll probably want to use the servo or continuous-focusing mode to track action. For the close-ups, the single-shot mode will be more convenient. As soon as you're through making the close-ups, readjust your focus setting so that you'll be ready for action again. By the same token, you may want to switch exposure modes from a depth mode for the close-ups to a stop action mode for the racing shots.

When you find an especially good subject, take at least two or three pictures of it. This will give you a choice of viewpoint, pose, expression, or composition, as well as insurance in case one of the negatives or slides gets damaged.

Auto-Winders and Motor Drives

When you want to take pictures rapidly, a handy accessory to have is either an auto-winder or a motor drive.

Auto-winders are a standard feature on many 35mm cameras. For SLR cameras without an auto-winder, you can attach a motor drive to the bottom of the camera. Both built-in winders and accessory motor drives perform the same function: They advance the film to the next frame and cock the shutter after each exposure. The chief difference between winders and motor drives is speed. Auto-winders advance the film one or two frames per second, while some motor drives run film as quickly as eight frames per second—far faster than your thumb could do it.

Auto-winders let you take a series of pictures of fast-action subjects, such as sports or parades. An auto-winder is also great for taking candid pictures of children, pets, or people. For informal portraits, an auto-winder will help you avoid missing fleeting expressions or sudden gestures.

Some built-in winders and most motor drives offer you the choice of two modes: single-frame-advance and continuous-advance. In the single-frame mode, you press the shutter and release it for each picture you take. The camera won't

fire a second time until you release the shutter button. In the continuous-firing mode, the motor will advance and fire the camera as long as you hold the shutter button down. The latter mode excels for fast action, like sports, but at three frames per second, you can go through a 24-exposure roll of film in only eight seconds!

In addition to advancing the film and readying the camera for the next exposure, both auto-winders and motor drives are usually capable of performing other tasks, including auto-film loading and auto-rewinding.

Auto-winders also simplify close-up photography, especially when shooting live subjects, such as insects or small animals. Since these subjects move almost continuously, you have to keep them properly framed in the viewfinder and sharply focused, which is much more difficult to achieve if you are continually pulling the camera away from your eye as you cock the shutter.

With an SLR camera, one minor problem is that when the reflex mirror flips up to let light reach the film, it briefly cuts off your view through the viewfinder. When you are shooting several frames per second, the viewfinder will be blocked for much of the picture sequence. Composition and focusing become a bit tricky. With direct optical viewfinders, you'll get a continuous view of the subject, because the viewing lens and the taking lens are separate.

Finally, be aware that when you use a built-in flash, the continuous-advance mode may not function because the flash needs a longer time to recharge than the motor will allow.

Al Riebeling Navarro

When photography isn't the only thing on your mind, a built-in auto-winder can free you to think of more pressing concerns.

Film Characteristics

The choice of films available for 35mm cameras is truly impressive and probably one of the biggest reasons why this format is so popular. But with so many film choices out there, film selection can sometimes be a bit confusing.

Your first consideration in selecting a film is the type of pictures you want. Prints or slides? In black and white or color? Do you need low, medium, or high speed film? Daylight or tungsten-balanced? Knowing the characteristics of 35mm films will help you select the best ones for the pictures you want to take.

SLIDE vs PRINT FILM

There are a lot of different color films to choose from, but all of them fall into one of two categories: color slide films (also called positive, transparency, or reversal films) and print (negative) films. Color slide films are direct positive films; that is, the film that goes in your camera and the slides you get back are the same film. With color and black-and-white print films, the film that goes in your camera is processed to a negative that you or the photofinisher enlarges into prints. Which is better? It depends on your needs and your tastes, and also the particular shooting situation.

Eric Lowe

Kodak high-speed (ISO 400 to ISO 1000) color print films are great for low-light conditions and action. They also perform extremely well under normal daylight conditions. Although balanced for daylight or electronic flash, you can expose them with most existing-light sources without filters.

Kodak color print films offer the best combination of color saturation, color accuracy, and sharpness currently available from any manufacturer. Photo taken on 100-speed color print film.

Agnes Najem

First, consider your preferences. By far the majority of amateur photographers use print films because they are so convenient. With print films, you get back fairly large prints that are easy to view and can be readily shared with others or mounted in an album for later viewing. Print films give excellent enlargements, can be transferred onto videotape, and can be scanned for a variety of digital applications—for example, for use on the Kodak picture network using the Internet. Color slides are used mainly for projection or viewing in handheld viewers, but you can also use them to make color prints and enlargements, have them transferred to videotape, and have them scanned. Color slides are also less expensive, since no printing stage is involved. If your primary interest is in giving slide presentations, use color slide films.

Each type of film also has technical characteristics that may make one or the other better in a given situation. Color slide films, on the whole, have greater contrast and can therefore add more snap to dull or low-contrast scenes. Correct exposure is also much more critical with color slide films.

Color and black-and-white print films, on the other hand, can record a wider range of contrasts and allow greater room for exposure error. Their wide exposure latitude makes them excellent general-purpose films that work equally well in SLR cameras or in simple 35mm cameras that lack exposure controls.

COLOR TEMPERATURE

A major technical consideration that you should be aware of when choosing a color film is its **color temperature** or **balance**. All color films are designed to be used in a certain type (often referred to as color temperature) of light, and you will get the best results when you are careful to match the film to the light source existing in the scene. Using the wrong film/lighting combination will result in distracting or unattractive color casts. Daylight films used

indoors with incandescent lamps, for instance, will produce pictures with an overall reddish or orange cast. Similarly, indoor (tungsten) films used outdoors will have an overall blue color.

Virtually all color print films sold for amateur use are balanced for daylight and will give best results with that lighting or with electronic flash (both have a color temperature of about 5500 K). Because photofinishers can improve color balance when printing negatives, you can get good results with a variety of light sources, or you can filter the light source during picture taking to improve color. Color slide films, however, are available for two different temperatures of light: daylight (5500 K) and tungsten light (3200 K). Since no correction can be made in processing of slides, they have less tolerance for error. Whenever possible, you should choose a slide film that is balanced for the light you'll be photographing under.

You can use slide films balanced for one type of lighting in a different type of lighting if you use color-correction filters. But you will get optimum results if you shoot a particular film with its intended light source.

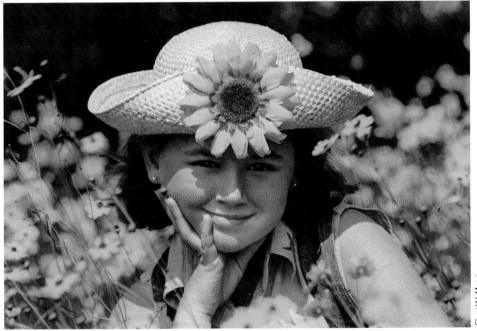

Sheri W. Morris

The premium family of Kodak color print films delivers extremely fine image detail to get the most from today's sharp lenses. The films offer outstanding skin-tone and color reproduction, with slightly less contrast and color saturation.

Kodak 100-, 200-, and 400-speed color print films have a wide exposure latitude that yields good quality prints from negatives three stops overexposed to two stops underexposed.

200-speed color print film three stops overexposed (EI 25)

200-speed color print film two stops underexposed (EI 800)

FILM SPEED

The film speed indicates relative sensitivity to light. The speed is expressed as an ISO number or an exposure index (EI). The higher the speed, the more sensitive or faster the film; the lower the speed, the less sensitive or slower the film. A fast film requires less light for proper exposure than a low-speed film. For example, a film with a speed of ISO 25 is slower—requires more light— than a film with a speed of ISO 200. To find the speed number for your film, look on the film carton or on the film magazine. You set the film speed on exposure meters and on cameras with built-in meters to obtain the correct exposure. Some cameras automatically set the film speed by reading a code on DX-encoded films.

ISO speeds have replaced previously used ASA speeds. ISO speed numbers are

Kodak color print films at ISO 800 and ISO 1000 offer maximum versatility for 35mm cameras. They provide maximum shadow detail and can yield pleasing results in situations where the lighting is difficult to meter.

numerically the same as ASA speed numbers. For example, if the speed of a film is ISO (ASA) 200, you would set 200 on the ISO (ASA) dial of your camera or meter.

Kodak's very high speed (ISO 800 and ISO 1000) color print films are intended for low-light situations, for use with telephoto lenses, and for subjects that require faster shutter speeds to stop action.

Several Kodak 35mm films now feature packaging that makes film handling and identification easier. The user-friendly packaging system includes color-coded boxes and film cassettes, translucent canisters, and note-taking areas on the cassette and canister lid.

Marcia McKenzie-Hodge

Kodak 200-speed color print films are good general-purpose films for color prints. They offer plenty of speed (ISO 200) for moderate action and some existing-light applications, as well as extremely fine grain and sharpness.

Mackenzie Strawser

Kodak 400-speed color print films offer excellent versatility for 35mm automatic cameras. They're a popular choice for taking pictures of fast sports action.

DX-ENCODED FILMS

DX-encoded films were developed by Kodak to help camera manufacturers make automatic cameras even more automatic. DX-encoded films provide compatible auto-exposure cameras with vital information about the film you're using, such as ISO speed, film type, film latitude, and number of exposures. All of this information is encoded in a checkerboard pattern on the film magazine. When you load the magazine into the camera, sensors in the film compartment read the code.

The checkerboard pattern (DX code) on Kodak 35mm film magazines allows sensors in DX-compatible cameras to automatically set the film speed when you load the film.

41

DX-encoded films offer great convenience because they save you from having to set the film speed manually each time you load the camera. More important, they make it impossible to set the wrong film speed or to forget to change film speeds when you switch from one film to another. Also the camera knows when it has reached the end of the roll. And by providing information about the film's exposure latitude, the DX encoding can help the camera make important exposure decisions.

DX-compatible cameras are programmed to a specific range of ISO film speeds. This range is quite wide for SLR cameras, typically ISO 25 to ISO 5000. For simple cameras, the range may be narrower. If the camera cannot read the film speed, it will typically set a default speed of ISO 100. While this film-speed range covers most ordinary films that you will be using, there may be occasions when you want to go beyond this range or when you want to set a speed different from the manufacturer's designated speed. In such cases, it's usually possible to set a different speed manually. Many cameras display the film speed set by the camera, so you can check that it is correct.

FILM GRAIN AND SHARPNESS

Two important aspects of image quality related to film speed are sharpness and graininess. Sharpness refers to the film's ability to record fine detail with good definition. Generally, the lower a film's ISO speed, the greater its ability to render subjects sharply. Graininess is the sand-like or granular texture sometimes noticeable in prints and enlargements. Grain is a by-product of the structure of the film's light-sensitive emulsion. It is more apparent in pictures made with faster films. As speed increases, so does the size of the grain pattern.

Enlargement of the negative also affects apparent sharpness and graininess. At moderate print sizes (5 x 7 inches or smaller), grain is barely noticeable, even with fast films. But as enlargement increases, graininess becomes more apparent, and image sharpness diminishes. If you're planning on making extreme enlargements, you'll get the best results with low- and medium-speed films (ISO 25–ISO 125).

For color print films, Kodak has recently designed a method of grain measurement called the Print Grain Index (PGI), which is based on how graininess appears when you look at a resulting print. In the PGI scale, a change of four units equals a just-noticeable difference in graininess. A PGI rating of 25 represents the approximate point where graininess can first be noticed by most people at a predetermined distance. Higher numbers indicate an increase in the amount of

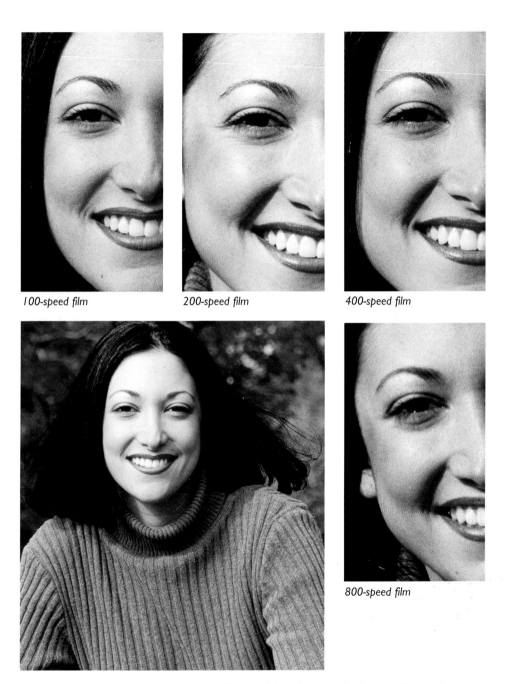

100-speed film

200-speed film

400-speed film

800-speed film

As this series shows, graininess increases with film speed. A medium-speed color print film provides exceptionally fine grain, while a high-speed film exhibits coarser grain. Medium-speed films, in addition to giving excellent results when enlarged, are fast enough for some action and some existing-light photography. The cropped photos here are magnified 20X.

graininess noticed. For example, a 100-speed color print film may have a PGI rating of 45, while a 400-speed color print film, with its coarser grain, may be rated at 53.

The relationship of film speed to grain and sharpness sometimes forces you to make crucial quality decisions. With action subjects, for example, you have to decide if you want to use a slower film for sharper, finer-grained pictures or a faster, action-stopping film. If you decide on a slower-speed film, you'll lose some action-stopping ability, but if you go for a faster film to halt action, you'll get increased grain. A medium-speed film (i.e., 200-speed) will give you action-stopping ability and extremely fine grain.

Recent improvements in film technology, such as KODAK T-GRAIN Emulsion, have minimized the problems of graininess, even with very fast films and at high degrees of enlargement.

Bill Cafer

Color slide films have more contrast and color saturation than color print films. Kodak low-speed (ISO 25–ISO 64) color slide films feature extremely fine grain and extremely high sharpness. They are excellent choices for a wide variety of bright daylight applications. Slide made on KODACHROME 64 Professional Film.

Keith Boas

Kodak 100-speed color slide films are ideal for all-around use in lighting conditions ranging from open shade or overcast to bright sunlight.

PROCESSING

Have your film processed promptly after exposure. You can process many 35mm films for general picture taking yourself. You'll need a film processing tank, a room that you can make totally dark, an accurate thermometer, and chemicals that are available from your photo dealer.

For traditional black-and-white film, you need only a few basic chemicals: developer, stop bath, fixer, and wetting agent (to avoid water spots during film drying). For each of these chemicals, particularly the developer, there are many products available. If you are interested in learning to process black-and-white film, a great guide for beginners is the KODAK Book, *Basic Developing & Printing in Black and White* (ISBN 0-87985-755-2).

For color print films (and for KODAK Black-and-White Film +400 Film), you will need chemicals for Process C-41.

KODAK EKTACHROME Films, require chemicals for Process E-6.

You cannot process KODACHROME Films successfully in your own darkroom. The highly complex process requires commercial photofinishing equipment.

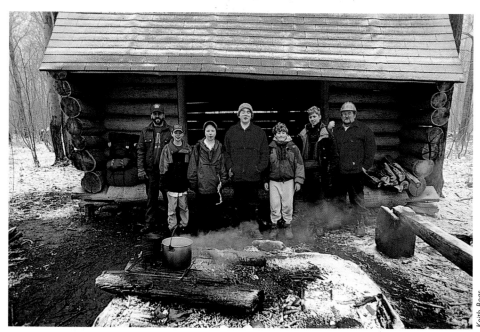

Keith Boas

Kodak 200-speed color slide films are excellent for general, outdoor picture taking.

Kodak tungsten-balanced color slide films are available in ISO 160 and ISO 320 speeds. They're designed for exposure with tungsten illumination (3200 K). You can use them outdoors at night for pictures of illuminated signs, buildings, fountains, and street scenes. They also give excellent results with the light from most household lamps.

Keith Boas

PUSH PROCESSING: SPEED BOOSTER FOR *KODAK EKTACHROME* FILMS

There will undoubtedly be times when you'll want to use a very-high-speed 35mm color slide film. This may be when you're shooting by low-level existing light, when you want to use a fast shutter speed combined with a small lens opening, or when you need a small lens opening to get good depth of field under dim lighting conditions. You, or a photofinisher, can double the speeds of some Process E-6 films by increasing the developing time in the first developer according to the instructions which come with the chemicals. This method is called push processing. For all the other steps, just follow the normal processing times in the instructions.

Very-high-speed KODAK EKTACHROME P1600 Professional Film is an excellent choice for low-light-level photography, action or sports photography, or situations that call for a combination of fast shutter speeds and small lens openings. The film is optimized for 2-stop push processing with Process E-6P. Designed for exposure with daylight or electronic flash, you can also expose this film under tungsten (3200 K) illumination with a No. 80A filter. Exposure at speeds higher or lower than EI 1600 may result in a visible loss of quality and is not recommended.

VERSATILITY OF *KODAK* COLOR FILMS

While the color films in the accompanying charts are designed specifically to produce color slides or color negatives for color prints, they also give you a great deal of versatility. You can have color slides made from your color negatives and color prints made from your color slides. You can also make color prints directly from your finished color prints using the KODAK Picture Maker. See your photo dealer.

In addition, you can have black-and-white prints made from your color negatives. Or you can make them yourself. KODAK PANALURE SELECT RC Paper was designed for this purpose. When color negatives are printed on this paper, the tones of gray in the print accurately represent the tonal relationships in the original scene. When color negatives are printed on regular black-and-white printing paper, you do not get this accurate tonal relationship.

CREATIVITY WITH *KODAK* INFRARED FILMS

Kodak offers two films that are sensitive to infrared radiation: a color slide film and a black-and-white print film. Both films have many scientific, government, and military applications, and they were perfected for these markets. However, because of their unique qualities, some pictorial and fine-art photographers enjoy using them for artistic interpretations.

KODAK High Speed Infrared Film is a fast, moderately high contrast black-and-white print film that is sensitive, of course, to infrared radiation. When you

Ernest East

Kodak 400-speed color slide film is great for capturing existing-light scenes like this one. The film can stop action in poor light or with telephoto lenses, and can provide extended depth of field without using slow shutter speeds.

use any of the recommended (No. 25, 29, or 89B) deep red filters with this film, you can create striking and unusual photographs of subjects such as landscapes, architecture—even people. In the resulting prints, the sky appears almost black, live grass and leaves appear almost white, and distant details normally obscured by haze show up with remarkable clarity. The film has an approximate daylight speed of 50 when used with a red filter.

KODAK EKTACHROME Professional Infrared EIR Film produces striking, false-color slides. When exposed through the

Keith Boas

A tree-framed farm scene on a sunny morning in autumn became a strange mixture of false colors when photographed with EKTACHROME Professional Infrared EIR Film.

recommended No. 15 (deep yellow) filter, green foliage reproduces in hues of vivid magenta, and skin tones go greenish yellow. Because the film is fairly high in contrast and because it's impossible to meter the amount of infrared radiation reflecting from the scene, take several shots, bracketing your exposures in half-stop increments. (See page 73 for more information on bracketing.) The film has an approximate daylight speed of 200 when used with a No. 12 filter.

Because of their extreme sensitivity to infrared radiation, you must load and unload these films into your camera in total darkness. If the room has fluorescent light illumination, wait about a minute after you turn off the lights before you remove the film from its canister—both when you load the camera and later when you load the film into the processing tank. This waiting time will allow any residual infrared radiation from the fluorescent tubes to dispel.

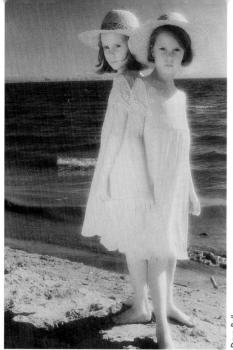

Dave Bell

KODAK High Speed Infrared Film is a moderately high-contrast, infrared-sensitive film that features abstract tone reproduction. With a red filter, it gives striking and unusual effects.

Bruce Schafer

High Speed Infrared Film is often used for pictorial landscape photos to create an eerie, dream-like effect.

50

David Moore

KODAK PROFESSIONAL T-MAX Black-and-White T400 CN Film is a recent addition to the stable of black-and-white films available. This 400-speed, multipurpose film is designed for Process C-41, the same chemicals used for processing color print films. The film can be printed on black-and-white or color papers with the result being a black-and-white print in either case.

David Moore

Using color paper, it's also possible for a photofinisher to change the overall tint of a print made from a T400 CN film negative. Here a sepia tone was created.

Medium-speed KODAK T-MAX 100 Professional Film excels in providing superior image quality. It's extremely fine grain and sharpness allow a high degree of enlargement.

Jacque Lee

With extremely fine grain and very high sharpness, high-speed KODAK T-MAX 400 Professional Film is versatile enough to cover a wide range of lighting conditions. It produces excellent results in bright sunlight, stops the action of moving subjects, and is especially useful for dimly lighted subjects.

Carol Murphy

KODAK T-MAX P3200 Professional Film successfully tackles the challenge of taking pictures in extremely dim lighting conditions where you want to stop fast action.

KODAK COLOR FILMS FOR 35mm CAMERAS

KODAK Film	Description	Use with	Film Speed and Filter			No. of Exposures Available
			Daylight	Photolamps 3400 K	Tungsten 3200 K	
COLOR PRINT FILMS						
GOLD (GA)	Features extremely high sharpness and extremely fine grain to allow for a high degree of enlargement and wide exposure latitude. Excellent for use in general lighting conditions.	Daylight or Electronic Flash	100	32 No. 80B	25 No. 80A	12 24 36
ROYAL GOLD 100 (RA)	With micro-fine grain and extremely high sharpness, this medium-speed film makes an excellent film for users requiring high-quality prints.	Daylight or Electronic Flash	100	32 No. 80B	25 No. 80A	24 36
GOLD 200 (GB)	Offers most of the qualities of GOLD 100 Film but with twice the speed. Good choice for general lighting conditions when you need higher shutter speeds for capturing action or smaller apertures for increased depth of field.	Daylight or Electronic Flash	200	64 No. 80B	50 No. 80A	12 24 36
ROYAL GOLD 200 (RB)	Excellent sharpness, contrast, and color similar to ROYAL GOLD 100 Film while adding a full f-stop in speed. Its superb skin-tone reproduction and exceptional grain make it a top choice for high-quality pictures and enlargements of people.	Daylight or Electronic Flash	200	64 No. 80B	50 No. 80A	12 24
MAX 400 (GC)	High-speed film for existing-light situations, fact action, great depth of field, and extended flash-distance ranges. Provides the best color accuracy of any 400-speed color-print film.	Daylight or Electronic Flash	400	125 No. 80B	100 No. 80A	12 24 36
ROYAL GOLD 400 (RC)	Kodak's finest grain 400-speed color print film. Very well suited for stop-action, sport, low-light, and telephoto pictures. Offers a greater range with flash pictures than is possible with 200-speed films.	Daylight or Electronic Flash	400	125 No. 80B	100 No. 80A	12 24 36
MAX 800 (GT)	Very high speed with very fine grain and medium sharpness. Use it in dim lighting or for fast action subjects.	Existing Light, Daylight or Electronic Flash	800	250 No. 80B	200 No. 80A	12 24 36
ROYAL GOLD 1000 (RF)	Very high speed. Offers very fine grain. Use it in dim lighting and for fast action when you want to make enlargements.	Existing Light, Daylight or Electronic Flash	1000	320 No. 80B	250 No. 80A	12 24 36

COLOR SLIDE FILMS

KODAK Film	Description	Use with	Film Speed and Filter			No. of Exposures Available
			Daylight	Photolamps 3400 K	Tungsten 3200 K	
KODACHROME 25 (KM)	Popular film noted for excellent color and extremely high sharpness. Has extremely fine grain and good exposure latitude.	Daylight or Electronic Flash	25	8 No. 80B	6 No. 80A	24 36
KODACHROME 64 (KR)	Medium-speed, general-purpose film. Exhibits remarkable sharpness and extremely fine grain. Excellent color rendition.	Daylight or Electronic Flash	64	20 No. 80B	16 No. 80A	24 36
KODACHROME 200 (KL)	Features extremely high sharpness and fine grain. Allows faster shutter speeds for hand-holding tele lenses, smaller lens openings for increased depth of field, and use in low-light situations.	Daylight or Electronic Flash	200	64 No. 80B	50 No. 80A	24 36
ELITE Chrome 100 (EB)	Medium-speed, general-purpose film. Features very high sharpness and has the finest grain in its speed class. Reproduces both subtle and bright colors with remarkable authenticity.	Daylight or Electronic Flash	100	32 No. 80B	25 No. 80A	24 36
ELITE Chrome 160T (ET)	Medium-speed film for use with 3200 K tungsten lamps and existing tungsten light. Features very fine grain and excellent sharpness. Can be push-processed to double the film speed.	Tungsten Lamps 3200 K or Existing Tungsten Light	100 No. 85B 200* No. 85B	125 No. 81A 250* No. 81A	160 320*	24 36
ELITE Chrome 200 (ED)	Medium-speed film for existing light, fast action, subjects requiring good depth of field and high shutter speeds, and for extending flash-distance range. Has extremely fine grain and very high sharpness. Can be push-processed to double the film speed.	Daylight, Existing Light, or Electronic Flash	200 320*	64 No. 80B 100* No. 80B	50 No. 80A 80* No. 80A	24 36
ELITE Chrome 400 (EL)	High-speed film for existing light, fast action, subjects requiring good depth of field and high shutter speeds, and for extending flash-distance range. Fine grain and high sharpness. Can be push-processed to double the film speed.	Daylight, Existing Light, or Electronic Flash	400 800*	125 No. 80B 250* No. 80B	100 No. 80A 200* No. 80A	24 36
EKTACHROME P1600 Professional (EPH)	Very-high-speed film for existing light in situations that demand fast shutter speeds and small lens openings for good depth of field. Optimized for an effective film speed of EI 1600 using a two-stop push in processing.	Daylight, Existing Light, or Electronic Flash	1600	500 No. 80B	400 No. 80A	36
EKTACHROME Professional Infrared EIR	Medium-speed, infrared-sensitive film for use in scientific and special-effects applications. False colors appear red/magenta. Load/unload camera and canister in the total darkness.	Daylight, Existing Light, or Electronic Flash	200 (No. 12)	—	—	36

*Use these speed settings to expose these films when you want your film push-processed one stop.

KODAK BLACK-AND-WHITE FILMS FOR 35mm CAMERAS

KODAK Film	Description	Film Speed	No. of Exposures Available
T-MAX 100 Professional (TMX)	Medium-speed, panchromatic film with extremely fine grain and nearly the same speed as KODAK PLUS-X Pan Film. Particularly good for detailed subjects. Features extremely high sharpness and allows a high degree of enlargement.	100	24 36
PLUS-X Pan (PX)	Excellent general-purpose, panchromatic film that offers medium speed and extremely fine grain.	125	24 36
TRI-X Pan (TX)	High-speed, panchromatic film especially useful for photographing existing-light subjects, fast action, subjects requiring good depth of field and high shutter speeds, and for extending flash-distance range. Has fine grain and excellent quality for such a high speed.	400	24 36
T-MAX 400 Professional (TMY)	Panchromatic film that offers the same film speed as TRI-X Pan Film and finer grain than PLUS-X Pan Film. Especially useful for photographing subjects in low light, stopping action, or expanding depth of field. Allows a high degree of enlargement. Can be exposed at speeds of 800 and 1600 with very acceptable results.	400	24 36
Black & White + 400 PROFESSIONAL T400 CN	Multi-purpose, chromogenic, black-and-white films for processing in Process C-41 with color print films. Negatives can be printed on either black-and-white papers or color print papers (for different hues such as sepia, blue, etc). The films have wide exposure latitude, extremely fine grain, and high sharpness.	400	24 36
T-MAX P3200 Professional (TMZ)	Extremely high-speed, fine-grain, panchromatic film for use in existing light, such as sports stadiums and night events. With push processing, you can expose it at 3200 and 6400 with good results and up to 25,000 with acceptable results.	800-1000	36
Technical Pan (TP)	Panchromatic film with extremely fine grain. Gives large-format performance with 35mm convenience. Great enlargement capability. Suitable for general and scientific applications, such as photomicrography, precision copying, titling, and pictorial photography, depending on exposure and processing used.	25†	36
High Speed Infrared (HE)	Infrared-sensitive film that produces striking and unusual results. With a red filter, the blue sky reproduces almost black and clouds look white. Live grass and trees appear as thought they are covered with snow. The film has fine grain.	125 tungsten‡	36

*To expose this film at speeds higher than 6400 (up to 25,000), make tests to determine if the results are appropriate for your needs.
†Use this speed for daylight pictorial photography when processed in KODAK TECHNIDOL Liquid Developer.
‡Use this speed as a basis for determining your exposures with tungsten light when you exposed the film through a No. 25 filter.
For daylight photos, follow the exposure suggestions on the film carton.
Note: Panchromatic means that the film is sensitive to all visible colors.

CHAPTER **3**

Exposure

Accurate exposure is important in producing a high-quality photograph and it is critical when you use a slide film. Exposure is the amount of light reaching the film. Each film requires a specific amount of light to produce a picture of the proper brightness. How much light a film requires depends on its speed. The versatility of your camera enables you to shoot pictures at sunrise, during a blizzard or rainstorm, in your family room, or at a night baseball game.

For such unusual lighting situations, a light meter is a must. Most 35mm cameras have built-in meters. The built-in meters of SLR cameras indicate the shutter speed and aperture required for correct exposure. Those cameras that set the aperture and shutter speed are automatic exposure cameras. Those that leave it up to you to set the shutter speed and aperture are manual exposure cameras. Many cameras offer both automatic and manual exposure.

EXPOSURE WITH AUTOMATIC CAMERAS

Most new cameras set the exposure and film speed automatically. Not all automatic cameras, however, have the same features. Many compact 35mm cameras have very simple exposure systems and allow little (if any) control of exposure. Some sophisticated SLR models offer several exposure modes. Between the two are cameras that have only partial auto-exposure systems. These may require you to make part of the exposure decision—setting the shutter speed or aperture, for example. If your camera has several exposure modes, knowing the advantages of each mode is of great importance in making the most of auto-exposure capability.

Automatic cameras that offer a choice of modes do so to suit different needs, such as extending depth of field or stopping action. Other modes optimize results with a particular piece of equipment, such as a telephoto lens. Following is a look at each of the different auto-exposure modes. Read your instruction manual for specifics about your camera.

Accurate exposure was critical for this delicate window-light portrait, taken on 400-speed color print film. For situations like this, where there is an extreme range of brightness, base your exposure only on the light that is reflecting from the subject's face—the most important part of the picture. Photo by Jeanne Van Alphen.

Pat Minton

APERTURE PRIORITY

In this mode you select the aperture and the camera automatically picks a shutter speed for correct exposure. Aperture priority is ideal if you want to control depth of field. By choosing a small aperture for extensive depth of field or a large one for selective focus, you get the benefits of auto exposure while being able to manipulate scene sharpness.

SHUTTER PRIORITY

In this mode you sct the shutter and the camera sets the aperture required for correct exposure. You can choose a fast shutter speed to halt action subjects or a longer shutter speed to accentuate motion (to blur water going over a waterfall, for instance).

If the shutter speed you have selected requires an aperture beyond the range of your lens, you may have to adjust the shutter speed or use a faster or slower film. If you wanted to make a 1-second exposure in daylight with medium-speed film, for example, even a very small aper-

The aperture-priority mode allows you to set the aperture for creative effects—either great depth of field or little depth of field. Here the photographer set a large aperture so the background would be out of focus and not distract from the foreground subject. The camera will automatically set the shutter speed.

Janalee Stock

The shutter-priority mode enables you to set the shutter speed required by the subject. Here the photographer used a fast shutter speed to freeze the action. The camera will automatically set the aperture.

In the program mode, the camera sets both the shutter speed and aperture. If the subject does not require a particular shutter speed or aperture, use the normal program mode. It sets a moderate shutter speed and aperture. Exposure: 1/125 second at f/16 with 100-speed slide film. Camden, Maine.

ture, such as $f/22$, wouldn't be small enough to give proper exposure. The solution in this example would be to switch to a slower film or to use a neutral density filter.

PROGRAM MODE

Cameras that offer a full program mode choose both the aperture and the shutter speed for you. In the normal program mode, the camera provides a moderate shutter speed (one that is safe for handheld shooting and a relatively stationary subject) and a moderate aperture for an average amount of depth of field. Unless you have specific creative or technical demands that require other settings, this is the best mode for general photography.

Some cameras have a feature called program shift that allows you to choose any equivalent combination of shutter speed and aperture by simply turning a dial or pressing a button (usually near the shutter release). With this feature you can let the camera figure the exact exposure, but then quickly tailor the exposure combination to your subject's needs. If the camera meter chooses a combination of 1/125 second at $f/8$, for example, you could shift to an equivalent exposure: 1/250 second at $f/5.6$, 1/60 second at $f/11$, etc.

Two special program modes that some cameras feature are a depth-of-field program and an action program. Both are full program modes (aperture and shutter speed are chosen for you), but they allow you to tailor the exposure system to a particular type of subject. When set to the depth mode, for example, the camera will automatically choose the smallest possible aperture that still allows a safe handheld shutter speed. This is a good mode to use in scenic photography when you want great depth of field. Similarly, in the

It's easy to determine the exposure for a normal scene. Just make the meter reading from the camera position by aiming your light meter or camera with built-in meter toward the subject.

action-program mode, the camera will pick a fast shutter speed with a large aperture to stop fast-moving subjects.

Some cameras that use interchangeable lenses often switch automatically to these special program modes as you switch lenses to choose a mode that best complements the specific focal length of the lens. For example, if you're using a telephoto lens (typically the cutoff point is 135mm or longer), the camera will automatically go into the action mode and set a fast shutter speed to prevent blurred pictures caused by camera shake. If you attach a wide-angle lens, the camera will switch to the depth program and select an aperture that will give the maximum available depth of field–since gaining

maximum depth of field is a prime reason for using a wide-angle lens.

What about zoom lenses? Cameras with a choice of programmed exposure modes often have sensors in the lens mount that monitor focal length and set the program mode accordingly.

Finally, you can use most automatic cameras in a full manual exposure mode by selecting the manual mode on the mode-selection switch. In the manual mode you are free to select both aperture and shutter speed to handle a particularly difficult subject or to create an imaginative effect.

SELECTIVE METER READINGS (AUTOMATIC CAMERAS)

Automatic cameras are programmed to give you good exposures with subjects of average brightness under average lighting conditions and generally they do this job very well. But as mentioned in the previous section, you won't always be working under average lighting conditions or with average subjects. The meter in your automatic camera can be fooled, although some exposure systems are more foolproof than others.

A few automatic cameras, for example, are able to evaluate even the most complex light situations and provide accurate exposure information. They do this with a system called matrix or zone metering. In this type of metering system, the camera's computer divides the picture area into a grid. It compares various data, such as contrast, brightness, and subject size, and then uses this information to make "educated" exposure decisions. In some cameras these decisions are based on comparisons with hundreds of thousands of exposure patterns that have been programmed into the camera's memory. This type of camera can make a correct exposure even if, for example, the main subject is backlit.

The exposure corrections we suggest for unusual lighting conditions may not always be needed for cameras with matrix or zone metering. If your camera has such a system, study your pictures to see how accurate the meter is in handling tricky lighting. If it sometimes falls short, you may be able to switch to an averaging meter mode (or manual) and follow our recommendations.

Donna Nelson

Spot meters work well in uneven lighting, especially when an important part of the scene is relatively small and is surrounded by a much lighter or darker background.

No matter how sophisticated the metering system, all automatic cameras occasionally need your guidance. And most provide one or more controls that can alter the exposure. Common controls are the spot meter, exposure lock, backlight button, and exposure compensation control. With any exposure-compensation feature, be sure to set it back to its neutral or zero position when you change subjects or settings.

A **spot meter** enables you to take a reading from a small area (usually marked by a circle in the center of the viewfinder) that you deem important, such as a brightly colored flower against a black background. To activate this feature, you

61

would typically depress the spot-metering button and then activate the meter by pressing the shutter release partway. As long as you keep the shutter release depressed (or until you take the picture), the meter will lock in this spot reading. With some cameras, just pressing the spot button locks the exposure until you take a picture.

A **memory-lock** button lets you take a reading from the entire metering area and hold that reading until you take the picture. By moving in close (physically or with a zoom lens) to fill the frame with the main subject and locking the reading, you can get accurate exposure for the important part of the scene—a face, for instance. As long as the exposure remains locked, you can recompose the scene in any way you want and still get the right exposure.

Memory-lock is particularly useful in very contrasty situations. For example, if you needed to make a close-up meter reading of a dark subject in front of a light background (or vice versa), you could move in close to make the reading, push the memory-lock button to hold the exposure, and then move back to your original shooting position to take the picture. If you were using a zoom lens, you could zoom to the longest focal length, take a reading and lock it, and then recompose the scene by adjusting the zoom setting.

An **exposure compensation** control lets you alter the exposure automatically by up to plus or minus 2 or 3 stops, usually in 1/2- or 1/3-stop increments. Exposure compensation is useful for back-

The exposure compensation control on your camera might be a button that you press or it may be a dial that you set.

lit scenes and for very bright or dark subjects that would normally mislead the meter.

Some simpler cameras have a similar but less sophisticated exposure-compensation feature called a backlight button. This is actually an exposure-compensation button that gives a fixed amount—usually 1 1/2 or 2 stops—of extra exposure to compensate for dark foreground subjects (such as faces) in strongly backlit situations.

If your automatic camera doesn't have a compensation control or a backlight button, it may be possible to change the exposure by changing the setting on the film-speed dial. All you have to remember is that each time you double the film speed, you decrease exposure by one stop; each time you halve the film speed, you increase exposure by one stop.

To correct the exposure by altering the film-speed setting or using any type of compensation feature, you first have to know the amount of correction that's needed. Estimating the correction is fairly simple for overall light or dark scenes, especially when they don't include people. Also, the amount of correction isn't as critical when you are using color print film, which has a wide exposure latitude.

For example, a sunlit, snow-covered hill would cause a meter to underexpose the scene so that the snow would appear gray rather than bright white. Since this kind of scene usually requires 1 stop more exposure than that indicated by the meter, simply divide the film speed by 2 (effectively adding 1 stop of exposure) and set this lower film speed on the film-speed dial. Or set +1 stop on the compensation control. With a 200-speed film, for instance, you would set the dial to 100. Conversely, if you were photographing a very dark scene that the camera would normally overexpose, multiply the film speed by 2 (ISO 400 instead of 200, for example). Or set -1 stop on the compensation control.

With cameras that set the ISO speed automatically for DX-encoded films, you may or may not be able to alter the ISO speed. If you do change ISO speeds in mid-roll, be sure to set the correct speed back when you're done or you will alter the exposure for the rest of the roll.

MANUAL EXPOSURE WITH BUILT-IN METERS

Most manually adjustable SLR cameras have a built-in reflected-light exposure meter that takes light readings through the camera lens (called TTL metering). Some built-in meters measure the light as it enters the lens and hits sensors on or near the reflex mirror; others measure the intensity of the light at the film plane (called OTF or "off-the-film" metering).

One important way that meters differ is in the area where they measure the light. Most TTL meters measure the average of all the light reflecting from a scene. Others take a weighted reading. In meters that weigh the reading, a small area has the greatest influence on exposure determination but the remaining picture area also exerts some influence. Some cameras have TTL meters that work on the same principle as a spot meter; they read only a small segment of the scene.

Using a built-in meter is easy. Once you've set the film speed on your camera dial (not necessary with a camera that senses DX-encoded film), all you have to do is aim your camera at the scene and the meter will measure the light reflecting from the scene. You then adjust the aperture or shutter speed (or both) until a viewfinder display indicates you have set the exposure correctly. The correct exposure may be indicated by matching a needle to a specific mark or area in the viewfinder, or by a lighted display.

When you set the shutter speed and aperture, consider subject demands. With moving subjects, for example, you may want to select a shutter speed fast enough to stop action and then find an aperture

to give the correct exposure. With breath-taking vistas, you may want to select an aperture small enough to make a picture sharp from foreground to background, and then find an appropriate shutter speed.

SELECTIVE METER READINGS (MANUAL CAMERAS)

The exposure indicated by the camera's meter works well for most subjects. But you will encounter difficult situations where you'll have to use the built-in meter to make more interpretive, or selective, readings.

Very contrasty scenes that have large dark and bright areas, for example, may require selective meter readings. An overall meter reading from the camera position is affected by the large areas in the scene, such as light or dark foregrounds or backgrounds. If the main subject (a person, for example) is surrounded by a large area that is much lighter or darker than the subject, the meter will indicate an exposure that's correct for the background but wrong for the main subject.

In situations such as this, you should make a selective meter reading. For example, move in and make a close-up reading of the subject (a person's face or body) that excludes the unimportant light or dark area. You may sacrifice detail in the larger background or foreground area, but the main subject will be correctly exposed. When you make a close-up reading, be careful not to measure your own shadow or the shadow of your camera. If you have a spot-metering camera, making a selec-

When your subject is in front of a very bright background, your light meter may be fooled into "thinking" that the entire scene is bright. The result will be underexposure.

To achieve correct exposure, you need to measure the light reflecting only from the subject and then set your camera accordingly.

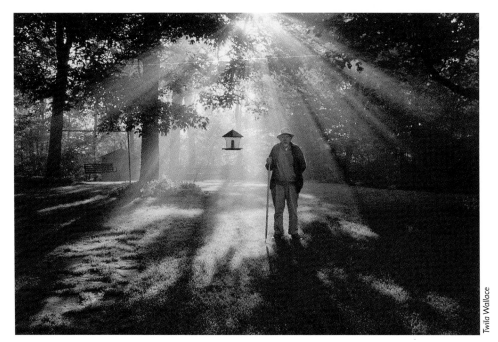

In backlit scenes, the background is often brighter than the subject, so here again take a close-up meter reading of the subject. Also, the sun can shine into the meter cell or camera lens on a camera with through-the-lens metering causing a meter reading that's way too high and resulting in underexposure. To avoid this, hold your hand or some other object so it blocks the sun from shining on your meter or camera lens. Be careful not to include your hand or other object in the field of view.

tive reading is just a matter of centering the important subject area in the spot-metering zone.

Scenes that include a large proportion of sky often require selective meter readings. Since the sky is usually brighter than other parts of the scene, your exposure meter may indicate too little exposure. As a result, a subject that's darker than the sky will probably be underexposed. This effect is even greater with overcast skies than with blue skies. One trick to avoid this problem is to aim your camera down slightly when taking a light reading so that the meter isn't fooled by the bright sky.

In backlit scenes, the background is often sunlit and therefore brighter than the subject. Also, light coming from behind the subject may shine directly into the lens or metering cell. Both situations often result in underexposure of your subject. The solution is to take a close-up reading, being careful to shade the lens from extraneous light.

If you're using a zoom lens, taking close-up readings is easy since you can often do it without changing your shooting position. Simply zoom the lens to its longest focal length, take a reading from the important areas of the scene, and then

The reverse of the bright background situation is a background darker than the subject. Dark surroundings can mislead your light meter and cause a meter reading that's too low, resulting in overexposure. To get the correct exposure, make a close-up meter reading of just the subject—the same as you would do if the background was very bright. Vietnam Memorial, Washington, D.C.

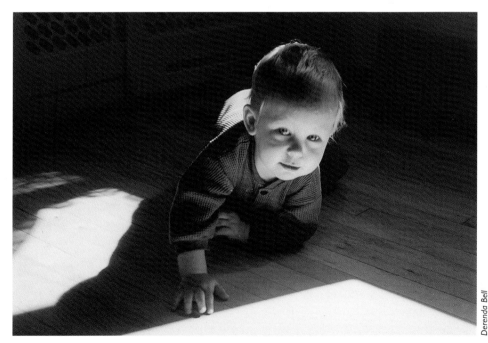

When the scene contains large shadow areas and/or bright highlights, move in very close to the subject to take a meter reading. Set the indicated exposure on your camera and return to your original position to take the photo.

return to the focal length that you want to use for shooting the picture. Be sure to use the exposure you determined from the close-up reading, even if the meter is warning you of under- or overexposure when you change the zoom setting to take the picture.

Sometimes a large very light area or a large very dark area is an important part of the picture and you'll want to be sure that it is exposed correctly. Vistas filled with snow or white sand fall into this category. If you used an overall or average meter reading, the scene would be underexposed–too dark. White subjects, such as snow scenes, would come out a drab gray instead of white because the meter is trying to make everything in the scene an "average" tone. This type of scene usually requires about 1 to 1-1 /2 stops **more** exposure than indicated by the meter. It's a good idea to compare the camera settings you have determined with your TTL meter with those recommended in the film instructions. If your meter reading is much less, you'll probably get better results by following the film instructions.

Conversely, when you encounter an important dark scene–a black horse against a dark forest, for example—you'll want to use 1 to 1-1/2 stops **less** exposure than the meter indicates. Otherwise your meter, in its effort to average all subjects, will cause the horse and background to record too light. You'll get a gray horse instead of a black one. For difficult scenes like these, it's often a good idea to bracket your exposures to get a properly exposed picture.

To avoid poorly exposed photos, learn the proper metering or exposure compensation techniques to use for predominantly light or dark subjects.

Finally, if a scene has both very bright and very dark areas, make a meter reading of the brightest and darkest areas that are important to your picture and then use a setting midway between the two. This won't guarantee you perfect exposure of all parts of the scene, but it will keep the meter from being swayed too far in either direction.

Note: Most print films have good exposure latitude. With Kodak color print and black-and-white films, you will get good results even if your exposure is off by 2 stops in either direction. They'll give even better results if your exposure is correct. With color slide films, always strive for accurate exposure.

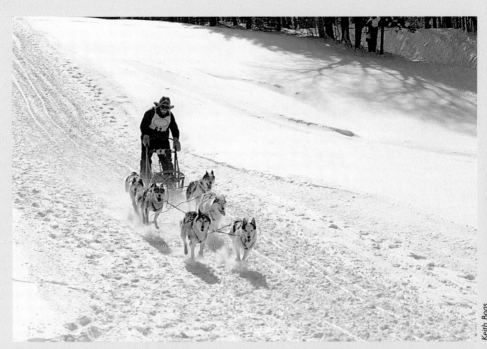

Keith Boas

The brightness of sand or snow can also trick the camera into making pictures too dark (underexposed). To adjust for this situation when using a meter, you have several options:

1. Base exposure on a close-up meter reading of just the subject.

or

2. Increase exposure one f-stop by adjusting the compensation control on an automatic camera or opening up the lens aperture one f-stop on a manual camera.

or

3. Take a close-up meter reading off the palm of your hand and open up one f-stop.

or

4. Take a close-up meter reading off a gray card (a piece of cardboard coated with a gray ink which reflects the same amount of light as an average scene).

INCIDENT-LIGHT EXPOSURE METERS

Incident-light meters measure the illumination falling on the scene. You hold this type of meter in the same light that's illuminating the subject, usually near the subject, and point the meter at the camera (unless the instruction manual for your meter recommends a different technique).

Exposure determined by an incident-light meter assumes that the subject has average reflectance. Fortunately, most scenes have average reflectance so the exposure indicated by an incident-light meter is good for most picture-taking situations. However, if a very bright or very dark area is an important part of the picture and detail recorded in that area of the

picture is wanted, you should modify the exposure indicated by the meter:

- Use a lens opening 1/2 to 1 stop **smaller** than the meter indicates if a bright subject is the most important part of the picture.
- Use a lens opening 1/2 to 1 stop **larger** than the meter indicates if a dark subject is the most important part.

If the scene is unevenly lit and you want the best overall exposure, make incident-light readings in the lightest and darkest areas of illumination that are important to the picture. Then use the f-number that's midway between those that the meter indicates.

Mark Maierle

A conventional meter reading from the camera position would lead to overexposure because of the dark surroundings in this scene. With a spot meter, you could make a meter reading of just the lighthouse or the girl's face without moving from where you want to take the picture.

Keith Boas

A good way to determine normal exposure when most of the scene is very bright is to use an incident-light meter.

Donna Mckay

One advantage of an incident-light meter is that it isn't misled by surroundings darker or lighter than the subject. Here an incident light reading, made at the photographer's location in the same lighting, would not be influenced by the area in shadow or the very bright foreground.

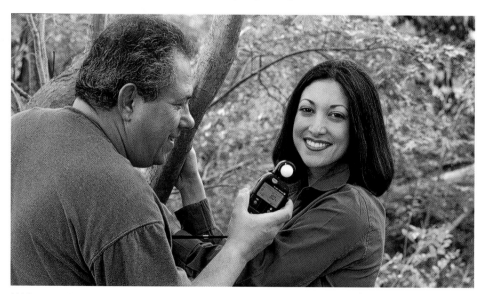

With an incident-light meter, you point the meter toward the camera position to make the reading. An incident-light meter is not influenced by the brightness of the subject. If the lighting at the camera position is the same as the lighting on the subject, you can make the meter reading at the camera position with the meter facing the camera. If the lighting is different at the subject, you must make an incident-light reading at the subject location.

BATTERY POWER

To obtain accurate readings from a meter, be sure the batteries that power it are in good condition. Cameras that have other automatic features, such as autofocus, auto-wind and rewind, and built-in flash, depend even more on battery power. Many cameras have a battery-check indicator to tell you when batteries are okay; it's a good practice to check this indicator frequently, especially before an important shooting event such as a party or vacation.

If your camera doesn't have a battery checking device and the exposure meter behaves erratically or the camera doesn't operate normally, it's probably time to replace the batteries. Clean contacts are important, too; if batteries seem weak, clean the contacts in your camera and on the batteries with a rough cloth or pencil eraser. Most batteries will last about a year in normal use, although lithium batteries usually last longer. Actual battery life will depend on the number of battery-dependent features your camera has and how many rolls of film you shoot. When AA batteries are required, use **alkaline** batteries.

Remember, too, that batteries weaken quickly in cold weather. It's a good idea to carry a set of spare batteries. In the winter, put them in an inside pocket to keep them warm, and then switch them when the batteries in your camera become weak. Battery strength returns when cold batteries warm up.

When you're taking pictures outdoors in extremely cold weather, "wear" your camera inside your parka between exposures to keep the batteries warm. Cold batteries will be weak and may not perform correctly—or at all! Photos by Keith Boas.

Bracketing your estimated exposure is good insurance for getting a picture with proper exposure when you're not sure what the exposure should be. These photos show exposure bracketing of 1 f-stop on either side of the estimated exposure. Photos by Keith Boas.

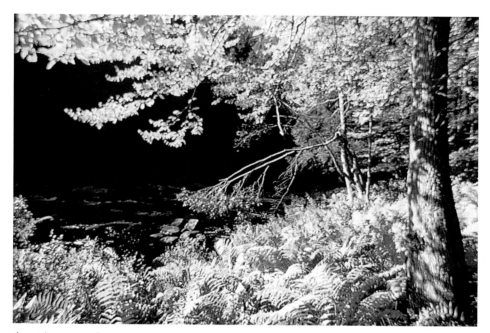

1 stop overexposed

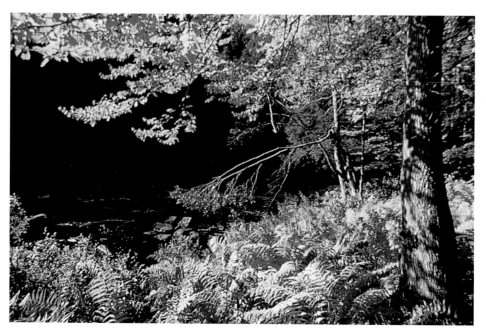

Normal exposure

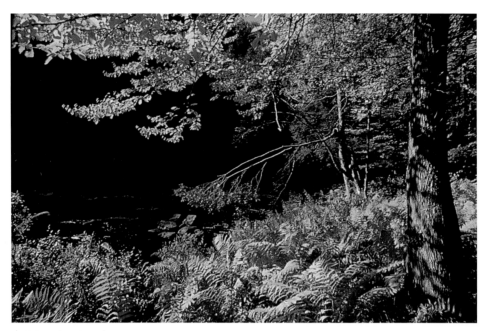

1 stop underexposed

BRACKETING EXPOSURES

There may be times when very unusual lighting or subject brightness will exhaust the versatility of you and your meter. To be sure of getting the best exposure when this happens, it's wise to bracket your exposures. Take a picture at the exposure setting indicated by your meter, another with 1 stop less exposure, and a third with 1 stop more. If it's a case of now or never, also shoot pictures with 2 stops more and 2 stops less exposure than the meter indicates.

A few automatic cameras have auto-bracketing features. You choose the amount of bracketing (usually up to plus or minus 2 stops in half-stop increments) and the camera motor drive will automatically fire off a series of pictures in rapid succession when you press the shutter button. Most cameras with this feature make 3 bracketed exposures.

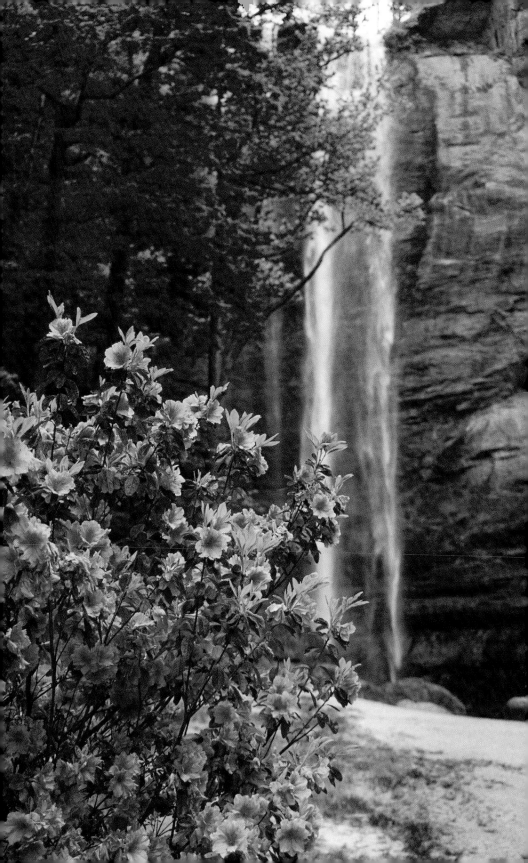

Daylight Photography

> "Eventually he began to see that light was what he photographed, not objects. The objects merely were the vehicles for reflecting the light. If the light was good, you could always find something to photograph."
>
> Robert James Waller
> *The Bridges of Madison County*, Warner Books, 1992

Outdoor lighting in the daytime can range from intense, directional sunlight to the soft, shadowless illumination of an overcast sky. It can be the dim, "quiet" light within a forest or the brilliance of specular reflections dancing on the surf. It can be the warm hues of an approaching September sunset or the cold bluish gray of an impending storm. Knowing how to photographically make the most of diverse daylight lighting conditions can expand your picture-taking opportunities and help you produce better, more rewarding images.

BASIC DAYLIGHT LIGHTING CONDITIONS

To become familiar with the nature of outdoor lighting, you should have a clear impression of the basic daylight lighting conditions and the exposures they require. Even though most 35mm cameras have built-in light meters, you can use the exposure guidelines in this chapter to verify that you're using your meter correctly or to determine the correct exposure in situations where accurate metering is difficult or impossible.

Although the subject is important in a picture, the quality of light often has the major effect on a photo's appeal. Had this scene received bright sunlight on the azaleas and minimal or no light on the background, the harsh contrast would have produced a different mood and, perhaps, less successful result. Photo by Greg Langston.

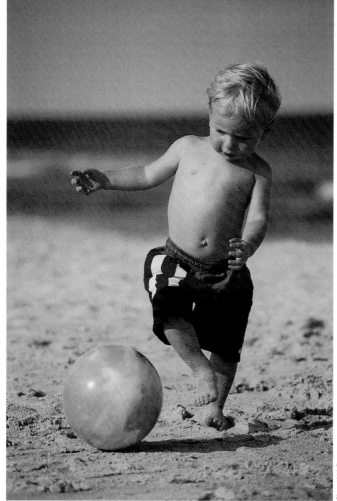

Bright sunlight is very popular for outdoor photography, especially in late afternoon when colors appear more saturated and skin tones are warm.

Sherri W. Pass

BRIGHT OR HAZY SUN, AVERAGE SUBJECTS

The sun is shining with a blue sky or the sun is covered with a thin haze. The sun is unobstructed and clearly defined, though scattered clouds may be present. Shadows are sharp and distinct.

You can determine the **basic exposure** for frontlit, average subjects in bright or hazy sun by a simple formula:

$$\frac{1}{\text{Film Speed}} \text{ second at } f/16$$

For example, if you're using a film with a speed of ISO 100, the exposure would be 1/100 second at $f/16$. Use 1/125 second, the speed nearest to 1/100 on your camera. You can use this formula to find the exposure if you don't have a light meter or if your meter is in need of repair. We will refer to this basic exposure in our discussion of other lighting conditions.

When photographing snowy scenes in bright sunlight, increase the exposure 1 or 1-1/2 stops from the meter reading so the snow appears white (instead of gray) in your pictures.

Millie Rogers

BRIGHT OR HAZY SUN, ON LIGHT SAND OR SNOW

The sun and sky condition is the same as for the first lighting condition given previously, but the subjects are on very light sand or snow. Because these bright surfaces reflect a lot of light, the recommended exposure is 1 *f*-stop less than the basic exposure for average subjects.

Note that the exposure corrections given in this section are for use with the basic daylight exposure defined on page 75, not with light meter readings. Refer to the chapter on exposure beginning on page 57 for how to use in-camera and handheld light meters.

Because reflected-light meters can be fooled by bright backgrounds, determine the proper exposure by making a close-up reading of the subject. If this is not practical, be suspicious of a meter reading that indicates an exposure different from 1 *f*-stop less than the basic exposure for average, frontlit subjects. If the meter reading is too high because of an extremely bright background, you'll probably get better results using the exposure recommendations given here.

Since the appearance of a scene varies with the time of day and the outdoor lighting conditions, you'll get better pictures by observing these differences and taking the picture when the conditions are optimum for the effect you want show.

Midday

Late afternoon

Sunset

Anna Marie Mywaart

Weak, hazy sun is flattering lighting for informal portraits.

WEAK, HAZY SUN

The light from the sun is weakened by a heavy haze and the sun's disk is visible but diffusely outlined. Shadows are weak and soft but readily apparent. Since there are no harsh shadows, these conditions are excellent for photographing people.

With weak, hazy sun, use 1 *f*-stop more exposure for average subjects than the basic exposure for bright sunlight.

With some architectural subjects, the deep shadows produced by bright sunlight can add an interesting counterpoint to the basic design theme.

Under cloudy-bright sky conditions, there are no dark shadows to obscure details or create distractions in your pictures. Photo by Guadelupe Hernandez.

CLOUDY BRIGHT

The sun is hidden by light clouds. The sky may be completely overcast or there may be scattered clouds. You can't see the sun's disk, but you can determine where it is by a bright area in the sky. There are no shadows.

A cloudy-bright condition usually requires an exposure 2 *f*-stops greater than for bright sunlight.

HEAVY OVERCAST

The sky is filled with heavy clouds and there is no bright area to show the location of the sun. There are no extremely dark areas to indicate an approaching storm and there are no shadows.

Heavy-overcast lighting generally requires 3 stops more exposure than bright sunlight.

Don't let rainy days discourage you from taking pictures, as colors often appear more saturated when wet. Keep your camera dry by shooting from under shelter, using an umbrella, or placing your camera inside a plastic bag with only the front of the lens poking out.

Wilford Yoder

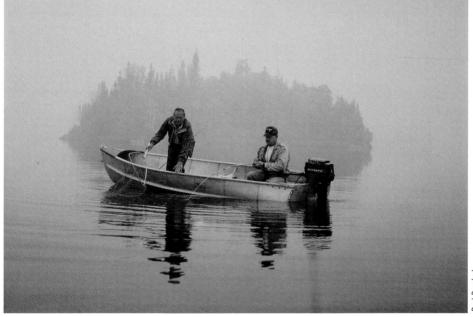

Rod Perchak

The extremely overcast lighting on a foggy day is nearly shadowless and produces delicate colors with a mix of gray tones. It's excellent weather for isolating nearby subjects from the background.

Shadows are softer and it's easier for people to have natural expressions when the sunlight is not so bright for their eyes.

Octavio Barcelo Durazo

OPEN SHADE

This is the kind of lighting you have when your subject is in the shadow of a nearby large object such as a building. But you can still see a large area of open sky overhead in front of the subject.

Like heavy overcast, open shade usually requires an exposure increase of 3 stops over that for bright sunlight.

Open shade describes the lighting conditions when your subject is in the shade of a nearby object that is not overhanging the subject and there is open sky overhead. Exposure is usually about the same as for heavy overcast lighting— 4 stops more than in bright sunlight (your base exposure).

To avoid squinting, move subjects out of the sunlight and into open shade. Their expressions will be more relaxed and natural.

It's easy to photograph subjects lit by bright sunlight. The exposure is easy to determine and colors will reproduce in vivid hues.

BRIGHT SUNLIGHT

Most outdoor pictures are made in bright sunlight. This type of lighting offers the advantage of making colors look their brightest and snappiest. Exposure calculation is also simpler in bright sunlight because you can use the same exposure settings for most subjects. As long as you take pictures of average frontlit subjects, you can shoot during most of the day at the same exposure settings.

SIDELIGHTING AND BACKLIGHTING

If you photograph all your subjects by frontlighting, you'll miss some excellent picture possibilities. Sidelighting and backlighting can help create interesting and pictorial photographs. You can use sidelighting and backlighting to produce strong separation between a subject and the background because the lighting creates a rim of light around the subject. You can use this type of lighting to emphasize the shape of the subject since sidelighting and backlighting create highlights and shadows called modeling. You can also use strong sidelighting to bring out surface textures and backlighting to capture the translucent quality of flowers and foliage. These advantages are lost when the sunlight comes over your shoulder and falls directly on the front of your subject.

When you're taking backlit pictures, you should use a lens hood or shield the camera lens with your hand or another object to keep the sun from shining into the lens. It's also very important to keep your lens sparkling clean. Sunlight shining into the lens can cause reflections and flare inside the lens and camera, which can degrade your pictures.

No exposure increase is usually required for sidelighting or back-lighting in scenic views where the shadows are small without important detail. Oahu, Hawaii.

Keith Boas

In this backlit photo, bright sun has produced shimmering highlights on the fountain's pictorial spray.

Gabriel Sotel Monroy

When you take pictures of backlit and sidelit subjects, shielding your camera lens from the direct rays of the sun will help to avoid lens flare. You can use a lens hood or the shadow from your hand or a near-by object. Also be sure the sun's rays don't strike the light-sensitive cell of an automatic camera or light meter.

You'll usually need to use larger lens openings or slower shutter speeds for this type of lighting than for frontlit subjects. In close-up pictures, especially of people, the shadows will probably be large and contain important details. To capture this detail, increase exposure for sidelit subjects 1 *f*-stop over the normal exposure you'd use for frontlit subjects, and give backlit subjects 2 stops more exposure than normal. When you're photographing subjects at a medium distance and shadows are part of the scene but not too prominent, increase exposure by only 1/2 stop from normal for sidelit subjects and 1 stop for backlit subjects. If you're photographing a distant scenic view in which shadows are relatively small and don't contain important detail, usually no exposure increase is necessary.

Keith Boas

Sometimes the best time of day to take pictures is early or late when strong shadows are created by the sun, which is near the horizon. As the sun is not as intense during these times of the day, you'll have to increase exposure 1 or more stops from your base exposure. Ocho Rios, Jamaica.

Keith Boas

Shadows created by sidelighting make subjects appear more three-dimensional by revealing texture and form. Outdoor billboard—early morning in Saratoga Springs, New York.

Tom D'agostino

Exposure determination is simple if you want your backlit subject to be in silhouette; just use the exposure settings indicated by your light meter.

Annegret Pries

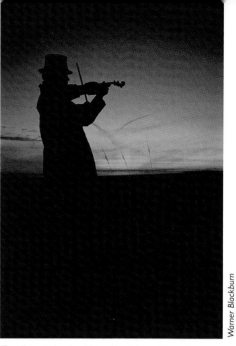

Warner Blackburn

Backlit close-up pictures may contain important shadow areas. To capture the detail in the shadows, give a backlit subject 2 stops more exposure than you would use for a frontlit subject.

To silhouette a backlit subject, base the exposure on the brightest part of the scene. But if the sun is present, exclude it from the metering area. Set the indicated exposure on your camera and take the picture.

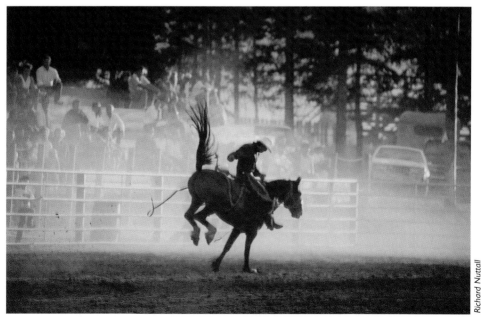

Richard Nuttall

Backlighting, created here by bright sunlight on the background, dramatically isolated the rodeo action by placing the participants in silhouette.

REDUCING LIGHTING CONTRAST

The contrast between shadow and highlight in brightly sunlit conditions is frequently greater than film can reproduce. The answer is to reduce the contrast by brightening the shadows of important scene elements to preserve valuable detail.

FILL FLASH

Fill flash is especially useful for brightening the shadows in scenes with nearby people or objects with detail you want revealed. With people, you'll probably get more relaxed expressions because your subjects will be looking away from the sun. Now they won't have to squint.

SLR cameras with built-in or dedicated accessory flash units make fill flash easy. Often you have only to turn on the flash or camera. The camera will then fire the flash with the correct amount of light to lighten the shadows. Low- and medium-speed (ISO 25–100) films work best with fill flash. On bright days, slower films allow you to use the correct shutter speed required for flash. For detailed procedures on using fill flash, see the chapter on flash photography.

Steve Kelly

In bright-sun conditions, you can use fill flash to get natural expressions on your subjects. Pose your subjects so the sun doesn't make them squint—then use flash to lighten (fill) the shadow side of their faces. Many SLR cameras with built-in or dedicated flash units can provide fill-flash illumination automatically. See the chapter on flash for more on fill-flash techniques.

REFLECTORS

Another good way of reducing the contrast of a nearby subject on a sunny day is to use a reflector to bounce light into the shadow areas. The reflector can be almost anything that will reflect light—a large piece of white paper, crumpled aluminum foil, or even a white sheet. Don't use a colored reflector with color films because it will reflect light of its own color onto your subject.

Try to have the reflector close enough to your subject, but not in the picture, to bring the light level in the shadows within 1 stop of normal sunlight exposure. Expose as you would for a normal frontlit subject.

Sometimes you'll be able to take advantage of natural reflectors in a scene to fill in the shadows. If you can photograph your subject in surroundings including bright reflective surfaces like light sand, white buildings, or snow, the light reflected from them will often fill in the shadows to produce a pleasant lighting effect.

For relaxed, natural expressions, place your subjects in the shade and use a reflector to illuminate their faces.

Angelica Alba Gomez

Without reflector　　　　　　　　　　*With reflector*

To lighten the subject's face, the photographer reflected some sunlight into the shadows with a piece of white cardboard.

Joan L. Funk

Overcast days are ideal for taking pictures of people because the soft lighting flatters skin tones.

INDIRECT SUNLIGHT

On overcast days or for subjects in the shade, lighting contrast is very low. In these situations you simply use an light meter to determine exposure. With this very soft and shadowless type of lighting, you usually won't need to use fill-in flash or reflectors.

When you are planning to take color slides on overcast days or in the shade, you may want to use a warming filter, such as a Tiffen 812 filter on your camera or choose a KODAK PROFESSIONAL EKTACHROME Film that has a warm tone. Warm-tone color slide films are designed specifically to neutralize the slight bluish cast of open shade and overcast lighting.

You're bound to encounter some unusual outdoor lighting situations, such as those found on foggy days or on the back porch during a rainstorm. In such situations, your best friend is a light meter or an automatic camera.

The even lighting of overcast sky on a lazy summer afternoon helped make this appealing portrait in muted colors.

Edwin G. Giacomozzi

Nancy E. Barkheimer

When your subject is in the shade of objects blocking the sky overhead, you'll have to rely on light-meter readings for proper exposure. The amount of light varies considerably and typically requires 1 or 2 stops more exposure than open shade.

William H. George

Francisco Jaier Vazquez

Sunrises and sunsets often cause built-in meters, whether in an automatic or manual camera, to recommend the wrong exposure. Set the exposure based on a meter reading of the sky next to, but excluding, the sun. This exposure will record the sky at the brightness you see and cause foreground subjects to become silhouettes.

SUNSETS

Beautiful sunsets are superb subjects with rich, dramatic color, and sunset pictures are easy to take. For proper exposure, just go by the meter reading of the colorful sky and clouds but do not include the sun in the metered area. Usually the exposure for a 100-speed film, when the sun is partly or wholly obscured by a cloud, is 1/125 second at *f*/8. To have more assurance of obtaining saturated colors, it's best to bracket the estimated exposure by plus and minus 1 *f*-stop. When the sun is

below the horizon, the sunset is dimmer, so try an exposure series of 1/60 second at *f*/5.6, 1/60 second at *f*/4, and 1/60 second at *f*/2.8 with a 100-speed film.

Your sunset pictures will be even better when you include a foreground object that will photograph as a silhouette with the sunset in the background.

Keep your lens sparkling clean because dust particles, fingerprints, or other foreign matter can cause considerable lens flare when you photograph sunsets.

Keith Boas

At sunrise the sky tends to be clearer than at sunset because atmospheric moisture hasn't had all day to accumulate. Take several pictures of the rising or setting sun, because the sky colors and lighting change rapidly, greatly affecting mood. Use water in the foreground to add a mirror-like reflection.

The soft, warm lighting produced at sunset is especially flattering in portraits.

Rafael Buelna

Sunsets don't always have to brashly show the sun. Here, although obscured by the horizon, the sun still illuminates the clouds and gives them dramatic texture.

Omar Seth Carrasco Rueda

Just as including the sun when metering a sunset can cause underexposure, so including a dark foreground when metering can cause overexposure.

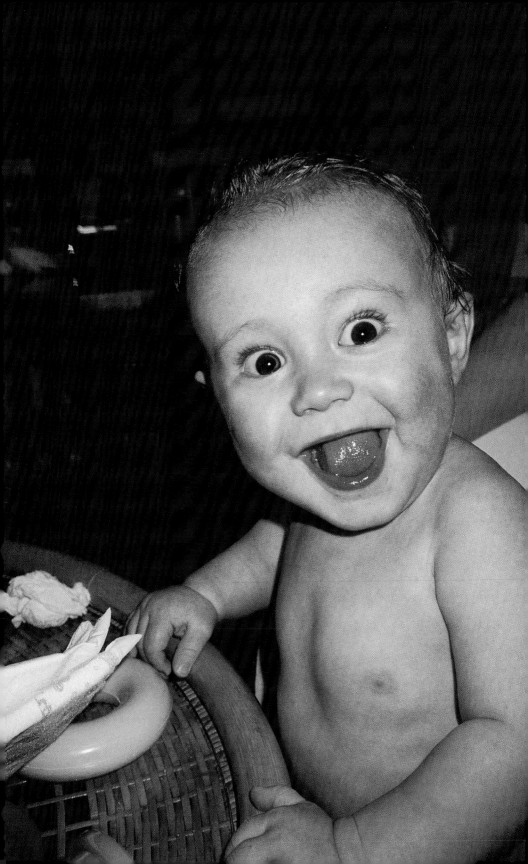

Flash Photography

With your 35mm camera and an accessory or built-in electronic flash unit, you can take pictures indoors almost as easily as you take pictures in daylight. And as you will see, you can use your flash to improve the quality of your outdoor pictures, as well as create special effects both indoors and out.

Flash also can expand your picture-taking opportunities—it provides concentrated illumination where you need it, rather than forcing you to rely on daylight or a fixed artificial light source which may not be adequate to produce correctly exposed pictures.

But flash is not the final answer to all limited lighting situations. Just as you would not expect to illuminate an entire arena or auditorium with a small flashlight, you should not expect the flash of light from your camera or accessory flash unit to adequately illuminate the same vast expanse. It doesn't have enough power. Rather, concentrate your flash pictures on subjects closer at hand—within the effective reach of your flash (see your flash or camera manual for details)—to make the most of your picture-taking opportunities.

ELECTRONIC FLASH

An electronic flash unit is convenient to use because it allows you to take a little slice of daylight with you wherever you go. A single set of batteries will provide hundreds of exposures. Also, because the light from electronic flash is similar to daylight, you don't have to worry about color balance as long as you're using daylight films. As an added bonus, the burst of light from electronic flash is brief enough to halt almost any subject or camera motion.

Flash is a convenient, portable light source, excellent for taking pictures indoors. Photo by Lois Weston.

Although built-in flash units are now common on SLR cameras, the extra power of an accessory flash gives you more options in setting f-numbers and using different flash techniques.

On-camera candid flash pictures are easy and fun to take, especially when your subjects are cooperative.

Kamila Kulesza

There are three basic types of electronic flash units: manual, automatic, and dedicated. These three types of flash units differ from one another mainly in the way that they (or you) determine exposure. With **manual** flash units, you determine the proper lens opening for your camera based on the guide number for your flash unit and the film you're using, or from a calculator dial on the flash. Manual units are slower to use because each time you change flash-to-subject distance, you must also change your lens aperture.

Automatic flash units have a light sensor that measures the light reflected by the subject from the flash and automatically controls the duration of the flash to produce the correct exposure. You determine the aperture by using a calculator dial on

the flash unit. Within a given distance range, the flash unit will provide accurate exposure even if you change your flash-to-subject distance.

Dedicated flash units, the most complex technologically, are the easiest to use. They also offer the most flexibility. Dedicated units automatically set your camera to the correct sync shutter speed and lens aperture and then control exposure by regulating the amount of light the flash emits. These flash units measure the light with a sensor on the unit or through the lens (TTL) by using the camera metering system. Many TTL units read the amount of light reflected off the film plane (called OTF flash) and automatically control the flash duration.

FLASH SYNCHRONIZATION

The camera shutter speed that you use with a manual or automatic flash unit is very important. While the duration of the flash is extremely brief (usually measured in thousandths of a second), the burst of light must occur when the shutter is fully open; otherwise the shutter curtain may obscure part of the image (see photo below). This timing between electronic flash and shutter is called **flash synchronization** or X sync.

Cameras with leaf shutters sync at all shutter speeds. Cameras with focal-plane shutters (nearly all SLR cameras) sync only at certain speeds. Although your main concern with shutter speed is synchronization, different shutter speeds can affect the appearance and exposure of your flash pictures in other ways; for more on this, see "Shutter Speed for Flash Pictures".

When using flash, if you set a shutter speed that is too high, the camera will not synchronize properly and you will get only a partial picture. Typically, focal-plane shutters are designed to synchronize at 1/60 second, 1/90, or 1/125 second, depending on the camera. See your camera's instruction manual.

Most SLR cameras have focal-plane shutters consisting of fabric curtains or metal blades placed between the lens and the film. When the shutter is closed you can see it covering the area directly in front of where the film will be exposed. Since the focal-plane curtain is a delicate mechanism, do not touch it with your fingers.

CAMERAS WITH FOCAL-PLANE SHUTTERS

Most 35mm SLR cameras have focal-plane shutters. The typical synchronized shutter speed is 1/60, 1/125, or 1/250 second. If your camera has a shutter-speed dial, this speed is usually marked in red on the dial. If you have an older camera that has a switch with a choice of X sync or M sync (M Sync was for use with flashbulbs) or a choice of X- or M-sync-cord sockets, use the X-sync setting or socket with electronic flash.

The focal-plane shutter will be fully open to expose the film only at the specified shutter speed or slower shutter speeds. At faster speeds, the shutter curtain forms a moving slit. If you set a faster shutter speed, light from the flash will expose only the band of film uncovered by the slit at the moment the flash fires, and most of the scene will be cut off.

At least one camera manufacturer has recently bypassed the sync problem with focal plane shutters by modifying the flash unit to emit light during the full time the shutter (at any speed) is moving. Check your camera manual.

Putting your focal-plane camera and flash in sync is simple: If your camera is equipped with a hot shoe,* all you have to do is attach the flash and set the shutter speed dial to the proper sync speed. If your camera doesn't have a hot shoe or if

you're using the flash off camera, you can use a sync cord to plug the flash into the X-sync socket.

*A bracket on top of the camera to hold the flash. It's "hot" (nearly all are) if it has an electrical contact to complete a circuit with the flash unit.

CAMERAS WITH BETWEEN-THE LENS (LEAF) SHUTTERS

Many newer compact 35mm cameras and some older cameras have shutters located between the elements of the lens. Cameras with this type of shutter will synchronize with electronic flash at virtually any shutter speed. The ability to synchronize flash at any shutter speed is particularly useful for controlling very bright or very dim ambient light or for balancing flash and ambient light—for example, when you use fill flash.

DEDICATED FLASH SYNC

With dedicated flash units and compatible cameras, the camera will automatically set the synchronized shutter speed when you attach the flash unit. Although the camera may be able to sync at other shutter speeds, most dedicated flash/camera combinations will usually choose the fastest possible shutter speed so that only the flash, and not the ambient light, exposes the film. When you want to record ambient light, you can usually manually set any shutter speed in the sync range.

Most compact (non-SLR) cameras have between-the-lens shutters. This kind of shutter has leaves (blades) located between the lens elements close to the aperture. Usually, you can see the camera lens when the camera back is open.

The very brief flash duration of an electronic flash unit is ideal for stopping action or catching fleeting expressions.

FLASH EXPOSURE

EXPOSURE WITH A BUILT-IN FLASH

Many compact and some advanced SLR cameras have small flash units built into them. In some cameras, the flash is hidden (in the prism housing, for instance) and pops up when activated; in others the flash is built into the face of the camera. Although quite convenient, these low power flash units produce good results only within a rather short range (usually about 3 to 12 feet when using a medium-speed film). You can use them as a main flash indoors or as a fill light outdoors.

Some cameras automatically turn on the flash in dim light. Other cameras flash an indicator or beep to tell you to switch on the flash. Typically, the flash begins charging as soon as it is activated, and on most models, an indicator light in or near the viewfinder will notify you when the flash is fully charged. With all built-in-flash cameras, exposure is fully automatic —measured either by an external sensor or inside the camera by a TTL (or OTF flash) metering system.

What do you do in dimly lit situations where you **don't** want the flash to fire automatically? One way to keep some pop-up flash units from firing is to hold your finger on top of the unit to prevent it from popping up. **Read your manual** first to make sure that this won't damage your camera. With face mounted built-in flash units, you may be able to block the flash by holding your fingers (or a small piece of black cardboard) in front of the flash.

Cameras with built-in flash are particularly suited to outdoor fill flash work, and many are programmed to automatically create an accurate exposure balance between flash and ambient light. Some of these cameras will turn on the flash and automatically activate the fill flash whenever the foreground subject is significantly darker than the background.

In addition to supplying a ready source of light, built-in flashes on some cameras provide other helpful services. On autofocus cameras, the built-in flash may have an autofocus illuminator to help your lenses focus in low light. With SLR cameras that have both built-in flash and the capability of accepting an accessory flash unit, you may be able to use the built-in flash as part of a multi-flash setup. To take a group portrait, for example, you might use an accessory flash bounced off the ceiling as your main light and use the built-in flash as a frontal fill light to open up shadows in faces.

EXPOSURE WITH A DEDICATED ELECTRONIC FLASH

Dedicated electronic flash units provide the most versatile flash available. The term **dedicated** comes from the fact that these units are brand-specific; that is, they are designed to be used with—or are dedicated to—a certain brand (and often a specific model) of camera. As mentioned earlier, many sophisticated dedicated models measure the intensity of the flash inside the camera as it reflects off the film (OTF) itself; a few simpler models measure light from a flash-mounted sensor.

While most dedicated flash units can be used as automatic (if they have a flash-mounted sensor) or as manual units with any other camera brand or model, they are truly dedicated only with a specific model of camera. Most dedicated equipment is made by camera manufacturers for their own cameras. Some universal dedicated flash units can be adapted to a variety of cameras with accessory modules, but most offer fewer features than a same-brand flash. Read your camera manual and talk to your photo dealer before attaching any dedicated flash other than one designated to be used with your camera.

Though they can handle complex tasks, dedicated flash units are extremely simple to use because they'll make all the exposure decisions for you. Once you attach a dedicated flash to your camera, you are ready to start taking flash pictures. No calculations or complex tables are required. Through a series of electronic contacts and circuits, the flash and camera are able to relay information to one another almost instantaneously.

After you mount the flash on the camera and turn them both on, the camera tells the flash the speed of the film in the camera and automatically sets the proper shutter speed for flash sync. If you're using a camera with a programmed exposure mode, the camera also sets the lens aperture automatically. After you press the shutter button, the flash fires and the

The convenience of a built-in flash makes it very desirable.

camera measures illumination at the film plane; when the film has received enough light for proper exposure, the camera turns the flash off. All of this happens in microseconds as soon as you press the shutter release button.

With most dedicated flash/camera combinations, the settings chosen by the camera are displayed in the viewfinder and sometimes on an LCD panel on the back of the flash. If you want a different aperture (to control depth of field, for example) or a slower shutter speed (to record a dimly lit background), you can usually switch to an aperture- or shutter priority flash mode. If proper flash exposure with the aperture/shutter speed combination you have chosen is not possible, the flash and/or viewfinder will display a warning—usually by flashing the aperture or shutter speed or both. Some cameras with matrix-light metering will know if the background is unusually dim (at twilight, for instance) or bright (a white-sand beach) and set the exposure accordingly—using camera controls to expose for the background and flash duration to light the main subject.

Other helpful displays in the viewfinder of a dedicated camera are a flash "ready" light to tell you that the flash is fully charged, and a sufficient-light indicator to tell you that the flash has provided adequate lighting. Units with an LCD panel may also provide you with a maximum distance (or the near/far range) for the aperture you select. This is a particularly useful feature since it tells you beforehand if the aperture you're using will provide sufficient light at your working distance.

Another benefit of using an OTF dedicated flash is that the amount of light is being measured **behind** the lens; this means that you don't have to make any special calculations when you use extension tubes or bellows for close-up work, or place colored filters over the flash or camera lens. And since dedicated cameras measure light at or near the film plane, you can use the flash in a bounce or off-camera mode and still get good exposure automatically.

Dedicated flash units for some autofocus cameras have autofocus "illuminators" that enable the camera to focus in very

A dedicated flash unit works only with specific cameras. Contacts in the flash foot complete circuits with identical contacts in the camera hot shoe. To use a camera in the dedicated flash mode, you may have to set the camera to "P" (program) or "A" (automatic). Other cameras set the dedicated mode automatically when you attach the flash to the camera.

When the background is very light and at about the same distance as the subject, the automatic sensor may be fooled into underexposing the pictures. For proper exposure, either use the flash on manual or increase the aperture by 1 f-stop, or for dedicated units, set the exposure compensation control to +1.

Donna Lee

dim—or even totally dark—situations. By projecting a visible near-infrared grid of red light on the subject (usually when the shutter button is partially depressed), the flash provides the camera with sufficient contrast for accurate focusing. In any flash situation, the camera may adjust flash power or aperture based on distance information provided by an autofocus lens.

The options and possibilities offered by dedicated flash are many and useful; take the time to study your manual fully to get the best results from your flash.

EXPOSURE WITH AN AUTOMATIC FLASH UNIT

An automatic unit uses a calculator scale or dial to indicate the aperture that will give the correct exposure for the speed of the film and the flash-to-subject distance. Once you have set the aperture, a light sensor in the flash unit will automatically adjust the duration of the flash to provide correct exposure within a specified distance range—for example, 3 to 15 feet.

As long as you stay within that range, your pictures should be correctly exposed.

Some automatic units have a mode switch that enables you to choose from several apertures over different distance ranges. For example, the yellow mode may allow you to use $f/5.6$ over a distance range of 3 to 20 feet. A blue mode may allow you to use $f/8$ (for greater depth of field) over a distance range of 3 to 15 feet. Automatic units usually have a manual setting that lets you choose the best aperture for correct exposure in situations that might fool the automatic exposure system. Scenes that have large bright or dark areas, such as a white or dark brown wall, can trick the flash sensor. With large white areas, the automatic flash would underexpose the photo (making the scene too dark), and with large dark areas, it would overexpose (making the scene too light). By setting the flash on manual, you disengage the sensor. But now you have to refer to the calculator dial and use the f-number indicated for the flash-to-subject

Keith B. Cram

When you take a flash picture against a very dark (or distant) background, the flash sensor may put out too much light for the subject, thereby overexposing it. For this type of scene, you should override the automation by using the flash on manual, by compensating with a 1-stop smaller aperture, or by setting the exposures compensation control to −1 for a dedicated flash.

John R. Markey

Here the subject is close and wearing light colored clothing, which counteract the light-absorbing background. In this situation, automatic flash will provide acceptable exposure.

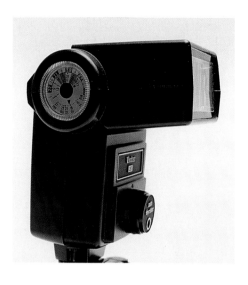

distance. As long as you are in the manual mode, you will have to change the aperture setting any time you change the flash-to-subject distance.

With light and dark scenes, you could also remain in the automatic mode if you simply used an *f*-number one stop larger for light scenes (*f*/5.6, if f/8 is indicated) and one stop smaller for dark scenes (*f*/11, if *f*/8 is indicated). The exposure should be correct as long as you remain within the recommended range for the mode you are using.

EXPOSURE WITH A MANUAL FLASH UNIT

Even though only a few manual flash units are being sold today, the ability to figure exposure with a manual flash unit (or an auto or dedicated unit in the manual mode) can be very useful. In extreme close-up photography and outdoor flash-fill photography, for example, you may be faced with situations in which manual flash exposure would provide more accurate and predictable results. The same is true of subjects that might fool an auto-flash sensor—such as a particularly dark or light subject.

To determine the correct lens opening for proper exposure with a manual flash unit, you need to know the light output of the electronic flash unit you're using, the speed of the film you're using, and your distance from your subject—and how to calculate these factors.

Most manual (and some auto) flash units have a dial that will perform calculations for you—simply set the speed of the film you're using and read the correct

Automatic flash units typically use a calculator dial or scale with color indicators, making it easy for you to match the aperture and the flash-to-subject distance with the proper sensor setting.

aperture opposite the flash-to subject distance. If your flash unit doesn't have a calculator dial, you need to use a guide number for your calculations. A guide number lumps all these variables into one easy-to-use number for each combination of flash power and film speed. Guide numbers are easy to use and are usually provided in the flash manual.

To figure the correct exposure with a manual flash unit, simply divide the guide number for your film/flash combination by the flash-to-subject distance in feet. (If your flash is camera-mounted, you can simply read the subject distance from the focusing scale on the lens barrel.) The result is the lens opening to use. Here's how the formula looks:

$$\frac{\text{Guide Number}}{\text{Distance in Feet}} = \text{Lens Opening}$$

For example, if the guide number is 110 and the subject is 10 feet away, the correct lens opening is $f/11$. When the calculated lens opening is one that's not marked on the f-number scale of your camera lens, just use the nearest one that is marked or a point halfway between the two nearest ones. Of course, if you have a metric guide number, you would divide by the distance in meters to obtain the f-number.

If you know the guide number for only one film speed, you can calculate it for others by using this formula.

$$GN_2 = GN_1 \left(\sqrt{ISO_2/ISO_1} \right)$$

For example, if the guide number for an ISO 100 film is 110, the guide number for an ISO 400 film would be 220.

$$GN_2 = 110 \text{ X } 400/100$$

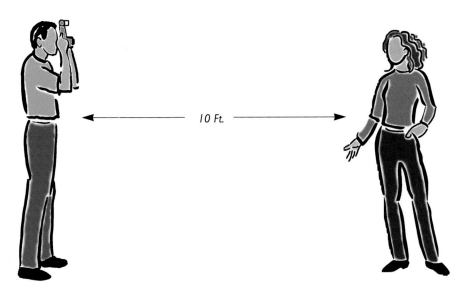

With a manual flash unit, you must determine the flash-to-subject distance and set the aperture accordingly. Each time the distance changes, you must set a new aperture.

TESTING YOUR FLASH UNIT

Although most modern flash units give reasonably accurate results, you can easily test your unit and adjust exposure if it is off the mark. Here's how:

1. Use a slide film to make it easier to evaluate the results.
2. Mount the flash on the camera and place your subject 10 feet from the camera.

Manual and Automatic Flash Units

3. Set the film speed on the flash calculator dial.

Auto flash units only: Choose the mode setting (not offered on all flash units) on the flash. Choose a setting in which 10 feet is roughly halfway between the minimum and maximum distances of the flash range.

4. On a medium-tone card, write the following information:
 Film speed; Lens aperture; Flash-to-subject distance; Mode (sensor) setting—auto flash units only
5. Set the flash aperture recommended by the calculator dial. If the flash lacks a calculator dial, divide the guide number by 10 to obtain the aperture. On the card, write "R" for recommended.
6. Turn on the flash and set the sync speed.
7. Wait several seconds after the ready light glows then take the first test shot.
8. Take additional test shots with the lens aperture set to give 1/2 stop, 1 stop, and 1-1/2 stops more exposure. For each test shot, write the aperture you used on the card in the scene. Be sure to wait several seconds after the ready light glows before taking each test picture.
9. Repeat step 8, but take test pictures with the aperture set to give l/2 stop, 1 stop, and 1-l/2 stops less exposure.

Dedicated Flash Units

Note: If the light sensor of your dedicated flash is mounted on the unit, follow the procedure for manual and automatic units.

3. On a medium-tone card, write the following information:
 Film speed; Lens aperture; Flash-to-subject distance; Exposure-compensation setting (0, + 1/2, -1/2, etc.)
4. Set the film speed on the flash calculator dial if the flash has one.
5. Turn on the flash and the camera. The camera should automatically set the shutter speed and may even set the film speed, depending on the model.
6. On the card for the first test shot, write a big "R" for recommended, because the camera will automatically set the aperture. Also write "exposure comp. = 0" to indicate you did not alter the exposure compensation control.
7. Wait several seconds after the ready light glows then take the first test shot.
8. Without changing anything else, take additional test shots with the exposure-compensation control set to give l/2 stop, 1 stop, and 1-l/2 stops more exposure. For each test shot, write the exposure compensation on the card placed in the scene. Be sure to wait several seconds after the ready light glows before taking each test picture.
9. Repeat step 8, but take test pictures with the exposure compensation control set to give l/2 stop, 1 stop, and 1-l/2 stops less exposure.

Correctly exposed

1 stop overexposed

Have the film processed and evaluate the results. Does the slide with the recommended exposure give the best results? If not, adjust the exposure according to the slide that does give the best results. For example, if the slide with an extra stop of exposure (*f*/5.6 instead of *f*/8) looks best, in the future use 1 stop more exposure than recommended by the calculator dial or guide number. Or for a dedicated flash, set the exposure compensation control to give 1 stop more exposure; be sure to reset it to normal when you take non-flash pictures.

1 1/2 stop overexposed

With most manual and automatic flash units, you can easily determine the correct lens opening by referring to a calculator on the flash unit.

TAKING THE PICTURE WITH A MANUAL FLASH

1. Mount the flash on the camera's hot shoe. Or if you are using off-camera flash, connect the flash to the camera with a sync cord.
2. Set the speed of your film on the flash calculator dial. If the flash has no dial, look in your instruction booklet for the proper guide number for the film you're using.
3. If you are using an automatic or dedicated flash in the manual mode, set the flash to "manual."
4. Set the shutter speed at the fastest available sync speed, usually 1/60 or 1/125 second. If you are using an automatic programmed camera, also be sure to set the camera on manual and then set the shutter speed.
5. Focus on your main subject and read the distance opposite the index mark on the lens barrel.
6. Find this distance on the flash calculator dial and set your camera lens to the aperture indicated on the dial. Again, if there is no dial, you can figure the correct aperture by dividing the distance of your subject into the flash guide number.
7. Turn the flash on and wait for the ready light to glow.
8. Take the picture. Manual flash uses a lot of power, so recharging will take longer than with an automatic flash. However, if the flash takes an unusually long time to charge between shots (more than 12 to 15 seconds), install fresh batteries.

TAKING THE PICTURE WITH AN AUTOMATIC FLASH

1. Mount the flash on the camera's hot shoe, or connect it to the camera with a sync cord if you're holding the flash off-camera.
2. Set the film speed on the flash calculator dial.
3. Set the fastest available sync speed on the shutter-speed dial, usually 1/60 or 1/125 second. The fastest sync speed is usually marked in red on the dial. If you are using an auto exposure camera, **don't** set the camera to automatic because the camera and flash may be out of sync—set it to the sync shutter speed.
4. Focus on your main subject and read the distance opposite the index mark on the lens barrel.
5. Find this distance on the flash calculator dial and set the lens to the aperture indicated on the dial. Many auto-flash units offer a choice of several aperture/mode combinations; at any given distance, you may have a choice of 4 or more shooting apertures. To find out which apertures you can use at a given distance, see your flash manual. Each different aperture/mode pairing is usually color-coded to a mode-selector dial.
6. Turn the flash on and wait for the ready light to glow.
7. Take the picture. If your flash has a sufficient-light indicator, check to see that it has lit. If it hasn't, be sure that you are working within the distance range that applies to that aperture.

When you are using the flash in a bounce mode and you don't get a sufficient light indication, you may have to use the next larger aperture/mode combination—even if you're within the correct working distance. This is because the bounce surface absorbs and scatters much of the light from the flash. Or you can move closer to your subject.

Karen Reese

By using a slow shutter speed (for example, 1/30 second) and a flash outdoors in the dim light of twilight, you can illuminate your subjects and still record the colors of the sky.

TAKING THE PICTURE WITH A DEDICATED FLASH

1. Mount the flash on the camera's hot shoe.
2. Set the film speed on the camera and on the flash if it has a film-speed dial. Some cameras will read the DX code and set the film speed for both the camera and the flash.
3. If you are working in the full program mode, set the flash to the TTL (through-the-lens) or OTF (off-the film) mode.
4. Set the camera mode selector to "P" (program) mode or the equivalent mode on your camera (see your manual). The camera will automatically set the proper sync speed and aperture. As you move around a subject and the ambient light changes, the camera may also change the aperture. On some cameras, you may have to set the aperture ring to the "A" position or the smallest aperture for programmed operation.
5. If your camera has an LCD panel or printed scale that tells you the working distance range for the aperture it has chosen, be sure that you remain within that distance or check your instruction booklet for flash-to-subject limits. If your dedicated flash unit has the light sensor on the unit (non-TTL), you may have to set the aperture yourself. To do this, follow the instructions for choosing an aperture for automatic flash.
6. Turn the flash on and wait for the ready light to glow.
7. Take the picture.

8. Most dedicated cameras have a sufficient-light indicator in the viewfinder that will light if the subject has received adequate light. If it doesn't light, check to see that the flash and camera are in the proper modes and that you are within the required distance range.

SHUTTER SPEED FOR FLASH PICTURES

Because the duration of electronic flash is so brief, the camera shutter stays open for a period longer than the flash duration—even leaf-type shutters at high shutter speeds. As a result, the shutter lets all of the light from the electronic flash pass through the lens regardless of shutter speed. Consequently, changing the shutter speed with electronic flash does not affect the exposure for a main subject illuminated mainly by flash. Different shutter speeds can, however, alter the appearance of the scene. In some situations you may want background light to register; in others, you may want to use a faster shutter speed to subdue it.

When you want to minimize the background light, use the fastest sync speed possible (such as 1/125 or 1/250 second). You might want to control background light in this way, for example, if you're using daylight film and the background lighting is tungsten (giving an orange cast to the background). A fast shutter speed is also useful with fill flash. Use a fast shutter speed to get proper exposure for a bright

background when you want to use a relatively large lens aperture—to use selective focus in an outdoor portrait, for instance. Also, if there is strong light present when you are photographing action with electronic flash, use a shutter speed fast enough to stop the action or you will get a "ghosting" effect from the moving subject.

If stopping action is not a problem and if dimly lit background detail is important, use a slower shutter speed, such as 1/30 second. For example, if you are photographing a person on a beach at twilight, and want to use flash to illuminate your subject and still record the colors of the sky, a slow shutter speed would be the answer. As mentioned earlier, some auto and dedicated units will provide this background/subject balance automatically. If you use speeds slower than 1/30 second, remember to use a tripod.

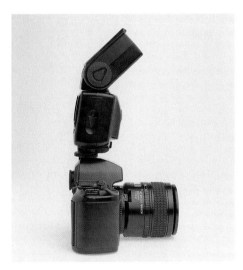

To take bounce-flash pictures indoors, aim your flash upward. The light will bounce off the ceiling and onto your subject. For color pictures, the ceiling should be white or near-white to avoid an overall color cast.

VARIETY IN FLASH LIGHTING

The simplest and fastest way to take flash pictures is with the flash mounted on the camera. However, if you want to take flash pictures that appear more professional, you may want to try the special flash techniques that follow.

BOUNCE FLASH

With this technique you aim the flash at a ceiling or wall and bounce the light back onto your subject. This produces gentle, even lighting similar to that found outdoors on an overcast day. Bounce flash is especially useful for large interiors or group portraits because you can illuminate a large area more subtly than with direct flash. With color film, be sure to aim the flash at a white or near-white ceiling or wall. Otherwise your subject may pick up a color cast from the reflecting surface. White is also an efficient reflector of light.

Flash units designed for bounce flash can usually be tilted or swiveled to let you bounce flash off a ceiling for both vertical and horizontal pictures. Units with lateral swivel can also be aimed at a wall. If your flash has no built-in bounce capability, you can probably purchase a special bracket that will allow you to position the flash in any direction.

When you use any camera-mounted automatic flash unit (or a dedicated flash with a flash-mounted sensor) for bounce lighting, the light sensor of the flash must always be aimed at your subject to determine exposure correctly. Exposure for bounce flash with a dedicated camera and flash combination that uses a TTL/OTF metering system is completely automatic

and accurate in almost all situations, since the light is being measured inside the camera.

Remember that even though your flash will figure bounce exposure automatically, just as it would for on-camera flash pictures, the maximum flash-to-subject distance recommended by the flash manufacturer is intended for **direct** flash only. With bounce flash, you lose about 50-percent efficiency. To avoid underexposure with bounce flash, be sure that the **flash-to-ceiling-to-subject** distance is less than half the maximum recommended flash distance for the aperture you're using. Check the maximum distance on your flash calculator dial.

If your automatic flash unit (or dedicated camera/flash) has a sufficient-light indicator, it will help you determine if your exposure for bounce flash is correct. With some units, you can test for sufficient light without actually taking a picture. To use this feature, you fire the flash without taking a picture and watch the indicator light to see if there is enough light from the flash. Most flash units have a button for firing the flash independently of the camera. If there's not enough light, you will have to use a larger lens opening, move closer to your subject, or use a faster film.

If you are using an automatic flash unit that has no tilt or swivel capability, the only way to use it for bounce is to take it off the camera and aim the whole unit at your bounce surface. However, because the exposure sensor will be aimed in the same direction as the flash (at the bounce surface and not the subject), it will read the light reflecting from that surface and not the subject—producing the wrong exposure. The only solution is to switch the flash unit to manual.

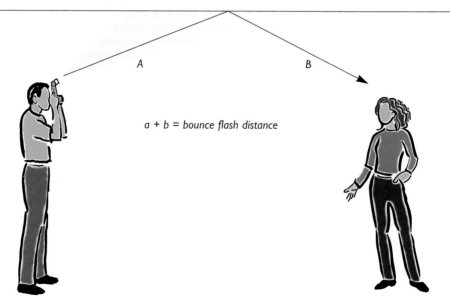

a + b = bounce flash distance

To calculate exposure for bounce flash with a manual or automatic unit, determine the total distance the light travels; from flash to ceiling to subject.

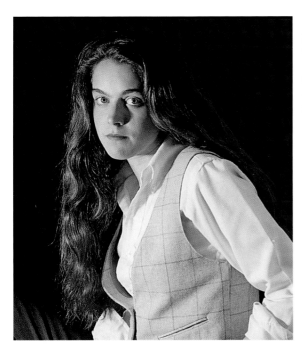

The soft light of bounce flash eliminates harsh shadows and glaring highlights. The use of a fast (400-speed) film will usually make up for the light absorbed by the bounce surface.

Direct flash

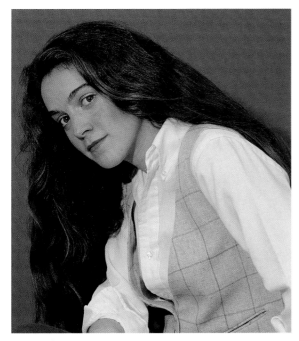

Bounce flash

To determine exposure for bounce flash manually, first find the **total** distance from the flash to the bounce surface and from the bounce surface to your subject. Find the aperture that corresponds to this distance on the flash calculator dial; then set an aperture 1-1/2 to 2 stops larger than the aperture on the dial. For example, if the dial recommends *f*/8, use *f*/4.

If the flash doesn't have a calculator dial, divide the guide number by the total distance. Then use a lens opening 1-1/2 to 2 stops larger than the *f*-number calculated from the guide number. Exposure also is affected by the size and color of the room.

OFF-CAMERA FLASH

Although on-camera flash produces well-exposed pictures, its flat frontlighting makes subjects seem shapeless. Off-camera flash adds the appearance of depth to subjects. It also creates interesting highlights and shadows on your subject. People will appear more realistic when facial texture and forms are revealed. By placing off-camera flash at a high angle, you can separate subjects from their surroundings and subdue distracting background shadows that straight-on flash often causes.

To use your flash off the camera, you'll need a long flash synchronization cord (also called a "PC" cord). Now you can hold the flash in one hand and the camera in the other. Don't worry if you're slightly wobbly in holding the camera. The flash will freeze camera motion. You can also mount the flash on a light stand or have a helper hold it. Make sure to set the aperture for the flash-to-subject distance and to aim the flash sensor at the subject. A special sync cord with a remote auto-sensor that fits in the camera's hot shoe is

You can take off-camera flash pictures by holding the flash above and to one side of the camera with one hand while holding the camera and snapping the pictures with the other hand.

available for some flash units. Once aimed at the subject, the flash sensor will provide correct exposure no matter where you hold or aim the flash.

With a dedicated flash unit, you will need to use an extension cord specifically dedicated to your camera/flash combination that attaches to the camera's hot shoe. This cord carries information between camera and flash so that both units can carry on their electronic conversation. Dedicated flash/camera combinations with TTL/OTF metering are especially accurate for off-camera use because the light is always being measured at the film plane.

Of course, you can also use a manual flash off-camera (or an automatic or dedicated flash set to manual), but you will have to calculate your exposure differently. Instead of dividing the guide number by the distance from the camera to the subject (as you would with a camera-mounted flash) to get your working aperture, you must divide the guide number by the distance from the **flash to the subject.** You may have to adjust the aperture slightly for very dark or light subjects.

Tom Murphy

Shooting flash head-on in a scene that includes glass, a mirror, paneling, or other shiny material will cause a glare reflection of the flash. To minimize this reflection, use a flash extension cord and hold the flash high and off to one side as you aim at the subject. Or, if your flash is built into the camera, change your picture-taking angle so you are not aiming directly at the background.

FILL FLASH

When subjects are in bright sunlight, deep shadows often obscure important details. You can lighten these shadows to reveal detail by using your flash. This is called fill flash.

Fill flash is particularly useful for lightening shadows on faces. As a bonus, when you're using fill flash with people, you can turn your subjects away from the sun so that they don't have to squint. The rim lighting created by the sun in backlit portraits also gives a pretty glow to hair and helps separate your subjects from distracting surroundings.

For best results, use a medium-speed film so that the camera can provide a good balance between sunlight and flash exposure.

The ideal fill-flash exposure gives your subject about one stop **less** exposure than the background receives. This opens the shadows sufficiently to reveal detail as it maintains a natural appearance. If you give the main subject the same exposure as the background, the picture tends to look artificially lit.

You can create fill flash with dedicated, automatic, or manual flash units. An automatic flash unit will be much easier to use, however, if you have a choice of several flash modes to choose from.

By far the simplest method of creating flash fill is with a dedicated flash/camera combination that has automatic fill-flash capability. The advent of dedicated flash/camera combinations with TTL/OTF metering, particularly those cameras with matrix OTF metering systems, has all but eliminated the need to calculate exposure for fill-flash pictures. These systems are programmed to provide proper exposure for the background and automatically fill the main subject with about one stop less light. A few sophisticated dedicated SLR camera/flash combinations even allow you to manipulate this subject-to-background lighting ratio with a switch.

In any case, using a programmed camera with OTF metering and automatic fill may require no more than attaching the flash to the camera. The camera will measure the ambient light and supply the correct amount of flash to fill your main subject. If the camera also has autofocus, it may even use the distance information from the lens to help calculate the amount of fill required. As you move closer or farther from the subject, the camera will adjust the aperture and/or the amount of fill accordingly. Also, if you want to maintain a constant aperture (e.g., for depth of field), some cameras let you use an aperture-priority mode and still get correct fill flash.

Review your equipment manuals to learn how to use fill flash with your camera and flash.

One caution: If you are using a compact or SLR camera with a built-in flash, be aware that cameras offering "automatic flash" may not offer "automatic fill flash." The difference is that the former will provide adequate flash exposure for the subject, but it will provide equal exposure for subject and background. Cameras that offer automatic fill will automatically create a more natural-looking brightness relationship between subject and background. Still, using a camera with automatic flash in contrasty situations is better than using no flash at all.

Calculating correct exposure with an automatic or a manual flash unit (or an automatic used in the manual mode) is a little more time-consuming, but can be reduced to a series of easy-to-follow steps. With either type of flash, the basic principle is to set the lens aperture for the ambient light and then use the flash to create light that is one-half to one-fourth as bright as the ambient light.

First take a meter reading of the bright ambient light. To do this, set the camera shutter-speed dial to the fastest sync speed available and then set the lens aperture as the meter indicates. In the manual mode, after making your initial reading of the ambient light, you can control the amount of fill light by altering the flash-to-subject distance; see the step-by-step procedure on the next page. With an automatic flash unit, you manipulate the amount of fill flash by choosing a mode that matches the amount of fill you want to use.

No fill flash

1:1 ratio

Shoot outdoors in front of a shadowed wall, this series shows how the ratio of sunlight to fill light affects appearance. When the fill flash equals the brightness of the sunlight (1:1) the result is unnatural. But when the amount of fill flash is less than the sunlight (3:1 and 5:1 ratios), the effect is more attractive.

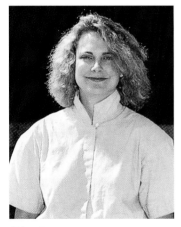

3:1 ratio

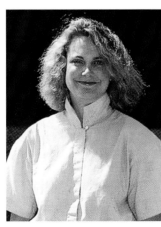

5:1 ratio

Fill Flash with a Manual Unit

1. Mount the flash on the camera's hot shoe, and if you are using an automatic flash, set the unit on manual.
2. Set the film speed on the flash calculator dial.
3. Set the fastest sync shutter speed.
4. Take a meter reading of the sunlit area and set the lens at the indicated aperture.
5. On the flash dial find the aperture that is **1 stop larger** than the meter reading indicated in step 4 (for example, if you set the lens at $f/11$, find $f/8$ on the calculator dial). Read the distance indicated opposite this aperture. This is the correct flash-to subject distance for fill flash that is 1 stop less bright than the sunlit area (3:1 lighting ratio). Move to this distance to shoot your picture (or take the flash off-camera and move it to that distance). If you want a stronger fill (equal to the ambient light), you can simply shoot from the distance opposite the *f*-number that you set on your lens. For a weaker fill, move the flash farther away from the subject. Use a zoom lens to adjust image size once you are at the proper distance.
6. Turn on the flash unit, and shoot the picture when the ready light glows.

Fill Flash with an Automatic Unit

1. Mount the flash on the camera's hot shoe and set the film speed on the flash calculator dial.
2. Set the fastest sync shutter speed.
3. Take a meter reading of the sunlit area and set the lens to the indicated aperture.
4. Set the flash-mode switch. Look at the flash calculator dial and find the mode corresponding to the aperture 1 stop larger than that set on the lens (for example, if $f/11$ is set on the lens, set the mode that corresponds to $f/8$). This will give you a pleasing 3:1 lighting ratio. You could also make the fill 2 stops dimmer (5:1 lighting ratio) than the ambient light by using a mode that requires **2 more** stops than the aperture set on the lens ($f/5.6$ if lens is set to $f/11$). If there is no flash mode to match the aperture your meter has chosen, switch your shutter-speed/aperture combination to one that uses a shutter speed that's 1 speed slower; then look to see if there is a mode that matches the corresponding new aperture. This will give you the same ambient-light exposure but will enable you to work within the allowable aperture range for the flash.
5. Turn on the flash unit and shoot the picture when the ready light glows.

NOTE: The light sensor on most automatic flashes will be affected only by the flash reflecting from your subject not by the ambient light. However, in situations where there is very bright light spilling around the edges of your subject and falling directly onto the flash, it may give the flash false readings. One answer is move your subject so that the excess light is not hitting the flash directly. With automatic flash it's important to experiment with your flash in different situations and see how it performs; see your flash manual for specific instructions.

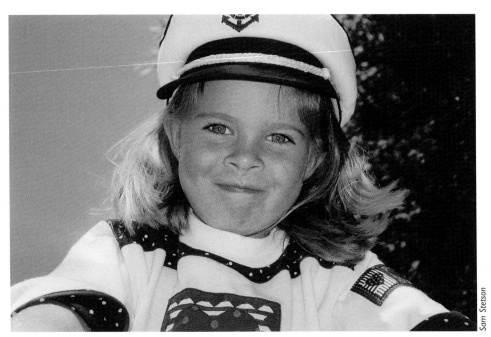

While brightening a shadowed face, fill flash can also add a twinkle to the eyes (and personality) of your subject.

PREVENTING FLASH FAILURE

The most frequent causes of flash failure are weak batteries and battery or equipment contacts that need cleaning. With electronic flash units, when the time required for the ready light to come on becomes excessive—about 30 seconds or longer—or it doesn't come on at all, it usually means the batteries are weak and need to be replaced or recharged, depending on the kind of batteries. See your flash equipment manual.

If there are deposits on the equipment or battery contacts, even brand new batteries won't fire the flash. To prevent this type of flash failure, clean the battery ends and equipment contacts with a rough cloth. If the battery compartment in the flash unit is small, wrap the cloth over the end of a pencil eraser to clean the contacts. Clean the contacts even if they look clean, because some deposits are invisible.

Be sure to use the type and size of battery recommended for your flash equipment. Alkaline batteries have a long life and a short recuperation time. They are generally recommended for electronic flash units. Nickel-cadmium batteries are rechargeable and are recommended for use in many electronic flash units. See your flash instruction manual for the kind of battery recommended for your flash unit.

When you're not going to use your flash unit for a period of time, remove the batteries to prevent possible corrosion of the contacts in the unit.

Check the fittings between the flash and the camera to see that they remain tight. If your flash connects to your camera with a flash cord, make sure any press-on adapters are tight. Also, a break in the cord will prevent the flash from firing. You can often detect an internal break in the cord by wiggling the cord. When momentary contact is made, the flash will fire. When you detect such a break, replace the cord.

CAUSES OF LIGHT LOSS WITH ELECTRONIC FLASH

RECYCLING TIME

After you have fired an electronic flash unit, it takes several seconds for the condensers in the unit to recharge. Most electronic flash units have a ready light that comes on after about 10 seconds, depending on the unit, to indicate that the unit is ready to flash. But at this point you may get only about 65 percent of the total light output because the ready light does not necessarily indicate when the condensers in the unit are fully charged. Recycling time for full light output varies in practice and depends on the electronic components in the unit, type and condition of batteries, and other factors. An automatic flash unit with an energy-saving circuit, called a thyristor circuit, will recharge more quickly on automatic than a unit without this circuit. An AC-powered unit may recharge faster than a battery-powered unit.

You will get more consistent photographic results if you wait until your flash unit has recycled completely before taking the next picture. After the ready light comes on, wait a few seconds before firing the flash. Or to be on the safe side, allow at least 30 seconds between flashes, because it may take that long for the condensers in some units to recharge fully. If necessary, you can take pictures more rapidly than this, but you may not get full light output from your flash unit. This can cause underexposed pictures, depending on the exposure latitude of the film you are using.

WEAK BATTERIES

As the batteries in your flash unit lose power with use and age, the recycling time increases. When the battery power drops below the required level, the unit will lose light output even though it may still flash. Replace or re-charge the batteries whenever the recycling time becomes excessive. Also, remember that it's important to keep the battery and flash contacts clean by wiping them with a rough cloth.

For this picture, a combination of flash and ambient light illuminated the scene. A slow shutter speed revealed the blurred motion of the carnival ride, while the brief flash froze the happy expressions. Photo by Roberto De La Fuente.

DE-FORMING OF CONDENSERS

Another factor which can weaken batteries and cause a loss of light output is the tendency of the condensers in an electronic flash unit to de-form after a month or so of inactivity. When this happens it will take an extra-long time to re-form the condensers and bring them back up to a full charge. This re-forming puts a considerable drain on the batteries. If you can use regular house current (AC) to power your unit, re-form the condensers by letting them recharge from the power line for an hour or so—and fire the flash a half dozen times—whenever the unit has been out of use for a few weeks. This helps your flash unit produce full light output.

Lenses

The ability of many 35mm cameras to accept interchangeable lenses is one of the features that makes these cameras so versatile. Choices run from ultra-wide-angle (fisheye) to powerful telephoto lenses. Many lenses have a macro-focusing ability, which allows for extremely close focusing without the aid of an accessory close-up device. A few wide-angle lenses even have built-in perspective control to minimize or eliminate keystone distortion. And a recent addition to the market includes image stabilization, a feature which provides increased sharpness for handheld picture taking with large telephoto lenses.

Since the lens plays a vital role in determining what the camera can do for you, knowing how to take full advantage of the various lenses for your camera pays dividends in terms of better, more exciting pictures.

A wide-angle lens often is the pictorial photographer's best friend. It can capture the sweeping vista, provide excellent depth of field, and add drama to a scene by accentuating nearby compositional elements. Photo by Dean Pennala.

ZOOM LENSES

Certainly the most popular lenses in use today are zoom lenses. Though early zooms suffered from the reputation of being heavy, awkward to use, and less sharp than fixed-focal-length lenses, today's zoom lenses are compact, easy to use, and sharp. Zoom lenses are available for both manual-focus and autofocus cameras.

Zoom lenses offer you the flexibility of many different focal lengths along with the convenience of having to carry only one lens. For example, instead of carrying a wide-angle, a normal, and a telephoto lens, you could take along a single zoom lens with a range of 35 to 135mm. Such a zoom not only replaces several fixed-focal-length lenses, but also offers you **all the focal lengths** that fall within that particular zoom range. Instead of having to decide between a normal and a telephoto lens, for instance, you could use a focal length anywhere between the two. Equally enticing is that a zoom lens lets you fine-tune your compositions without having to change your shooting position. Instead of walking closer to or farther from your subject, you can remain in place and adjust the focal length to fit the composition you have in mind. With a wide-angle-to-telephoto zoom, for instance,

The convenience and versatility of zoom lenses has made them popular with photographers. This 35 to 135mm zoom lens could replace all the single-focal-length lenses around it.

If you are thinking of buying your first zoom, those in the wide-angle-to-medium-telephoto group (35 to 135mm, for example) make a good choice; they offer a great range of focal lengths in a lightweight package and have relatively fast maximum apertures. Also very useful are the medium-to-long-telephoto zooms (around 70 to 210mm). They provide you with substantial telephoto capability but still allow you to broaden the composition when necessary. Many zooms in this range also have macro capability, which lets you take close-ups of small objects.

Most zooms in use today are called "one-touch" lenses. They have a single moving ring or focusing collar. To focus the lens, you rotate the ring around the lens barrel (much like focusing any other lens.) You change the focal length by pushing or pulling the ring up or down the lens barrel. A few zoom lenses are "two-touch;" they have separate controls for focusing and zooming. Auto-focus zooms are available, too, and they're even easier to use; they do the focusing and leave you to concentrate on adjusting the focal length until you get the composition you want.

What are the disadvantages of zooms? Weight is one disadvantage (especially among longer telephoto zooms); zooms are heavier and larger than comparable single-focal-length lenses. Flare is another; especially in backlit situations, zoom

you could take a group shot around the picnic table at a wide-angle setting and then zoom in close to take a full-frame portrait without taking a step.

Zoom lenses are available in a variety of focal-length ranges. Among the most common are those that cover a wide angle-to-normal range (28 to 50mm or 21 to 50mm), a wide-angle-to-medium telephoto range (35 to 105mm or 35 to 135mm), and a medium-telephoto to-full-telephoto range (80 to 200mm). The zoom lenses with the greatest ranges—28 to 210mm and 50 to 300mm, for example—tend to be heavier and less sharp than those with more moderate ranges. They're also more expensive. Their close-focusing distances may be as far as 10 feet.

lenses may flare noticeably, scattering light throughout the picture. But when you compare carrying one zoom lens to carrying several fixed-focal-length lenses, the zoom ends up being the lighter choice. Zooms also cost a bit more than fixed-focal-length lenses of similar focal lengths, but again, one zoom is cheaper than several fixed-focus lenses and considerably more flexible.

A more serious drawback of zoom lenses is that they are generally slower, i.e., they have smaller maximum apertures, than equivalent fixed-focal-length lenses. Also, most zooms have a variable maximum aperture that gets smaller (letting in less light) as you move toward the longer focal lengths of the lens. A 70 to 210mm $f/4.5$-5.6 lens has a maximum aperture of $f/4.5$ at 70mm, for example, but a maximum aperture of only $f/5.6$ at its longer focal lengths. The smaller aperture means slower shutter speeds, which can increase the likelihood of blur from camera shake or from moving subjects. Because it lets in less light, a smaller aperture makes focusing more difficult, too, particularly in low light levels.

Finally, remember that all of the information we're about to discuss for wide angle and telephoto lenses also applies to zoom lenses that have wide-angle or telephoto focal lengths.

35mm

70mm

105mm

Whenever changing viewpoint isn't practical, a zoom lens will prove vital. A 35 to 105mm zoom lens was used for this series.

131

Isabelle Pellerin

A normal (50mm) lens is also a good choice for informal photos of people. It provides sharp pictures, sufficient depth of field, and little distortion. For more formal portraits, most photographers prefer using a moderate (100mm) telephoto lens.

NORMAL LENSES

The normal lens is the one that comes with most 35mm SLR cameras. Because it gives such natural-looking pictures, you'll probably use it more than any other lens. The normal lens receives its name because it provides a natural perspective and an angle of view similar to the central vision of the eye.

The focal length of the normal lens for most 35mm cameras falls between 45 to 55mm.

The focal length of a camera lens is the distance from the film plane of the camera to the center of the lens when the lens is focused on infinity.

The normal lenses on 35mm cameras are usually fast, having maximum apertures of $f/2.8$, $f/2$, or as large as $f/1.2$. With today's fast films, a normal lens with a maximum aperture of about $f/1.8$ will usually suffice. You will pay much more to get a lens with a maximum aperture of $f/1.4$ or $f/1.2$. A lens with a large maximum aperture lets you hand-hold the camera to take pictures in dim light. Using a large aperture, such as $f/1.8$, also enables you to use high shutter speeds to stop action. However, the depth of field is quite shallow at such maximum apertures. Focus carefully. Otherwise you risk out-of-focus blur with all but distant subjects.

WIDE-ANGLE LENS

A wide-angle lens has a shorter focal length than a normal lens and takes in a greater angle of view. From any given spot a picture made with a wide-angle lens includes more than a picture made with the normal lens.

When do you use a wide-angle lens? Some of its uses are rather obvious. A wide-angle lens is helpful for taking pictures in places where space is limited. Without enough space, you just can't move back far enough to include every-

thing you want with the normal lens. When you're photographing such subjects as all the in-laws around the Christmas tree at home or a brand-new sports car on display at a crowded auto show, a wide-angle lens is a very handy item to have.

A wide-angle lens is often a good friend to have outdoors, too. When you take pictures of narrow city streets or crowded public markets, or sweeping scenic vistas, a wide-angle lens will let you get it all in; this may not be possible with the normal lens.

Another situation where a wide-angle lens may help you is in public places where people or other objects are between you and your subject. A wide-angle lens allows you to move closer to your subject and frame the picture the way you want it, thereby helping to eliminate unwanted objects.

PERSPECTIVE CONTROL

Perspective is determined by camera-to-subject distance. Whether you have a normal, wide-angle, or telephoto lens, perspective is the same if the camera-to-subject distance remains the same. When you get close to a subject, as you might with a wide-angle lens, nearby objects look unusually large, and distant objects look small and far away. This is because the distance between the near and far subjects is great compared to the distance from the camera to the near subject. The wide-angle lens exaggerates space relationships by expanding the apparent distance between nearby and distant objects. You'll increase the feeling of vastness in scenic pictures by using a wide-angle lens and including a nearby foreground object, such as a person, tree, or automobile, for size comparison.

Keith Boas

With a wide-angle lens, you can more easily include foreground subjects and emphasize the distance to the background. Evening in the Catskill Mountains of New York, with a 20mm lens.

When you're photographing indoors, you can use a wide-angle lens to include nearly the entire room. 18mm lens, U.S. Air Force Academy, Colorado.

To create this on-location portrait of a baseball fan, the photographer used an extremely wide-angle lens for deliberate distortion.

134

For the same reason—exaggerated perspective—a close-up picture of a person's face made with a wide-angle lens gives the features a distorted appearance. The nose, because it is closer to the camera, looks bulbous, while the more distant ears look exceptionally small. If you use a wide-angle lens to take a picture of an automobile from a front angle, it will look especially long and sleek. A welcoming hand stretched toward a wide-angle lens looks as large as or larger than the head of the person offering the greeting.

When you use a wide-angle lens to photograph entire buildings or similar subjects with prominent parallel vertical lines, try not to lift the camera up or down. If you do, the vertical lines will converge, or keystone, in your picture. While keystoning is usually undesirable, there may be times when you want to create this effect—to make a building look taller, for example, or to exaggerate perspective for creative composition.

DEPTH OF FIELD

Photography with a wide-angle lens offers the bonus of increased depth of field. For example, with a 28mm wide-angle lens on a 35mm camera, if the lens is set at $f/11$ and is focused on a subject 10 feet away, everything from about 4-1/2 feet to infinity will be in focus. In the same situation with a 50mm lens, the depth of field would extend from about 7 feet to 17 feet.

Depth of field is actually the same for all lenses, no matter what their focal length, if you adjust the subject distance to give the same image size. For a particular camera and particular subject distance, however, we can say that depth of field increases as focal length decreases.

As a camera with a wide-angle lens is tilted up or down, vertical lines will converge (keystone) in the picture. Here the photographer used this keystone effect to deliberately distort the façade of the building and create a greater sense of height.

A wide-angle lens will exaggerate perspective when you get very close to objects. Here the photographer took an extreme close up picture to give his subject distorted features. The warm light from sunset, reflected in the boy's sunglasses, accented the scene.

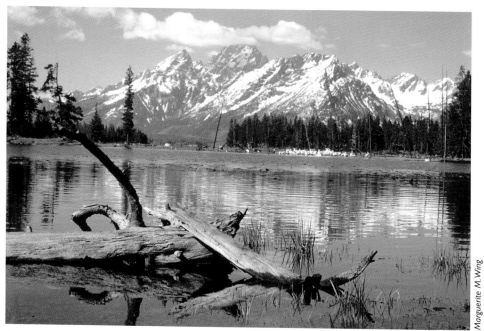

A wide-angle lens lets you include a large expanse of background to instill a photo with a sense of freedom.

TELEPHOTO LENSES

A telephoto lens has a longer focal length than the normal camera lens. Technically, the term telephoto refers to a particular kind of optical arrangement that has a positive front element and a negative rear element. This allows the physical length of some telephoto lenses to be shorter than the focal length. However, it has become common practice to call any lens with a focal length that is longer than normal a telephoto lens, so that's what we do in this book.

Telephoto lenses do just the opposite of what wide-angle lenses do. They include a narrower angle of view than the normal lens, so they take in a smaller area of the scene. Consequently, distant subjects photographed through a telephoto lens appear closer than they do when photographed through a normal lens. A telephoto lens magnifies the image similarly to the view you see through binoculars or a telescope.

When do you use a telephoto lens? As a rule, you use a telephoto lens when you can't get as close to your subject as you'd like—for example, when you're photographing a baseball game, a grizzly bear in the wild, or a chalet perched on a distant hillside. You can't climb into a cage at the zoo to get a close-up of a lion or stand in the middle of the Hudson River to get a close-up of a luxury yacht, but a telephoto lens can produce a big image of such subjects by bringing them closer to you optically.

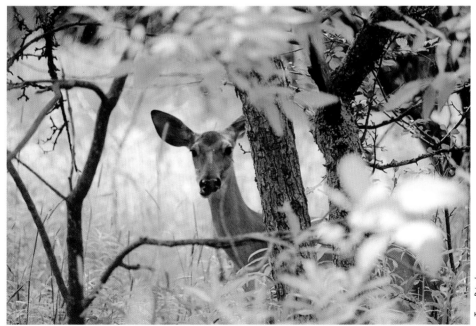

A telephoto lens is a required item for wildlife photography. By using a large aperture with a telephoto lens, the photographer was able to blur both the foreground and background to emphasize the deer.

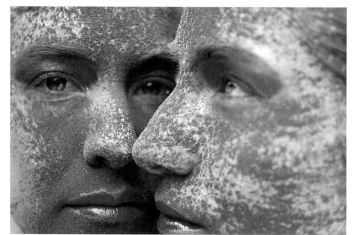

With both manual and autofocusing telephoto lenses, accurate focusing is important because of shallow depth of field. To get as much of your subject in sharp focus as possible, use an aperture of f/8 or smaller.

Roberto Lara Fuente

PERSPECTIVE AND COMPOSITION CONTROL

Like wide-angle lenses, telephoto lenses offer advantages that aren't so obvious, as well. For example, lenses in the 75mm to 105mm focal-length range are great for making head-and-shoulder portraits of people. You can be 6 or more feet from your subject and still get a nice-size head-and-shoulder image on the film with a moderate telephoto lens. This means that the nose-to-ears distance is very small in relation to the total subject distance, so the exaggerated perspective we mentioned in the section on wide-angle lenses doesn't exist. Being 6 or more feet from your subject also makes it easier to take pictures of people. You can move around your tripod-mounted camera and your subject without stumbling over them.

We mentioned that wide-angle lenses expand distances. As you might suppose, telephoto lenses have the opposite effect—they compress distances. Distant objects look closer to each other than they actually are. You've probably seen extreme telephoto pictures of a large city or rows of buildings on a distant hillside. In such pictures, the distant subjects appear squashed together. This effect is caused by the very narrow angle of view, which eliminates from the picture all the nearby objects that help us judge distances.

Because a telephoto lens has a narrow angle of view, it can help eliminate distracting elements in the composition of a picture. If there is a water tower next to a picturesque country church, you can crop the tower out of the picture by using a telephoto lens with its narrower angle of view. The lens sees the church, but not the tower. In the same way, you can photograph between the heads of spectators at a sports event or parade.

You can take pictures like this one from a safe distance away with a telephoto lens. Photo taken with 400-speed color print film.

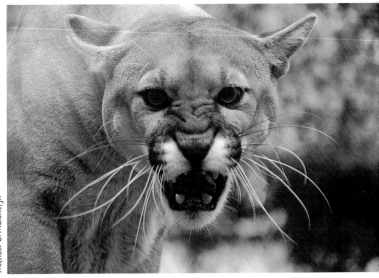

Michael C. Maione, Jr.

In making candid portraits, a telephoto lens lets you isolate your subject from its surroundings. If you use a large or medium aperture, such as f/5.6, the background will go out of focus and not compete with the subject.

Charlene P. Tucker

DEPTH OF FIELD

Telephoto lenses have shallow depth of field. The longer the focal length of the lens, the more shallow the depth of field. This means that accurate focusing is much more important with telephoto lenses than with normal and wide-angle lenses.

As mentioned earlier, you can use shallow depth of field as a creative tool for throwing a distracting background out of focus or for de-emphasizing foreground objects to help concentrate interest on the main subject.

CAMERA STEADINESS AND SUBJECT MOVEMENT

While a wide-angle lens is forgiving, the telephoto lens is demanding. In addition to focusing very carefully, you must hold your camera extremely steady to get pictures that are free of blur. This is because a telephoto lens magnifies camera movement as well as image size. Consequently,

it's a good idea to use a tripod and a cable release when using a telephoto lens. As a general rule, don't try to hand-hold the camera when you're taking pictures with a lens that has a focal length longer than about 400mm.

To minimize the effects of camera motion, it's essential to use a high shutter speed. A good rule to follow is to use a shutter speed approximately equal to 1/focal length in millimeters per second. For example, with a 200mm lens, you should use 1/200 second or higher. Since 1/200 second is not available on your camera, use the next higher shutter speed setting of 1/250 second. If you still have difficulty getting sharp pictures, use a shutter speed twice as fast—in this case 1/500 second. Be especially watchful with automatic cameras that determine the shutter speed. If the shutter speed indicated by the camera drops to a speed that's too slow for sharp pictures, use a larger lens opening so the camera will adjust for a sufficiently fast shutter speed.

Because telephoto lenses magnify the image, they will also magnify any unsharpness caused by camera motion. Many pictures taken with telephoto lenses are spoiled this way. When hand-holding your camera, you should use a high shutter speed to minimize effects of camera motion. If this is not possible and you don't have a tripod handy, use another solid support, such as a fence railing, to steady your camera.

Paula L. Anderson

A tripod is an important aid to help you get sharp, crisp pictures. It provides a firm support for your camera—essential when you use a telephoto lens.

Recently, at least one manufacturer has introduced high magnification (i.e., 300mm) telephoto lenses with a built-in image-stabilization feature, which reduces blurring caused by camera shake/motion when handholding the camera. Inside the lens, there are motion detectors which are linked to a microprocessor and movable lens elements. Whenever the camera and lens move, the internal stabilization mechanism makes instantaneous adjustments, and the image immediately steadies. The new technology allows photographers more freedom, with less dependence on a tripod.

A telephoto lens increases the effect of subject movement, too. Because the subject appears to be nearby and relatively large in the photo, any subject movement will be quite noticeable. This means that when you photograph action with a telephoto lens, you should use faster shutter speeds than you would to photograph the same action with a normal lens.

So, you may want to use a telephoto lens to—
- produce a large image of a distant subject by bringing it closer to the camera optically.
- make portraits.
- compress distances.
- eliminate distracting elements from a picture.
- get shallow depth of field.

TELECONVERTERS

A teleconverter, sometimes called a tele-extender, is an inexpensive way to increase the focal length of a telephoto lens. A teleconverter will also work with a normal-focal-length lens to produce the effects of a telephoto lens. These converters fit between the camera body and the lens. They extend or multiply the focal length of the lens by 1.4 or 2 times depending on the power of the converter. A 1.4X teleconverter converts a 100mm-focal-length lens to 140mm focal length, and a 2X teleconverter will convert the same lens to 200mm focal length.

Another advantage of a converter is that it will give you a larger image for close-up photography. You get a larger image because of the increased focal length of the lens with the converter and because you can focus at the same close-focusing distance as the original lens when it's used without the converter.

However, there are some disadvantages in using a teleconverter. A converter makes the effective lens opening smaller—a 1.4X teleconverter reduces the effective lens opening by 1 stop, a 2X teleconverter by 2 stops. For example, if your lens is set at $f/5.6$, the effective lens opening with a 1.4X converter is $f/8$; with a 2X converter it is $f/11$. Through-the-lens exposure meters in cameras will automatically compensate for the reduced effective lens opening. With a separate exposure meter or for flash pictures you will have to determine the exposure based on the smaller effective lens openings.

The reduced lens openings make the viewfinder dimmer for viewing. Also, you may have difficulty using a high enough shutter speed or getting enough exposure under dimmer lighting conditions. In addition, with a converter it's generally better to use a smaller lens opening to increase the image quality.

You may notice some darkness and a loss of the image around the corners and top edge of your viewfinder when you use a teleconverter. This happens because the mirror in a single-lens-reflex camera is not designed to reflect all the light from lenses when teleconverters are used with them. However, this affects only the viewfinder. The film should receive a complete image with no darkness around the edges when you take the picture.

In selecting a teleconverter, make sure that the mechanical linkage between the camera body and the lens will still work properly.

A teleconverter mounts between the camera and lens to increase the lens' focal length.

By using a teleconverter with a telephoto lens, you can increase the effective focal length. The picture on the top was taken through a 150mm lens, the one on the bottom was taken with the same lens plus a 2X teleconverter to extend the focal length to 300mm.

AUTOFOCUS LENSES

Perhaps the most exciting technological development in 35mm cameras in recent years has been the advent of fast, accurate, and affordable autofocus cameras. Although autofocus technology made its debut in relatively simple compact cameras, today the most sophisticated autofocus lenses are being made for 35mm SLR cameras.

Autofocus lenses for SLR cameras are available in a variety of fixed-focal lengths and zoom ranges. Some features to consider when buying an autofocus lens are weight, size, and focus response. To some degree each of these is related partly to the focal length of the lens and partly to the camera/lens system design. As with manual-focusing lenses, a wide-angle autofocus lens will be much lighter and focus faster than a telephoto autofocus lens.

The focusing mechanisms of autofocus lenses fall into two categories: those that use a focusing motor in the lens and those that use a focusing motor in the camera body. Lenses with a built-in motor may focus slightly faster than those that use a motor in the camera body, but they are generally more expensive because you're buying a focusing motor each time you buy a lens. Lenses used on autofocus cameras that have the focusing motors built into the camera body, on the other hand, are lighter and usually less expensive— though the initial investment in the camera body may be a bit higher. There is debate among manufacturers (and users) about which design truly focuses faster, but to the average photographer the difference in speed is negligible.

Autofocus lenses with built-in motors will not autofocus on a non-autofocus camera. This is because the focusing sensors that activate the focusing motor are in the camera body—regardless of where the focusing motor is located. You can, however, use an autofocus lens as a manual-focusing lens on any camera body that it's designed to fit. Similarly, a non-autofocus lens used on an autofocus body won't focus automatically, although you may be able to use it as a manual-focus lens. (Be sure to check your camera instruction booklet to see what lenses are safe to use on your body before attaching any lenses to it.) Also, a few camera manufacturers make autofocus adapters so that older non-autofocus lenses of the same brand can be used on a newer AF camera body.

The only exceptions to this discussion are a few "universal" autofocus lenses that have both built-in focusing motors and autofocus sensors; these lenses are **specifically designed for use as autofocus lenses on non-autofocus cameras.** With these lenses, you choose the lens you want and then buy an adapter to fit it to your specific camera body.

Off-center subjects can cause focusing errors for many autofocusing cameras. If the subject is outside the focusing target in the viewfinder, either manually focus on the subject or use the focus lock to obtain correct focus and then recompose the picture. Photo by Keith Boas.

INTERNAL FOCUSING

One major difference between autofocus lenses and most manual-focus lenses is that most autofocus lenses focus internally. In other words, as the lens focuses, the elements shift position internally, but the outer barrel neither rotates nor extends in length. With manual-focus lenses, the lens barrel turns, and the lens becomes longer as you focus on closer objects. On some autofocus lenses, the very front ring of the lens (particularly on zooms) does turn during focusing, which can be a problem if you're using a polarizing screen (or cross-screen filter) which has to be oriented in a certain direction for best effect. The only solution is to focus first, then mount the filter and rotate it to the correct position. (You may have to switch your lens to manual when mounting the filter to keep from damaging the focusing motor; see your manual.)

24mm lens

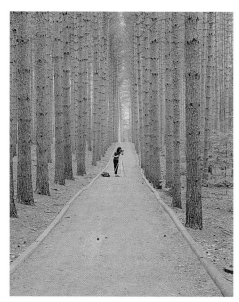

50mm (normal) lens

This series of pictures was taken from the same subject distance to show the effect of using different focal-length lenses. Note how the subject appears larger and closer as the focal length increases.

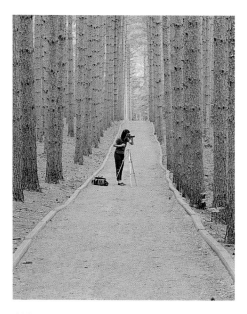

100mm lens

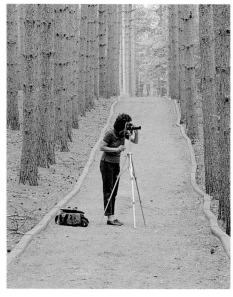

200mm lens

24mm lens

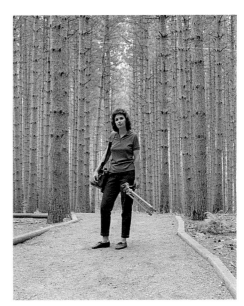

50mm lens

These pictures show how lens perspective changes with the focal length when the subject distance is adjusted to maintain the same image size.

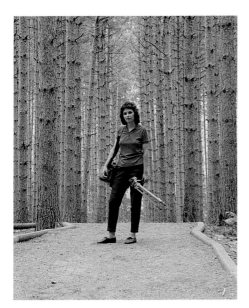

100mm lens

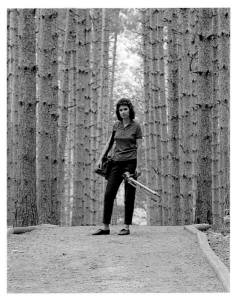

200mm lens

Composition

Most good pictures are not the result of a fortunate accident! The photographs you admire in exhibits may look like chance shots. But most often they have been created by the photographer. How do you create a picture? First you learn the rules of good composition given here. After you learn these rules, you'll realize that most pictures with good composition are the result of careful planning, patient waiting, or a quick sensing of the best moment to take the picture. But it's easier than it sounds. You'll find that the rules of composition will become part of your thinking when you are looking for pictures, and soon they will become second nature to you.

Photographic composition is simply the selection and arrangement of subjects within the picture area. Some arrangements are made by placing figures or objects in certain positions. Others are made by choosing a point of view. Just moving your camera to a different position can drastically alter the composition.

For moving subjects you select the best camera position and wait for the opportune moment to snap the shutter when the subject is in the best location for a good composition.

While the rules for good pictures are not fixed, certain principles of composition will help you prevent making serious mistakes in subject arrangement and presentation.

HAVE A STRONG CENTER OF INTEREST

It is usually best to have one main point of interest because a picture can tell only one story successfully. The principal subject may be one object or several. For instance, you may want to include a secondary subject, but make sure that it doesn't detract from your main subject. Whatever the main subject is, always give it sufficient prominence in the photo to make all other elements subordinate to it.

Composition is arranging picture elements and visualizing how well they will "play" together in the resulting photo. It is deciding how much of the scene to include in the viewfinder and where to position your camera to add depth and interest. It is the integral part of photography that can turn a potential snapshot into a compelling photograph and work of art. Photo by Bobby Winston.

Dean Pennaia

Sometimes you can include a secondary subject in the picture to complement the main subject and create a pleasing, balanced composition. When including secondary subjects, position them in the viewfinder so that they do not detract from the main subject. If each of these two bushes appeared as the same size, the composition would be static and uninteresting.

Avoid putting the center of interest in the center of your picture unless you are striving for a formal arrangement where the subject firmly commands attention. Usually, if the main subject is in the middle of the picture, it looks static and uninteresting. You can often make excellent picture arrangements that have pleasing composition by placing your center of interest in certain positions according to the rule of thirds. When you divide a scene into thirds both vertically and horizontally, the dividing lines intersect in four places. Any of these four intersections provides a pleasing position for your center of interest.

Keith Boas

Place the subject in the center of the viewfinder only when it has very strong graphic elements which command your viewers' attention.

Keith Boas

A bright-colored subject naturally attracts the eye, adding strength to the center of interest.

Jennifer Ham Calvert

Consider the power that color has when choosing and composing your pictures. To draw your viewer's attention to your subject, it helps to have that subject be the brightest element in the scene. Warm colors such as reds, oranges, and yellows, usually work best for attracting interest.

151

To understand the rule of thirds, imagine two horizontal lines cutting the picture into thirds. Then imagine two vertical lines cutting the same picture into thirds vertically. The intersections of these imaginary lines suggest four options for placing the center of interest for a pleasing composition.

When you find an interesting subject, try composing it several different ways. In this series, the overall scene of table and chairs on a hotel patio caught the eye of the photographer.

The photographer then moved closer to be more selective—cropping to include only the table and two chairs. Note how the key elements in this triangular composition fit the rule of thirds.

Finally, he tightened his composition more to include only the elements on the surface of the table. Positioned daringly in the center of the picture, the red ashtray acts as a target bull's eye to attract attention. Photos by Keith Boas.

Bare feet provide an unusual frame for this kitten, whose eyes fall nicely into the upper left third of the picture. For a pleasing composition, think in terms of thirds as you compose in the viewfinder.

In photographing this woman hanging colorful clothes on a line, the photographer used the rule of thirds to make an effective composition.

154

Karen Henderson

To make a group look unified, get them all to look at the camera—or at least in the same direction.

Terrance Bechel

Here the group was encouraged to get their heads close together, a simple technique for producing candid harmony and a pleasing composition.

Colleen Arcand

USE THE BEST CAMERA ANGLE

Good pictures usually depend on selecting the proper point of view. You may need to move your camera only a few inches or a few feet to change the composition decidedly. When you want to photograph a subject, don't just walk up to it and snap the shutter. Walk around and look at it from all angles; then select the best camera angle for the picture.

Outdoors, shooting from a low camera angle provides an uncluttered sky background. However, when the sky is overcast with cloud cover you'll want to shoot from a high angle and keep most or all of the sky out of the picture. Overcast skies look bleak and unappealing in most pictures.

Always consider the horizon line. Avoid cutting your picture in half by having the horizon in the middle of the picture. When you want to accent spaciousness, keep the horizon low in the picture. This is especially appropriate when you have some white, fluffy clouds against a blue sky. When you want to suggest closeness, position the horizon high in your picture. Another important point, easily overlooked, is to make sure the horizon is level in the viewfinder before you press the shutter release.

By choosing an unusual viewpoint—inside this hot-air balloon—the photographer made a striking image of the scene above him. Photographed with a one-time-use panoramic camera. Photo by Samuel B. Hester.

Jose A. Ceballos

Using a low angle to photograph active people further animates them to reinforce the sense of movement.

157

The low angle selected for this picture captured the strong, web-like pattern in the skylight nearly directly overhead.

Mark R. Shughart

Using a low camera angle and the raking light from the sun low in the sky, the photographer turned this adobe into an artistic architectural study. Santa Fe, New Mexico.

Judy Hogan

Pedro R. Vega

The photographer pointed the camera down from a high viewpoint to capture this unusual view of a bull-fighter in Mexico. A telephoto lens was used to further help isolate the center of interest.

Kamie Graves

On overcast days, you can avoid a cloudy, gray, uninteresting sky in your pictures by choosing a high camera angle.

A high camera angle can be an excellent way to remove distracting elements from the background and emphasize the features of your subject

Owen Konski

The best viewpoint can sometimes be at the same level as the action. You can take pictures like this easily with a waterproof one-time-use camera or camera with an underwater housing.

Elvira S. Mireles De Lozano

Where you position the horizon can dramatically alter the mood of a photo. A high horizon seems confining while a low horizon frees the eye.

MOVE IN CLOSE

One rule of composition you should always keep in mind is whether the picture you are about to take would be better if you move in closer to your subject. Close-ups convey a feeling of intimacy to the viewer while long shots provide a sense of distance and depth. A close-up picture focuses your attention on the main subject and shows details that you could otherwise overlook or defines details that are too small in more distant views.

Some amateur photographers look through the viewfinder when they're taking pictures and start backing away from the subject. This is not only bad from a safety standpoint, but it can also be bad for composition. Stepping back can have the effect of making the subject too small in the photograph and encompassing too many elements that do not support the subject. Including too much in the picture can be confusing and distracting to the viewer.

When you look through your viewfinder, move toward your subject until you have eliminated everything that does not add to the picture. Even though you can crop your picture later if you plan to enlarge it, it's usually better to crop carefully when you take the picture. Carefully composing the picture in the viewfinder is essential for taking color slides because cropping techniques are not generally used with slides. In addition, because the frame size of 35mm film is not large, you'll obtain the highest quality when you use all of the picture area. The larger the image size on the film and the less enlarging that's necessary, the higher the image quality. A good rule to remember is to fill the frame.

Rodrigo Alfardo

Move in close to your subjects for photos with simplicity, bold color, and impact.

Joaquin M. Ruiz

Moving in close to your subject gives the viewer the sense of being there.

Show interesting details by moving in close so the subject fills the frame.

Guadalupe Villa Lopez

Crop carefully when you take the picture. To emphasize the subject, show it big. Move in to eliminate extraneous elements.

Francisco Schmitt

164

A leading line is usually the most obvious way to direct attention to the center of interest. In this case, the driveway leads the viewer's attention to the distant castle—the center of interest. Photo taken in Scotland.

Earl J. Smith

USE LINES FOR INTEREST AND UNITY

Use leading lines to direct attention into your pictures. Select a camera angle where the natural or predominant lines of the scene will lead your eyes into the picture and toward your main center of interest. You can find a line such as a road or a shadow in almost any outdoor scene. The road will always be there, so it's just a matter of choosing the right camera angle to make it run into the picture. A shadow, however, is an ever-changing element in the scene. There may be only one time in the day when it's just right. So you should patiently wait for the best composition.

Here the line formed by the boy in the foreground and row of boats directs the viewer's eyes on a round trip into the scene (following the boy's gaze) and back again to the boy (in the direction the boats point).

Jean Victoria Gray

Darla R. James

Look for leading lines in whatever you choose to photograph. In this case, the country road leads you to the Amish buggies and distant farms.

Vicente Lopez

The repeating lines in the crosswalks combine to form two dominant leading lines in this composition—both pulling your eyes into the scene. The locations of the pedestrians add scale and human interest while providing counterpoints to the graphic distinction of the walkways.

Bryan Peterson

S curves often make effective leading lines. Here the water creates an interesting repetition of S curves on a beach. The nimble leading line is enhanced by the sunset reflecting off the water.

The S curve, formed by the river rapids, leads the viewer nicely through the picture. Vernal Falls, Yellowstone National Park, Wyoming.

Mark Testa

The subtle V formation of tulips perform the dual functions of providing foreground interest and leading your eyes to the Capitol in Washington, D.C.

Tim Hermetz

George F. Nachtigall

The radial arrangement of these canoes and their reflections draws attention to the center of the picture.

Caroline Lebda

In this composition, the rows of crosses on military graves form dynamic triangular arrangements, directing you to the center of interest in the foreground.

The randomly spaced mooring poles add rhythm to this pictorial harbor scene. The poles on the right join the gondolas and distant spire to form a meandering, triangular composition.

Always keep an eye open for elements that will unify a scene. Here the leading line of the fence ties the foreground to the background.

WATCH THE BACKGROUND

The background can make or break a picture. It can add to the composition and help set the mood of a picture, or it can detract from the subject if it is cluttered. Watch out for backgrounds that are more compelling than the subject. Cluttered, distracting backgrounds often spoil otherwise good pictures. Before you snap the shutter, stop for a minute and look at the background. Is there some obtrusive object or action in the background that does not relate directly to your subject and would divert the viewer's attention?

For example, is there a telephone pole "growing" out of your subject's head? Beware of an uncovered trellis or the side of a shingled house when you take informal portraits or group shots, because bright colors or patterns in the background can detract from your subject. Either reposition your subject or try moving the camera. Foliage makes a better background. A blue sky is an excellent background, particularly in color pictures. Remember to look beyond your subject, because your camera will!

A cluttered background with trees or other unwanted elements sprouting out of your subject's head usually makes a confusing or distracting picture. Also, people may not appear at their best when photographed head-on with their bodies perpendicular to the axis of the camera.

In this comparison shot, the photographer changed the camera position slightly to move the offending plant off to the side. The result was an improved portrait.

When the subject is interesting by itself, use a plain background that will not compete with it.

Add a natural frame to your scenics by including foreground objects such as trees. A foreground frame can help add the feeling of depth to a picture. Photo by Gabriela Saint-Andre.

Arranging the subject so that it is surrounded by an appropriate frame is another way to focus attention on the subject.

Alfredo Landa

TAKE PICTURES THROUGH FRAMES

For an added creative dimension, compose your pictures with an interesting foreground frame, such as a tree, a leafy branch, or a window. Try to choose a frame that links thematically with the subject—such as a sailboat's rigging framing a harbor scene. Foreground frames create a sensation of depth and direct the viewer's attention to the center of interest. Watch the depth of field of your lens so that both the foreground and the other details in the scene will be in focus. In scenic photos, avoid a very out-of-focus foreground that can distract from the subject. But in other kinds of shots, such as

informal portraits, an unsharp foreground frame emphasizes the main subject.

If you are using an auto-exposure camera and you want both the foreground frame and the main subject sharp, remember to use the aperture-priority mode or depth program so that you can use a small aperture. Or you can use this mode to set a large aperture to put the frame out of focus. If you are using an autofocus camera and you want only the main subject in focus, be sure to lock in the focus for the most important subject area first, and then include the out-of-focus foreground—otherwise the lens will focus on the foreground.

Frank Wilshusen

Overhanging branches are usually available and, consequently, popular as elements for foreground framing. Here they provide added dimension to a rocky coastline.

After you have followed the rules of composition for a while, you'll no longer need to spend much time trying to determine the best arrangement of the subjects you're photographing. As we all have some artistic ability, soon the recognition of pleasing composition will become almost automatic. You'll be aware that it is important to place figures or objects in certain positions. Figures should look into, not out, of the picture. Fast-moving objects should have plenty of space in front of them to give the appearance of having somewhere to go. And since bright tones or colors attract the attention of the eye, the most important elements of the picture usually should be the lightest, brightest, or most colorful.

Remember, composition is simply the effective selection and arrangement of your subject matter within the picture area. If you follow the suggestions given here, with time experience will teach you a great deal about this subject. When you look through the viewfinder, concentrate on how you want the final picture to appear.

When adding a foreground frame to your composition, make its image sharp (maximum depth of field) or extremely out of focus. If the foreground image is only slightly out of focus, it will look like the photographer made a mistake.

Keith Boas

You can usually improve a scenic sunset by using silhouetted objects in the foreground — in this example, as both a frame and a secondary center of interest.

Lawrence A. Glassco

Framing can give a picture the depth it needs to make it more than just another snapshot. In this picture, the photographer used the overhanging rock formation both as a frame and as a center of interest. Photo taken in Australia by Peter Gavlick, Jr.

175

Melba Doyle

A foreground subject can do more than make the picture attractive. It can also help tell a story—in this case, lazy living on a warm summer day.

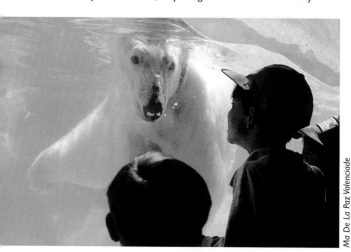

Ma De La Paz Valenciade

Children can become effective, storytelling foreground frames under the right circumstances. Always keep your camera ready for unplanned picture opportunities.

Don't limit your selection of foreground frames to trees and architecture. Keep an eye out for fresh approaches (i.e., a colorful play tunnel) to give your pictures depth and impact.

Sue Stechschulte

Sometimes you can use a colorful foreground such as a flowerbed to frame your subject. Here the flowers, besides framing the foreground, seem to mimic the crazy pattern in the subject's cow costume.

Susan Riley Stewart

Kenneth W. Miller

In this compelling photo, the photographer demonstrated excellent use of several compositional rules including scale, framing, leading lines, rule of thirds, and a strong center of interest.

Edith Rivera Gil

A wide-angle lens allowed the photographer to include the steer skull in the foreground and enhance a sense of depth and space in the scene.

Keith Boas

The magnifying power of a telephoto lens picked out the ship passing under San Francisco's Golden Gate, emphasizing the huge size of this impressive bridge.

The presence of a person in this scenic photo helps us appreciate the elevation and scale of this California vista.

High Falls in northern New York takes on added height with the inclusion of a person for scale in the lower right corner. Photos by Keith Boas.

Action Pictures

Racers pound through a turn. Skiers soar down a mountainside. Bikers sweep by in a blur to the finish line. There's plenty of great action to photograph just about anywhere you are or plan to be with your camera.

Action is a major ingredient in many successful, memorable photos. Images of subjects in action can convey a feeling of excitement, particularly if you have mastered the techniques required to record them well. How you handle your film, camera, lenses, and light will have a great deal to do with the quality and mood of your resulting pictures.

STOPPING THE ACTION

The most common technique for stopping action in a photograph is to use a fast shutter speed. For most action pictures, you'll probably want to use as fast a shutter speed as lighting conditions and depth-of-field requirements allow. Auto-exposure cameras that have an "action" program mode are especially good for stopping action; they automatically choose a fast shutter speed for the prevailing lighting conditions. Some auto-exposure cameras automatically switch to an action mode when you mount a telephoto (or telephoto zoom) lens on the camera.

Scott Sinclair

A photo that's sharp all over conveys less sense of motion, but it clearly reveals an instant from an ongoing action. To stop action, use the fastest shutter speed allowed by the conditions. Photo at left by Mark Hill.

181

Ray Herschberger

An ISO-400 high-speed film is a good general-purpose film for many photo subjects including ones that are moving. Its high speed lets you use shutter speeds of 1/500 second and faster even in dim lighting.

But even if you can use action modes, it's useful to know when you must use the fastest shutter speed and when you can stop the action with slower speeds.

Action moving at right angles to the camera is more difficult to stop than action moving diagonally. Action moving directly toward or away from the camera is the easiest to stop. Also, distant action is easier to stop than action close to the camera.

For example, suppose you were photographing a auto race. You would have to use your fastest shutter speed in an effort to stop the action if you were photographing the cars on a strait-away as they raced past you. If you were near a bend in the track and could photograph the cars coming toward you, you could get away with a slower shutter speed. Also, you could stop the action with a slower speed if you were in the last row of the bleachers rather than in the pits.

Certain types of action have a peak—a split second when the action almost stops. If you anticipate the peak of the action and begin pressing the shutter release so that the shutter clicks right at the peak, the action is easier to stop. A pole-vaulter at the top of a vault, a golfer at the end of a follow-through, and a tennis player at the peak of a backswing are all examples of peaks of action.

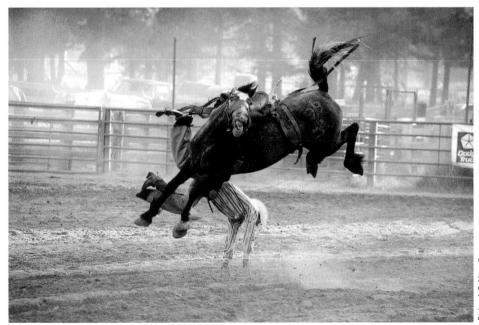

Richard C. Nuttall

Sports are a natural for action photography. Watch for the most opportune moment to snap the shutter as the action takes place. Here an auto-winder or motor drive comes in handy for making several exposures in rapid succession.

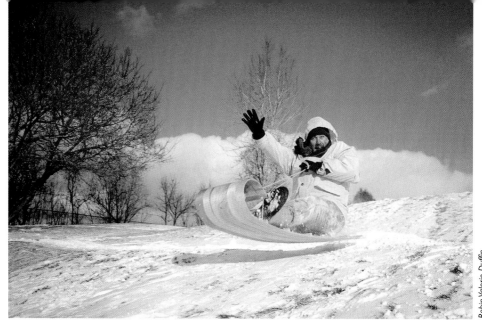

For this photo, full sunlight provided bright illumination to let the photographer use a fast shutter speed with just a medium-speed film.

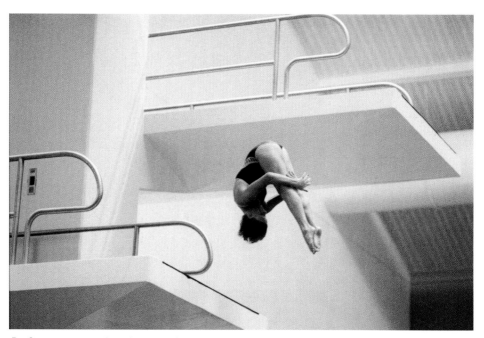

For freezing motion when shooting indoors, choose a high-speed film to compensate for low light levels and ensure you can set a fast enough shutter speed.

Another good way to arrest action is to pan with a moving subject. If you move the camera to keep the subject centered in the viewfinder as you squeeze the shutter release, the subject will be sharp and the background blurred. The slower the shutter speed, the more blurred the background will be. This technique is useful for creating a feeling of speed in a photograph. A picture of runners made at 1/500 second may show the action frozen in a rather static-looking photograph. But if you reduce the shutter speed to 1/125 second and pan the camera with the action, the result will be an exciting photograph filled with the feeling of motion.

It's not very difficult to track a moving subject with a manual-focus lens. But an autofocus camera that has a servo or continuous-focus mode makes panning easier because the camera will do the focusing while you follow the action in the viewfinder. The camera will continue to adjust focus almost until the instant of exposure. The disadvantage of this mode is that, unlike the single-shot focusing mode, the continuous-focus mode will allow you to take a picture whether sharp focus has been achieved or not.

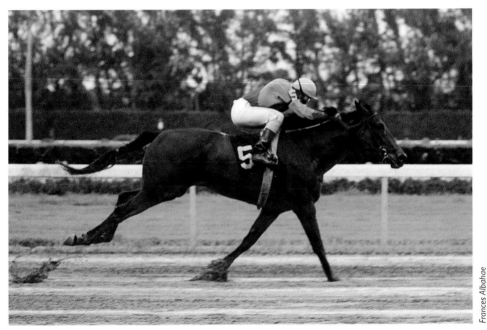

Frances Albahae

When a moving subject fills a large part of the picture, you need to use a very fast shutter speed to freeze the action.

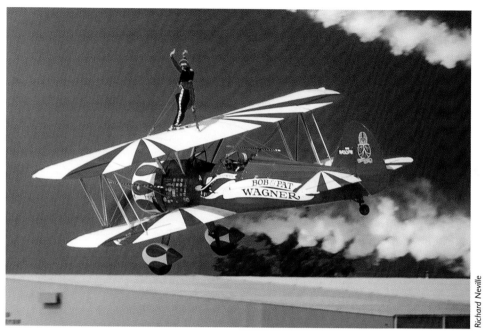

Richard Neville

To photograph the extremely fast movement of low-flying aircraft at an air show, use a shutter speed of 1/1000 second—or 1/2000 second if you're using a telephoto lens.

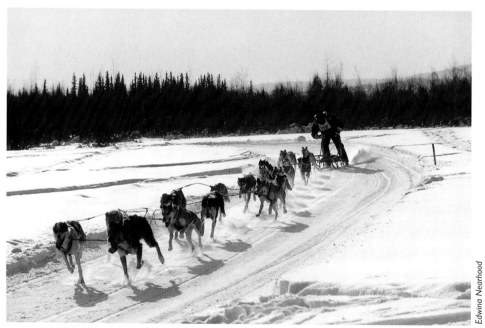

Edwina Nearhood

Action cutting diagonally across the scene is usually the most dynamic. For a fast-moving subject that's near the camera, such as this dog sled team and driver, use a shutter speed of at least 1/500 second.

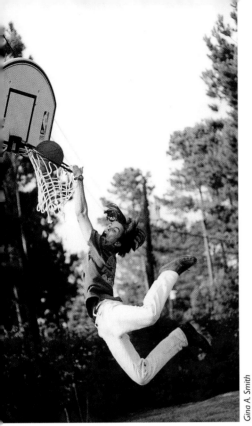

Gina A. Smith

Why wouldn't the focus always be sharp? One reason is that a moving subject may escape the focus target at the moment you press the shutter release. Another reason is that although autofocus lenses respond in fractions of a second, the subject may be moving faster than the focusing motor can adjust focus. Finally, there is a lag between the time you press the shutter and the time it takes for the camera to move the mirror out of the way and expose the film. At least one camera is programmed to take this time lag into consideration— along with the speed and direction of the subject—and adjust focus so that it is correct at the very instant of exposure.

Stop-action photos take on a strong sense of action when their subjects are in postures that reflect vigorous movement. An 800-speed film will let you use fast, action-stopping shutter speeds even in deep shade.

Jennifer Hill

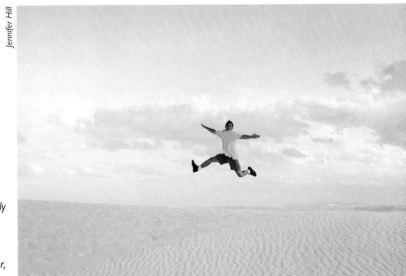

Subjects moving directly across the scene require a very fast shutter speed, usually 1/500 second or faster, to freeze their action.

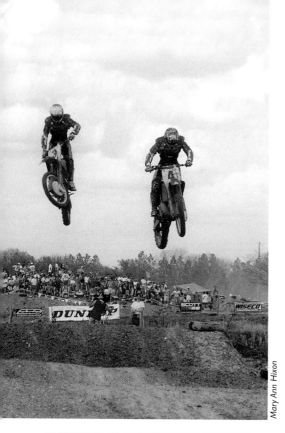

Often you can stop action coming directly at you with a fairly "slow" shutter speed, such as 1/125 second or 1/250 second.

Mary Ann Hixon

Miranda Hume

Autofocus systems can track and focus on fast-moving subjects fairly well. But when you know exactly where the action will take place, you can be sure of getting a sharp picture by prefocusing on that spot, then taking the picture as the action arrives.

Eloisa De Franco

Here the photographer snapped the picture at the instant when the girl was at the peak of her leap from the water. It's easy to stop motion this way, when the action momentarily stops before reversing direction.

Arturo Jasso Urzua

You can pan with the action to keep a moving subject centered in the viewfinder as you squeeze the shutter release. When you do this, the subject may or may not be sharp, depending on your shutter speed and how well your pan aligns with the moving subject. But the background always will be blurred, which helps to isolate and call attention to the subject. Try a shutter speed of 1/8 or 1/4 second for this type of effect.

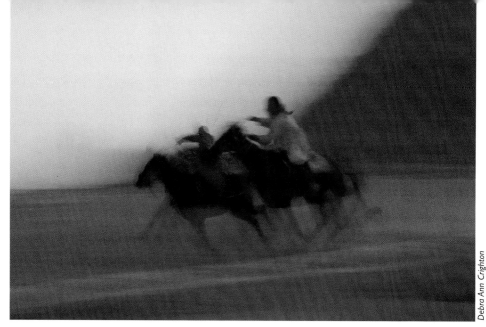

Rapid panning and a slow shutter speed combined to create this impressionistic, watercolor effect. Good shutter speeds to try for blurred action are 1/30 to 1/4 second depending on the speed of your subject and the amount of blur you want to capture in the picture. A medium-speed (ISO-100) film will generally allow the slow shutter speed necessary to get an attractive blur in overcast lighting. If the action is in bright sunlight, use a low-speed (ISO-25) film or a neutral density filter on your lens to reduce the amount of light reaching the film.

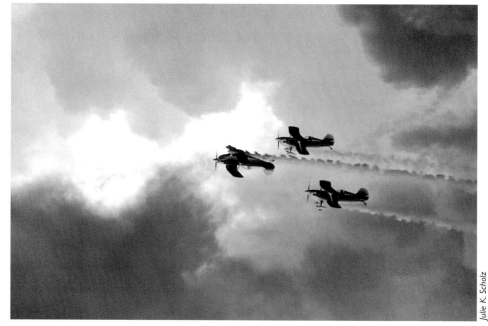

The composition of action photos often looks better when you leave some space for the subject to "move" into.

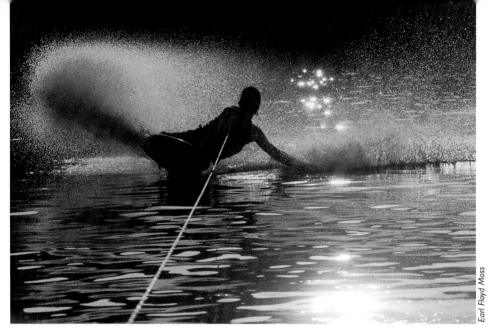

Here the camera, handheld on the tow boat, was moving at the same speed as the water skier, so an extremely fast shutter speed was not required to freeze his movement.

The best way to stop action is to use a fast shutter speed and high-speed film.

ACTION SHOTS WITH TELEPHOTO LENS

Sometimes you will want to photograph action that you can't get as close to as you'd like, so you may use a telephoto lens to bring the action closer. Remember that a telephoto lens not only increases image size but also increases the effect of subject movement. When the subject distance remains the same, the effect of subject movement increases in direct proportion to the focal length of the lens. For example, if you need a shutter speed of 1/250 second to stop the action with a 50mm lens, you'll have to use a shutter speed that is twice as fast or 1/500 second with a 100mm lens. The longer the focal length, the faster the shutter speed needs to be.

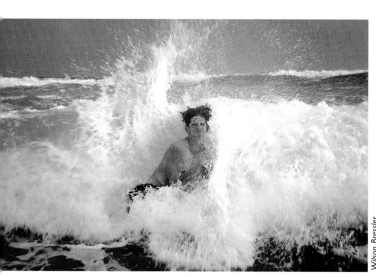

Because a telephoto lens magnifies the image and brings the action closer optically, you need to use faster shutter speeds than with normal or wide-angle lenses.

Wilson Bressler

A close-up action photo is usually possible only when you use a telephoto lens. It would be best to use a shutter speed of 1/1000 second for this kind of picture.

Janice R. Johnson

Because it is difficult to get close enough to most wildlife subjects—particularly grizzly bears—a telephoto lens is a great asset in getting a good image size to show the action. Depending on the magnification of your telephoto lens, shutter speeds of 1/500 or 1/1000 second are usually necessary to stop camera motion.

Jacqueline Jones

A telephoto lens can bring the action close while protecting the photographer and camera, in this case, from getting wet. Here the out-of-focus spray of water in the foreground adds interest and complements the jovial expression on the boy's face.

Alejandro Huereca Santos

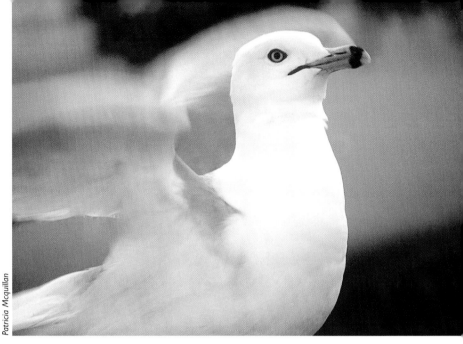

Patricia Mcquillan

Not all action pictures need to show completely stopped action. The blurred wings of this seagull created a pleasing nature photograph.

Marty Gonzales

If you can't use a fast shutter speed to stop the action, position yourself so that the action is moving toward or away from you.

Robert Mccann

Give some additional interest to your sunset pictures by including action in the foreground. People walking at some distance from the camera can be easily stopped in your pictures using a shutter speed as slow as 1/125 second. Birds in flight, on the other hand, may require a faster shutter speed, especially if they're near the camera.

194

FLASH FOR FREEZING ACTION

You can use the sudden burst of light from electronic flash to stop fast action, providing you are within the effective range of the flash. Regardless of the type or power of your flash, the burst of light lasts for only about 1/1000 second.

Just remember that the fastest shutter speed for proper flash synchronization with focal-plane shutters is usually much slower than the duration of the flash. If there is enough ambient light in the scene to register on the film at the required slower shutter speed, you will get some blurring (ghosting) at the edges of your sharp (flash-exposed) image.

If your camera has a leaf shutter, it will synchronize for flash at any speed. To avoid ghosting with a leaf-shutter camera, use a shutter speed fast enough to prevent ambient light from recording on the film.

Alan Farkas

To freeze this skateboarder in the air, the photographer panned the camera to follow the action while firing a burst form his electronic flash unit. Photo taken on 100-speed color slide film.

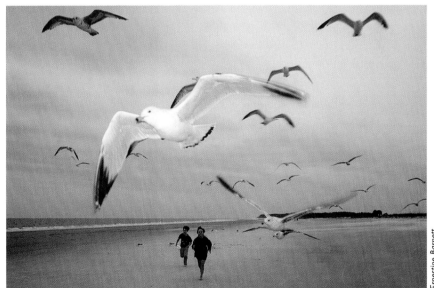

Ernestine Barnett

In this picture, the bright, close-by seagull was the only subject within the camera's acceptable flash range. The blur (ghost) image around the moving wing tips was caused by ambient light recording on the film after the burst of flash but before the shutter closed.

Existing-Light Photography

Existing light, sometimes called available light, includes artificial light which naturally exists in the scene, daylight indoors, and twilight outdoors. It is the light that happens to be on the scene. Technically, sunlight and other daylight conditions outdoors are existing light. But in defining existing light for photography, we are referring to lighting conditions that are characterized by lower light levels than you would encounter in daylight outdoors.

Existing-light pictures have a natural appearance because they are made by the natural lighting on the subject. Existing-light photography is also sometimes more convenient than picture-taking with flash or photolamps because you don't have to use extra lighting equipment or concern yourself about the light source-to-subject distance.

Multicolored stained-glass windows make interesting indoor existing-light pictures. Base your exposure on the window by getting close enough with your meter to exclude the dark surrounding area. If you don't have a working meter available, try an exposure of 3 stops more than you would use for the outdoor lighting conditions at that time. For color slides, use daylight film. Photo by Keith Boas.

Existing-light photography really isn't as new as we sometimes think. Photographers have been taking existing-light pictures for more than 50 years. But their exposures often lasted several minutes. The big advantage of today's fast lenses and fast films is that they make it possible to take existing-light pictures with much shorter exposure times. Often the exposure times are short enough to allow you to hand-hold your camera.

LENS OPENINGS

Since most existing lighting is comparatively dim, you need an *f*/2.8 or faster lens and a high- or very-high-speed film for hand-held picture-taking. An *f*/2.8 lens is sufficient for many existing-light scenes. But if you have an even faster lens, such as *f*/2 or faster, and use a high- or very-high-speed film—ISO 400 to ISO 1600—you'll have more versatility. The combination of an *f*/2 or faster lens and a 400-speed or faster film lets you take pictures in dimmer lighting conditions while hand-holding your camera. A fast lens and a high- or very-high-speed film also let you use faster shutter speeds for stopping action when the existing lighting is somewhat brighter. Another advantage is that you can use a smaller lens opening for greater depth of field under brighter existing-light conditions.

Bill Cafer

Taking pictures by the existing lighting lets you capture the realism of beautiful interiors you see in your travels. Photo taken on daylight color-slide film, in St Mary's Cathedral, Sydney, Australia.

TECHNIQUES

Hand-holding your camera is suitable for shutter speeds as slow as 1/30 second with a normal-focal-length lens. To obtain sharp pictures consistently when using a slow shutter speed, you must be able to hold the camera steady. Practice holding the camera steady at 1/30 second. Eventually you may find that you can get satisfactory results with even slower shutter speeds. However, at slower shutter speeds you should normally place your camera on a tripod; use a cable release so that you don't jiggle the camera when you trip the shutter.

If you don't have a tripod and you want to use a slow shutter speed, try bracing the bottom of your camera against a wall or post while you take the picture. If your camera has a self-timer, you can use it instead of risking camera shake when tripping the shutter with the shutter button. For example, set the self timer, press the camera against its support, press the shutter button, and wait a few seconds until the shutter trips.

You will take most of your existing-light pictures with a large lens opening, which means the depth of field will be shallow. Focus accurately so the subject is sharp.

Hugo Fernandez Crenshaw

The masterful workmanship adorning the interiors of some public buildings and cathedrals can be appreciated only through personal visits or existing-light photography. A flash, if powerful enough, would have masked the beautiful, warm effect of daylight illuminating the decorative ceiling.

Michael P. Galuppi

Morning light, streaming brightly into a cathedral, conveys the loftiness of the architecture while accenting a group of tourists below. The pictorial effect of existing light in this photo would not have been possible to achieve with flash.

199

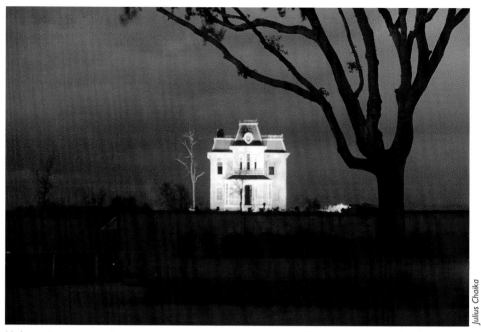

Julius Chaika

Night scenes are natural subjects for your existing-light photography. Dramatic lighting on buildings let you create pictures with a totally different appearance from that of conventional pictures taken in the daytime.

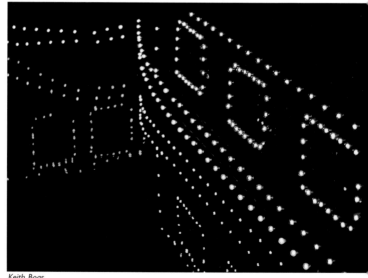

By moving close and deliberately underexposing the scene so that only the existing lights recorded on the film, the photographer created the essence of the scene. Houseboats decorated with strings of lights in Amsterdam, The Netherlands.

Keith Boas

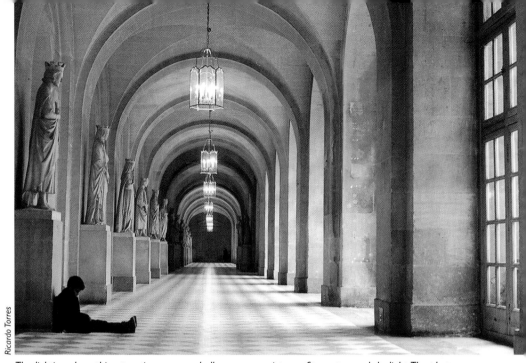

Ricardo Torres

The lighting along this attractive museum hallway was a mixture of tungsten and daylight. The photographer carefully chose a viewpoint that produced feelings of space and solitude in the photo. Taken on 100-speed color print film.

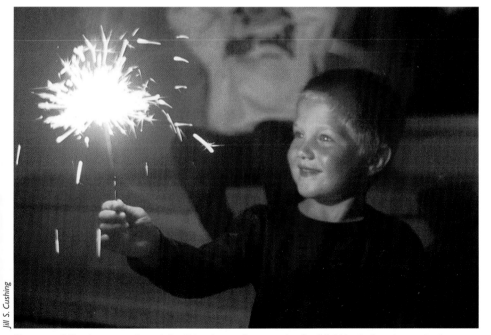

Jill S. Cushing

Focus carefully when you take existing-light pictures because depth of field is shallow due to the large lens openings required for the relatively dim lighting. Photo taken with 400-speed color print film.

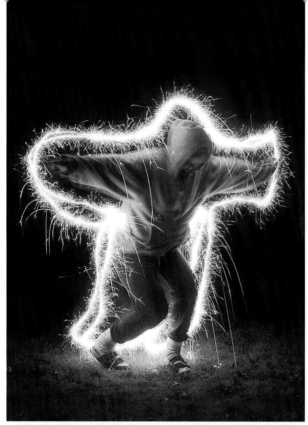

Teamwork was necessary to achieve this spooky image. During a time exposure of several seconds in the darkness of night, the subject held still while another person outlined his body with a lit sparkler.

Topasannah McArthur

Robert J. Lennon

For color slides, a film balanced for daylight is a good choice when you plan to take both existing-light pictures and daylight pictures outdoors on the same roll of film. A 200-speed film is adequate for many existing-light scenes if your camera has an f/2.8 or faster lens.

For taking color slides in tungsten lighting, tungsten film gives color rendition that appears natural as shown by the photo on the top. Slides made on tungsten film have a bluer, perhaps more realistic, appearance than slides made on daylight film (below), which have an orange-red color balance—augmented here by some red and orange lights on the tree. Both kinds of film produce good results. The one you select is usually a matter of personal preference.

FILMS

Kodak color print films with ISO ratings of 400 and up are excellent for existing-light photography because of their speed and versatility. You can take pictures in various kinds of existing light—daylight indoors, tungsten, and fluorescent illumination—without using filters. These films produce more natural color rendition under a wide range of lighting conditions because they have special sensitizing characteristics that minimize the differences between various light sources. Also, color rendition can be partially controlled during the printing process.

If you want color slides under existing-light conditions, you can select from a variety of Kodak high-speed color slide films with either daylight- or tungsten color balance. With existing tungsten light, you'll get the truest color rendition when you use film balanced for tungsten light. With daylight film the colors will appear warmer, or more orange. However, many people like this added warmth in their existing-light pictures. In fluorescent

Daylight film

Photos by Keith Boas

Tungsten film

204

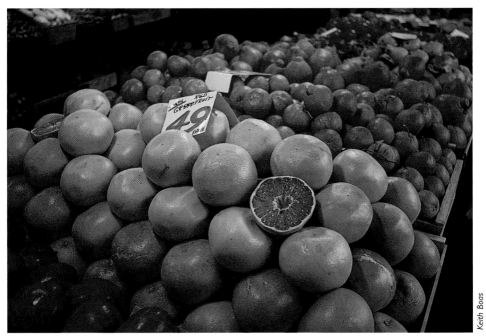

Keith Boas

By using a high-speed film for existing-light pictures, you can hand-hold the camera and sometimes use a small aperture for greater depth of field. Here the warm tones of the fruit were enhanced by using daylight color-slide film and tungsten illumination.

Keith Boas

Handheld exposure of Rockefeller Center, New York, on tungsten color slide film.

lighting, daylight film is the better choice, but the colors are still likely to have a cold greenish or bluish cast. When daylight from windows or a skylight illuminates your subject, use daylight film.

For taking existing-light pictures in black-and-white, both KODAK T-MAX 400 Professional Film, ISO 400, and KODAK T-MAX P3200 Professional Film, EI 3200, are excellent choices. You can get excellent results push processing either film in KODAK T-MAX Developer. You can push T-MAX P3200 Professional Film all the way to an exposure index of 25,000 and still get acceptable results. When you photograph existing-light subjects with black-and-white film, you don't have to be concerned with the color quality of the light or the type of lamps illuminating the scene.

Emasol Maldonado

Jack Riggin

High-speed black-and-white films with an ISO of 400 and up are very versatile for existing-light situations. You can use them outdoors at night to record a mood. Or use them indoors for sensitive, candid portraits by dim, existing lighting.

Very-high-speed films (ISO 800 and higher) are a tremendous help when you want to capture action by existing light. Here KODAK T-MAX P3200 Professional Film was used to record the dancer on stage.

800-speed color print film is a tremendous help when you want stop action in existing light.

This indoor photo was taken on daylight color slide film without a filter. The mixed lighting from flood-lights (tungsten balance) and carbon-arc spotlights (daylight balance) produced a slightly warm but acceptable color rendition of the event.

With FLD filter

Without filter

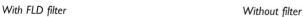

Fluorescent lights give off greenish light not readily noticed by the eye but clearly visible in photos. To improve color under fluorescent lights, use an FLD filter.

Home lighting is dim at best, so use a film with a speed of at least ISO 200 and a fast lens of f/2.8 or faster for hand-holding your camera.

Susan B. Scopie

EXISTING-LIGHT PICTURES INDOORS

You'll find lots of possibilities for existing-light pictures indoors. At home you can take unposed pictures of your family or you can record holidays and special occasions. Away from home you can take pictures of many subjects including ice shows, stage plays, musicals, dance recitals, graduation ceremonies, and sports events.

When your subject includes both very bright and very dark areas, such as spotlit performers, and you can't take a close-up meter reading, a built-in meter isn't much help unless it has a spot-metering feature.

An averaging meter sees the large dark areas surrounding the small bright area and indicates more exposure than is needed. In reality, there is plenty of light on the spotlighted subject. If you shoot at the exposure indicated, however, the meter will average the dark and light areas, causing the bright subject to be overexposed.

Auto-exposure cameras that have a matrix metering system will do better in such situations because they are programmed to recognize the signals of the contrast differences and bias their exposure for the important subject area. No matter how sophisticated the metering system, you must be careful not to aim the

lens directly into a bright light, such as a stray spotlight or even a reading lamp. If you do, the meter will underexpose the subject.

In many existing-light situations, you may find that using the existing-light exposure table found in this chapter gives more reliable results. Or you can simply bracket your exposures.

Autofocus systems may also be adversely affected by low light levels. As mentioned earlier, autofocus lenses have difficulty focusing in extremely dim or low-contrast lighting. Some cameras focus better than others in low light, but there are a few tricks you can use to help any autofocus system. If you are photographing a spotlit act, for instance, keep the brightly lit subject centered in the focusing area of the viewfinder. If you don't want the subject in the center, you can use the focus lock to hold focus while you recompose.

In the existing lighting at home, position your subject or select a camera angle where the light source is illuminating the front or side of the face so it is not in heavy shadow.

Susan E. Drey

Jane Huzar

Dyan L. Hitchcock

The photographer used 400-speed color print film for this environmental portrait of young ballerinas. Keep your camera handy and watch for picture-taking opportunities where mixed lighting (daylight and tungsten) can heighten the charm of the scene.

It helps to turn on lamps in the room to lighten the shadows on the subject. This also may provide enough light so you can hand-hold your camera when you use a high-speed film.

Maxine De Alvarez

The natural quality of lighting from existing daylight is excellent for photographing subjects indoors. If your subject is near a window, the brightness level will usually be high enough for handheld pictures without flash.

White translucent drapes served as a simple and effective background for this home-interior silhouette. A high level of illumination filtering though the drapes allowed the photographer to use a small aperture for good depth of field. 400-speed color print film.

Normally pictures taken by window light work best when daylight entering through the window is not intense. Here, however, the photographer took advantage of the strong daylight and shadow, plus the warm tone from the lamp, to record this triangular composition. Daylight color-slide film, hotel lobby in Miami, Florida.

Daylight from a window, behind and to the left, created rim lighting which set apart the subject from the background. It also reflected off the prayer book to lighten the woman's face.

Patrick Walmsley

You can often improve photos shot indoors with existing daylight by using a reflector to fill shadows on your subject's face, similar to using a reflector outdoors. In this example, light from a window is reflected off the sheet music to brighten the subject's face.

Daylight color slide film is the best choice for multi-vapor lighting, commonly used to illuminate the playing area in some large sports stadiums. These lights provide improved color quality suitable for color television and photography. Pictures taken on daylight film without filters under this illumination will have good color rendition for non-critical purposes.

Patrick D. Guanciale

For action events outdoors at night, you need a high film speed. Photographed with 1000-speed color print film.

EXISTING-LIGHT PICTURES OUTDOORS AT NIGHT

Brightly illuminated street scenes, amusement parks, campfires, interesting store windows, and floodlighted buildings, statues and fountains all offer good nighttime picture-taking possibilities. The best time to shoot outdoor pictures at night is just before complete darkness when there's still some rich blue left in the sky. The deep colors of the sky at dusk make an excellent background for pictures of cityscapes, monuments, and other large subjects.

Outdoor photography at night is easy, primarily because of the pleasing results you can get over a wide range of exposures. The subject usually consists of smaller light areas surrounded by large dark areas. Expose for the highlight and middle-tone areas of the scene. Do not allow the darker areas of the scene to influence your exposure-meter reading, causing you to overexpose the photograph. Short exposures leave the shadows dark and preserve the color in the bright areas, such as illuminated signs. Longer exposures tend to wash out the brightest areas, but produce photos with more detail in the shadows.

When your subject is evenly illuminated, try to get close enough to take an meter reading. Many floodlit buildings and store windows fall into this category. Night sports events also are usually illuminated evenly. Before you take your seat at the event, make a light meter reading from a position close to the spot where the action will take place, and set your camera accordingly. When you can't take a meter reading of your subject, use the exposure suggestions in the table on the next page as a guide.

If the idea of existing-light photography really catches your fancy, you may want to read the KODAK Workshop Series book, *Existing-Light Photography* (ISBN 0-87985-744-7), available from photo dealers.

Carry your camera when you go out at night and capture the bright lights of the city. This unique photograph of skaters at Rockefeller Center was taken by steadying a point-and-shoot camera on a low wall.

Thom Davis

SUGGESTED EXPOSURES FOR EXISTING-LIGHT PICTURES WITH *KODAK* FILMS*

Picture Subjects	ISO 64-100	ISO 160-200	ISO 320-400†	ISO 800-1000†	ISO 1600-3200
Home interiors at night— Areas with bright light Areas with average light	1/15 sec *f*/2 1/4 sec *f*/2.8	1/30 sec *f*/2 1/15 sec *f*/2	1/30 sec *f*/2.8 1/30 sec *f*/2	1/30 sec *f*/4 1/30 sec *f*/2.8	1/60 sec *f*/4 1/30 sec *f*/4
Interiors with bright fluorescent light‡	1/30 sec *f*/2.8	1/30 sec *f*/4	1/60 sec *f*/4	1/60 sec *f*/5.6	1/125 sec *f*/5.6
Indoor and outdoor Christmas lighting at night, Christmas trees	1 sec *f*/4	1 sec *f*/5.6	1/15 sec *f*/2	1/30 sec *f*/2	1/30 sec *f*/2.8
Ice shows, circuses, and stage shows—for spot-lighted acts only	1/60 sec *f*/2.8	1/125 sec *f*/2.8	1/250 sec *f*/2.8	1/250 sec *f*/4	1/250 sec *f*/5.6
Basketball, hockey, bowling	1/30 sec *f*/2	1/60 sec *f*/2	1/125 sec *f*/2	1/125 sec *f*/2.8	1/125 sec *f*/2.8
Night football, baseball, racetracks, boxing§	1/30 sec *f*/2.8	1/60 sec *f*/2.8	1/125 sec *f*/2.8	1/250 sec *f*/2.8	1/250 sec *f*/2.8
Brightly lighted downtown street scenes (wet streets make interesting reflections)	1/30 sec *f*/2	1/30 sec *f*/2.8	1/60 sec *f*/2.8	1/60 sec *f*/4	1/125 sec *f*/4
Brightly lighted nightclub or theatre districts—Las Vegas or Times Square	1/30 sec *f*/2.8	1/30 sec *f*/4	1/60 sec *f*/4	1/125 sec *f*/4	1/125 sec *f*/5.6
Store windows at night	1/30 sec *f*/2.8	1/30 sec *f*/4	1/60 sec *f*/4	1/60 sec *f*/5.6	1/60 sec *f*/8
Floodlighted buildings, fountains, monuments	1 sec *f*/4	1/2 sec *f*/4	1/15 sec *f*/2	1/30 sec *f*/2	1/30 sec *f*/2.8
Fairs, amusement parks at night	1/15 sec *f*/2	1/30 sec *f*/2	1/30 sec *f*/2.8	1/60 sec *f*/2.8	1/60 sec *f*/4
Skyline—10 minutes after sunset	1/30 sec *f*/4	1/60 sec *f*/4	1/60 sec *f*/5.6	1/125 sec *f*/5.6	1/125 sec *f*/8
Burning buildings, bonfires, campfires	1/30 sec *f*/2.8	1/30 sec *f*/4	1/60 sec *f*/4	1/125 sec *f*/4	1/125 sec *f*/5.6
Aerial fireworks displays—Keep camera shutter open on BULB for several bursts	*f*/8	*f*/11	*f*/16	*f*/22	*f*/32
Niagara Falls— White lights Light-colored lights Dark-colored lights	15 sec *f*/5.6 30 sec *f*/5.6 30 sec *f*/4	8 sec *f*/5.6 15 sec *f*/5.6 30 sec *f*/5.6	4 sec *f*/5.6 8 sec *f*/5.6 15 sec *f*/5.6	4 sec *f*/8 4 sec *f*/5.6 8 sec *f*/5.6	4 sec *f*/11 4 sec *f*/8 4 sec *f*/5.6

*These suggested exposures apply to daylight and tungsten films. When you take color pictures under tungsten illumination, they look more natural when you use tungsten film. Daylight film produces pictures more orange, or warm in color.

†You can increase the speed of some films by approximately 2 times by having them push processed when you return the film for processing.

‡Tungsten color film is not recommended for use with fluorescent light. Shutter speeds of 1/60 second or longer are recommended for uniform and adequate exposure with fluorescent lighting.

§Shutter speeds 1/125 second or longer are recommended for uniform and adequate exposure with lighting from multi-vapor or mercury vapor high-intensity discharge lamps.

Use a tripod or other firm support with shutter speeds slower than 1/30 second.

The background and surrounds for performers in stage shows are often dark. Since a light meter would measure the dark surroundings, the pictures would be overexposed. Make a close-up reading if you can or try the exposure given in the existing-light exposure table on the opposite page.

A good time to take night pictures is just after sunset when there is still some light in the sky to separate the subject from the background.

217

Jose Luis Cuervo Vazquez

A full moon and seascape combine to form an intriguing image. For best results, take photos of the moon at twilight, when it is still light enough to easily see the scene yet dark enough so that the moon dominates. Here some illumination from spotlights on the lawn and palm tree added detail to the foreground.

Bradley J. Smith

City streets at night are dazzling subjects for existing-light photos. A high location, such as in a building, provides a good viewpoint for taking pictures.

You can use medium-speed film for existing-light night pictures if you put your camera on a firm support and make a time exposure. Here an exposure time of several seconds recorded the tail lights of a moving car as interesting red streaks.

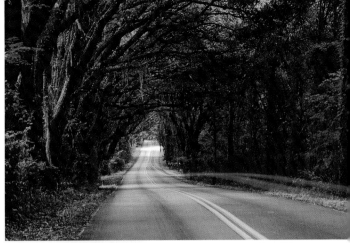

Russell Grace

Howard Penn

Carol Wade

You can record intriguing light patterns from traffic by making long exposures in areas where there is little or low-intensity ambient lighting.

Kim Hintzman

When you go to see fireworks, take your camera along. The colorful, striking displays make spectacular pictures. You will get the best results if you put your camera on a tripod, open the shutter on BULB, and record several bursts before you close the shutter. For 200-speed film, set your camera lens opening at f/11.

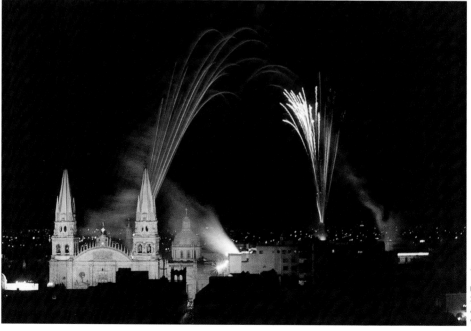

Sofía M. Zepeda

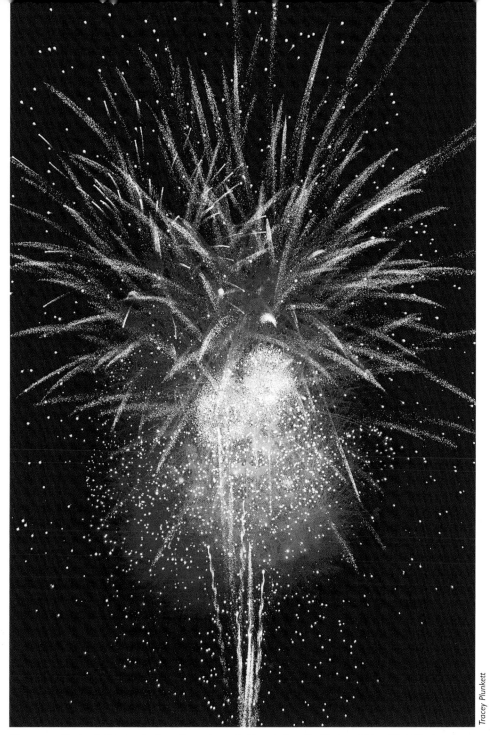

Tracey Plunkett

The unusual but colorful streaks from fireworks make them a favorite photographic subject. Center your tripod-mounted camera on the area of the sky where the majority of bursts are occurring. Next open the shutter, record three or more bursts, close the shutter, advance the film, and repeat the process. You'll want to take several pictures to increase your chances of getting perfectly framed bursts.

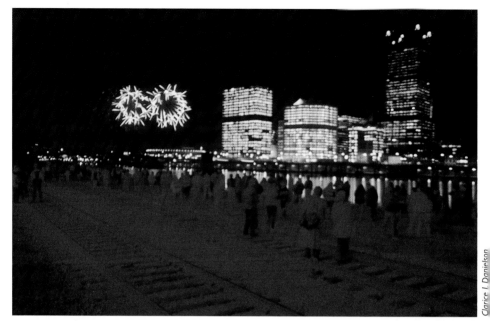

Clarice I. Danielson

A long exposure to record fireworks can also capture ghostly blurs of pedestrians who don't stand still.

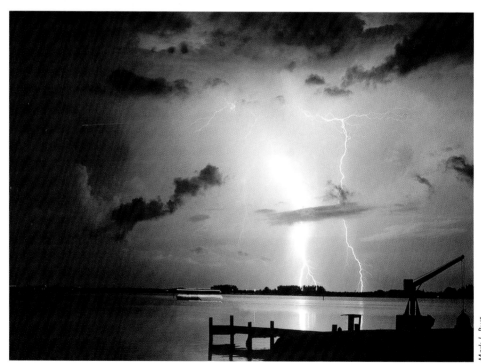

Mark L. Burt

As with pictures of fireworks displays, lightning requires a tripod-mounted camera set on BULB.

Exposures vary widely due to the intensity of the lightning strike and its distance from the camera. If you have time to make a film choice, go with color print film which has wider exposure latitude.

In photojournalistic images, such as this burning building at night, the extremes in brightness make exposure determination difficult. Color print film would be the best choice because of its wide exposure latitude.

Filters and Lens Attachments

Each of us sees colors in a very personal way. We're influenced by surrounding colors and brightness levels, by color temperature (K) and direction of the light, and by the reflection characteristics of the subject. Different types of films also see colors in different ways. Black-and-white films will record colors as gray tones other than we may expect. Color slide films, unless matched to the light source, will produce inaccurate color renditions. By using the appropriate filters, you can control the shades of gray in black-and-white photos and obtain technically correct color balance in your color slides.

You can also use filters to create unusual effects or enhance the mood of a picture. Besides filters, you can use other materials in front of the lens to refract, diffuse, or vignette the light before it reaches the film. The effects on the resulting image can range from subdued soft focus to bursts of multicolored light patterns.

FILTERS FOR COLOR PHOTOGRAPHY

For color pictures, no filter is necessary when you use a film balanced for the light source. Nevertheless, there is one filter that some photographers like to have on hand. This is the skylight (No. 1A) filter. The skylight filter was originally designed to help reduce the bluishness caused by ultraviolet (UV) radiation in daylight scenes. However, modern Kodak color films have built-in UV protection, so the condition is no longer a problem for picture taking. These days, photographers like to use the skylight filter primarily to protect their camera lens from dust, smears, and scratches. (It's much less expensive to replace a damaged skylight filter than an entire lens.) No exposure compensation is necessary with the skylight filter.

CONVERSION FILTERS

When you use a color film with a light source other than the one for which it was designed, you should use a conversion filter over the camera lens. The conversion filter adjusts the color of the light source to match the film's color balance (see the chart on page 227).

The chapel at the U.S. Air Force Academy in Colorado stands out dramatically when the deep blue sky behind it is made even darker with a polarizing filter. Photo by Keith Boas.

In color photography you can use filters to bring lighting and other environmental conditions to realistic terms with the film in your camera. You can also use filters to create dramatic interpretive views, such as the photo here, taken with a split-field amber filter under hazy, uninteresting lighting.

William Utech

A conversion filter adjusts the color of the light source—sunlight for these pictures—to match the color balance of the film. The photos were taken with tungsten color slide film. The one on the right was taken with a No. 85B conversion filter over the camera lens. The picture on the left, taken without a filter, appears too blue.

These pictures were taken on daylight color slide film with 3200K tungsten illumination. A No. 80A conversion filter over the lens was necessary to adjust the color of the light for the daylight balance of the film. The photo on the left, taken without a filter, is too yellow.

226

CONVERSION FILTERS FOR COLOR FILMS

Light Source	Color Print Films and Daylight Color Slide Films	Tungsten Color Slide Films
Daylight	None	No. 85B
Electronic Flash	None	No. 85B
Tungsten 3200 K	No. 80A	None

POLARIZING FILTERS

A polarizing filter or polarizer looks like a simple piece of gray glass. However, you can put this handy screen to work performing such tasks as darkening blue skies and reducing reflections in your pictures.

Reflections. You can use a polarizing filter to reduce or eliminate reflections, except those from bare metal. If you look through a polarizer at reflections on a shiny surface and then rotate the filter, you'll see the reflections change. At one point they may be completely eliminated. The polarizing filter will have the same effect in your pictures when you use it over your camera lens.

When you're looking through the polarizing filter, if reflections from a shiny surface are not reduced enough, try a different viewpoint or camera angle. Sometimes this will make the polarizing filter more effective.

You'll obtain the maximum effect with a polarizing filter in reducing reflections when the camera angle is about 35 degrees from the reflecting surface, depending on the surface material. At other angles the polarizer is less effective. At 90 degrees a polarizing filter has no effect in controlling reflections.

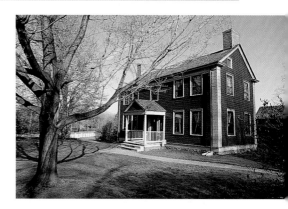

Glare, from daylight reflecting off windows and a painted wall of this historic home, has been eliminated with a polarizing filter. The filter also deepened the blue sky. Stone-Tolan House, Rochester, New York. Photos by Keith Boas.

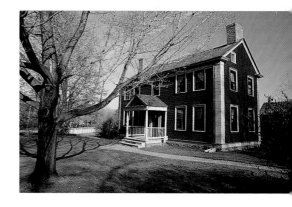

Without a polarizing filter.

With a polarizing filter.

Colors may become more saturated when you use a polarizing filter because reflections are reduced. Photos by Keith Boas.

We mentioned earlier that you can get some great shots with backlighting. But backlighting often creates bright reflections from the sun (or other light sources) on water, foliage, boat decks, etc. You can use a polarizing filter to reduce or eliminate these reflections in your pictures. And since reflections desaturate the colors of a subject, reducing the reflections allows the colors in the photograph to be more saturated.

Dramatic Skies. With a polarizing filter, you can make a blue sky darker in a color photograph without affecting the color rendition of the rest of the scene. When you photograph the sky at right angles to the sun, you can control the depth of the blue, from normal to dark, simply by rotating the polarizing filter. The sky will look darkest when the indicator handle of the filter (if it has one) points at the sun. If your polarizing filter does not have a handle, you can determine the area of the sky that it will darken by forming a right angle with your thumb and index finger. Point your index finger at the sun and as you rotate your hand, your thumb indicates the area in the sky that the polarizing filter can darken. With black-and-white film you can get night effects by using a red filter and a polarizing filter together. The sky effects created by a polarizing filter appear most striking with a very clear blue sky, but disappear completely with an overcast sky.

You can also use a polarizing filter to reduce the appearance of atmospheric haze in distant views.

228

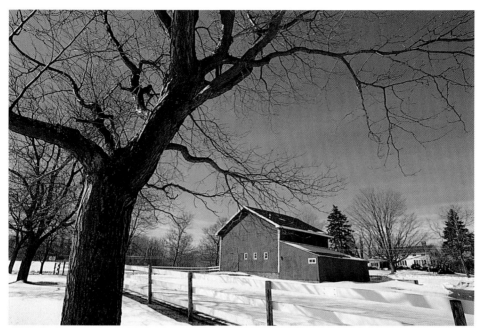

Without a polarizing filter.

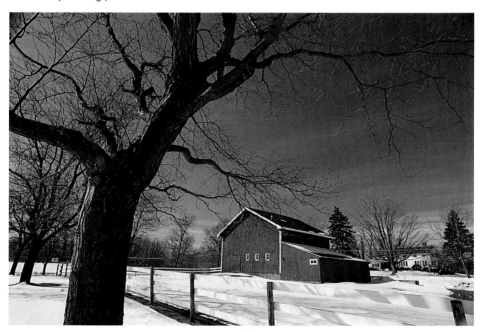

With a polarizing filter.

You can use a polarizing filter to darken a blue sky. You control the degree of darkening by rotating the polarizing filter. Photos by Keith Boas.

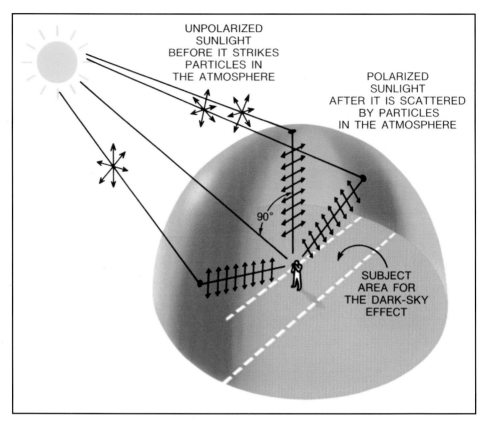

UNPOLARIZED
SUNLIGHT
BEFORE IT STRIKES
PARTICLES IN
THE ATMOSPHERE

POLARIZED
SUNLIGHT
AFTER IT IS SCATTERED
BY PARTICLES
IN THE ATMOSPHERE

90°

SUBJECT
AREA FOR
THE DARK-SKY
EFFECT

This illustration shows the area or band across the sky that will darken when you use a polarizing filter and take pictures standing at a right angle to the sun with the handle of the polarizer—if it has one— pointing at the sun.

Handling. When you use a polarizer on an SLR camera, you can see its effects through the camera viewfinder as you rotate the filter. But remember, if you are using a lens in which the filter ring on the front of the lens barrel turns as you focus, the polarizing filter will also turn and alter the effect if you change focus. Before you take the picture, be sure to check that the filter is in the proper orientation. With non-SLR cameras, hold the polarizing filter and look through it as you rotate it; when you see the effect you want, keep the filter in exactly the same orientation as you slip it over the lens.

Other Applications. A polarizer has another application you may find useful. Since you have to increase exposure with it over the lens (see *Exposure*), you can use a larger lens opening to reduce depth of field, such as when you want the background out of focus to concentrate attention on the subject.

Exposure. When using a polarizer, you must compensate for the light it absorbs. For a normal frontlit subject, increase the exposure by 1-1/2 stops. This increase applies regardless of the rotation of the filter. If your subject is sidelit or toplit, as it will be when you are using the filter to get a dark-sky effect, give it 1/2 stop more exposure, or a total of 2 stops more than the exposure you would use without the polarizer. The extra 1/2 stop usually is not necessary with a distant landscape where shadows are only a tiny part of the scene.

When you determine the exposure for subjects with bright reflections, remember that removing the reflections with a polarizing filter will make your subject appear darker than it was before. So in addition to the 1 1/2 stops more exposure required to compensate for the polarizing filter and any exposure increase necessary for the direction of the lighting, increase the exposure by another 1/2 stop when bright reflections will be removed from the subject.

Calculating the exposure increase to compensate for a polarizing filter on the camera lens is more effective in obtaining correct exposure than using a light meter to make the reading through the filter. A reading made through a filter with a built-in meter or with a separate meter varies with the rotation of the filter. Such a meter reading can indicate the wrong exposure, because the exposure increase required for a polarizing filter is the same regardless of its rotation. For example, when you use a polarizing filter to darken a blue sky, the meter reading would be affected by the darkened sky; however, you really don't want to make the adjustment the meter indicates because you want the sky to be darker than normal.

Also, because of the semi-silvered mirrors used in autofocus (and some autoexposure) cameras, the normal "linear" polarizing filters used for manual-focus cameras can cause problems with the exposure systems and even with autofocusing. With most autofocus cameras, you should use a circular polarizing filter—one that has its crystals arranged in a **circular**, rather than linear, pattern. See which type of filter your manual recommends before buying a polarizing filter.

This photo shows the color and tone rendition of the original scene.

Exposed on black-and-white film without a filter

Exposed through a No. 15 deep-yellow filter

Exposed through a No. 25 red filter

Photos by Keith Boas

Most SLR cameras automatically indicate the correct exposure when reading light passing through a colored filter. Check your camera manual to see if your camera does. A No. 25 red filter was used to darken the blue sky in this photo.

Keith Boas

FILTERS FOR BLACK-AND-WHITE PHOTOGRAPHY

The two basic classes of filters for black-and-white photography are correction filters and contrast filters.

CORRECTION FILTERS

Panchromatic films respond to all the colors that the human eye can see, but they don't reproduce them in the same tonal relationship that the eye sees. For example, although blue and violet normally look darker to the eye than green does, black-and-white panchromatic film is very sensitive to blue and violet. Consequently, these colors will be lighter than green in a black-and white print.

Fortunately, you can easily change the response of the film so that all colors are recorded with approximately the same tonal relationship that the eye sees by using a correction filter over the camera lens. To get this natural tonal relationship with Kodak panchromatic films, use a No. 8 filter in daylight or a No. 11 filter in tungsten light.

CONTRAST FILTERS

A filter lightens its own color in a black-and-white print and darkens the complementary color. For example, a yellow filter lightens yellows and darkens blues.

You can use contrast filters to lighten or darken certain colors in a scene to create brightness differences between colors that would otherwise be reproduced as nearly the same shade of gray. For example, a red apple and green leaves that are equally bright would reproduce as about the same tone of gray in a print. To provide separation between the apple and leaves, you might shoot through a red filter. This would lighten the red apple in a print and darken the green leaves.

DAYLIGHT FILTER RECOMMENDATIONS FOR
KODAK BLACK-AND-WHITE FILMS IN DAYLIGHT

Subject	Effect Desired	Suggested filter	Increase Exposure by This Many Stops for	
			TRI-X and PLUS-X Films	T-MAX 100 T-MAX 400 Professional Films
Blue sky	Natural	No. 8 Yellow	1	2/3
	Darkened	No. 15 Deep Yellow	1-1/3	1
	Spectacular	No. 25 Red	3	3
	Almost black	No. 29 Deep Red	4	4
	Night effect	No. 25 Red, plus polarizing screen	4-1/2	4-1/2
Marine scenes when sky is blue	Natural	No. 8 Yellow	1	2/3
	Water dark	No. 15 Deep Yellow	1-1/3	1
Sunsets	Natural	None or No. 8 Yellow	1	2/3
	Increased brilliance	No. 15 Deep Yellow or No. 25 Red	1-1/3 3	1 3
Distant landscapes	Increased haze effect	No. 47 blue	2 2/3	3
	Very slight addition of haze	None	—	—
	Natural	No. 8 Yellow	1	2/3
	Haze reduction	No. 15 Deep Yellow	1-1/3	1
	Greater haze reduction	No. 25 Red or No. 29 Deep Red	3 4	3
Foliage	Natural	No. 8 Yellow or No. 11 Yellowish-green	1 2	2/3 1-2/3
Outdoor portraits against the sky	Natural	No. 8 Yellow or No. 11 Yellowish-green	1 2	2/3 1-2/3
Architectural stone, wood, sand, snow when sunlit or under blue sky	Natural	No. 8 Yellow	1	2/3
	Enhanced texture rendering	No. 15 Deep Yellow or No. 25 Red	1-1/3 3	1 3

This comparison illustrates the use of a split-field neutral-density (ND) filter. The filter is effective for darkening a bright sky in scenic photos without changing the hue. International Museum of Photography at George Eastman House, Rochester, New York. Photos by Keith Boas.

EXPOSURE COMPENSATION WITH FILTERS

Since colored filters absorb some of the light that would normally reach the film, you must compensate for the light lost by using a larger lens opening or a longer exposure time. This extra exposure, which is different for each type of filter, is based on a filter factor. A filter factor is a number that lets you know how much to increase the exposure when you use that filter.

In practice, however, you probably won't have to concern yourself with filter factors because most cameras with built-in TTL meters will measure the light through a lens-mounted filter. Simply set the speed for the film you are using and put the filter on the lens; the meter will automatically make the adjustment for the light loss.

If you want to use a filter factor, take your meter reading through the lens without the filter (or use a handheld meter), calculate the extra exposure needed, set the adjusted exposure on the camera, and then mount the filter. For example, a filter with a factor of 2 means that you need twice as much light (one *f*-stop more exposure). After you make your meter reading, you can either open the lens by 1 stop or use an exposure time twice as long (the next slower speed). A filter with a factor of 4 means you need 4 times as much light—or 2 stops. (Just remember that each time the filter factor doubles, you have to add another *f*-stop.)

Filters offer the photographer many of the tools that can enrich and improve colors in photographs. A wide selection of enhancing filters offered by the Tiffen Manufacturing Corporation are shown here. These filters are available in a variety of sizes through photo dealers.

USING FILTERS AND LENS ATTACHMENTS FOR CREATIVE PICTURES

There are many dramatic effects you can obtain in your pictures by using filters and other lens attachments creatively. The use of color filters with color film can enhance or change the mood of a picture. You can use an orange or magenta filter to suggest rich, warm sunlight of late afternoon in your color pictures. With a blue filter you can portray the somber, cool effect of twilight or moonlight while the sun is still above the horizon. You can also use filters of other colors depending on the effect you want to create. Just look through the filter for a preview of how the scene will look in the picture.

Determining the exposure is easy when you use filters to give the picture an overall color cast. Since you are altering the appearance of the original scene and orange and blue filters are suggesting early or late times of day, the exposure is not critical. Less exposure, which gives darker pictures, implies dimmer lighting while more exposure, which produces lighter pictures, implies brighter lighting. Usually you can just follow the exposure indicated by a meter reading made through the filter. You may want to bracket your exposures so that you have a choice of brightness in your pictures.

Dark-colored filters block a lot of light. These filters can interfere with the focusing of autofocus cameras. When you use these filters, you must switch to manual focusing.

Most filters produce only 1 color. But variable-color filters are available that let you adjust the intensity of the color from light to dark. Other variable color filters produce either of 2 colors or various shades in between—for example, yellow or red with shades of orange between the two extremes. Once you have a variable-color filter adjusted for the color you want, you can use it just like a conventional color filter.

You can obtain still other filters that are similar to conventional filters except that only half of the filter is colored while the other half is clear. This feature lets you change the color in only part of the scene, such as the sky.

For a fresh approach to your picture taking, you can take advantage of filters and lens attachments and expand your creative experience. This picture was taken with a split-field sepia-tone filter to reduce the brightness in the sky and add an extra blush of color.

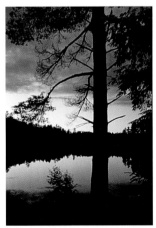

Normal scene—no filter Blue filter Orange filter

You can use filters with color slide film to change the mood of a scene and its overall appearance. Use a blue filter, such as a No. 80A filter, to suggest dawn or dusk. Or use an orange filter, such as a No. 21 filter, to suggest the orange light from the setting sun. The hues of blue and orange filters seem to work best because these colors sometimes naturally appear to a limited extent during periods of dawn or dusk. As a result, scenic pictures with blue or orange tones are somewhat believable. Photos by Keith Boas.

237

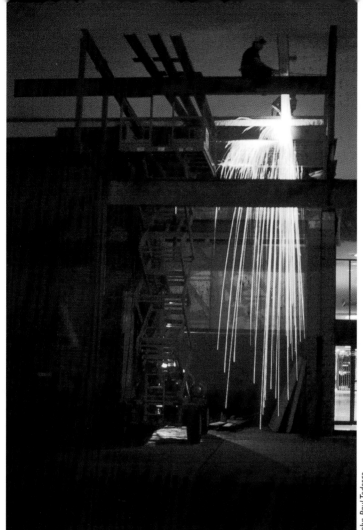

Choose the color of the filter to reinforce the mood of the scene. Here an orange-red filter exaggerates the sunset and the heat implied by the welder's torch.

John Paul Tedesco

For a surrealistic rendition, you can use a No. 25 red filter.

Keith Boas

The use of color filters to alter the normal appearance of the scene is more effective with backlighting, sunsets or sunrises, overcast skies, and misty or foggy days. Here a filter was used to intensify the sunrise. Photo by Aleck Boutselis.

Without a filter.

With a No. 85C filter. No exposure change.

When you want just a slight amount of orange, you can use a No. 85, 85B, or 85C amber filter with daylight color slide film. Photos by Keith Boas.

Keith Boas

You can use a blue (i.e., No. 38A) filter with a backlit scene to create a moonlight effect. Try underexposing by 1 stop to produce the proper mood.

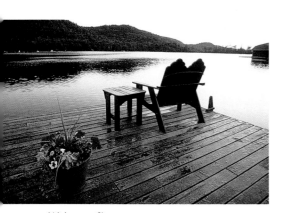

Without a filter.

With a No. 80A filter. No exposure change.

Rather than using color filters, you can use other kinds of filters over your camera lens for a different approach to creative pictures. These filters are constructed with various optical properties that produce effects such as diffusion, pointed-star images, and streaks of light with bands of color in them. It's easy to use these filters because you can see the effects you'll obtain when you view the scene through the filter. When you use the filter over the lens on a single-lens-reflex camera, you can see the effect through the camera viewfinder. With a camera that has a direct optical viewfinder (non-single-lens-reflex), you'll have to view the scene through the filter first before putting it on your camera.

You can intensify the cool tones of twilight by photographing the scene through a pale blue filter. Photos by Keith Boas.

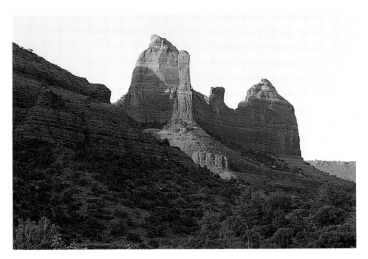

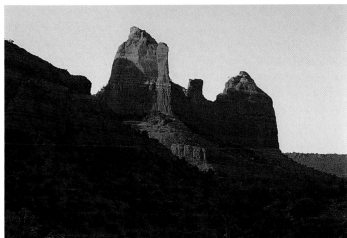

You can alter the
appearance of the
scene through a range
of color intensity with a
variable-color filter. For
this series, the photogra-
pher used a variable
filter which produced
hues of both pale and
saturated magenta.
Photos by Keith Boas.

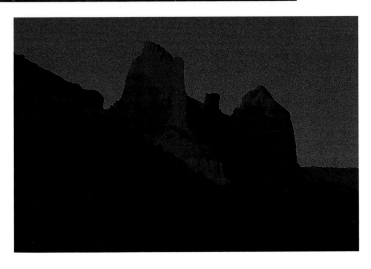

A diffusion filter will give you a soft-focus, diffused image which portrays a subdued, dream-like effect. These filters come in various degrees of diffusion which produce effects ranging from a slight haziness to pronounced diffusion with a misty appearance, soft highlights, and merging colors. Diffusion filters do not usually require any change in exposure unless you want to produce a light, misty, or fog effect with a minimum of dark tones. Then you should try from 1/3 to 1 f-stop more exposure depending on the degree of diffusion in the filter. See the manufacturer's instructions for your filters.

Star-effect filters produce pointed star-like images of light sources and specular reflections that look like points of light in the original scene. These filters create streaks of light that radiate outward from the point of light. You can get 4-, 6-, and 8-pointed stars depending on the construction of the filter. By rotating the filter, you can change the direction of the streaks of light. Usually, no exposure increase is required.

A diffraction filter is another filter you'll find useful for creating pictures that are out of the ordinary. Diffraction filters separate the light from light sources and specular reflections in the picture into a rainbow of colors in exotic patterns. Diffraction filters can form multicolored, linear streaks of light in two, four, or several directions. Other diffraction filters form different multicolor patterns, such as circular ones. These filters are easy to use, because you can see the optical effect when you look through the viewfinder of a single-lens-reflex camera with the filter over the lens. With non-reflex cameras, look at the scene through the filter while rotating the filter. When you see the effect you want, keep the filter oriented in that position as you put it on your camera. No exposure increase is required with diffraction filters.

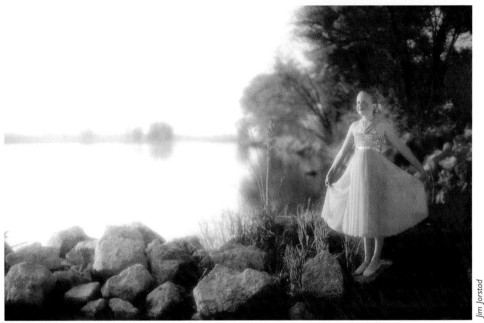

Jim Jorstad

Keith Boas

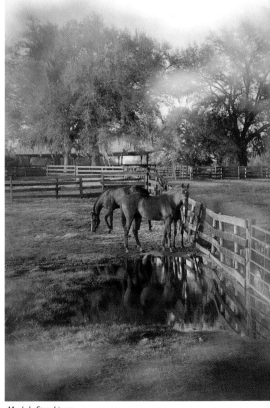

A diffusion filter softens tones and gives scenes a dream-like quality. Diffusion is effective with all kinds of subjects—portraits, scenics, and close-ups. In portraiture, diffusion smoothes and flatters complexions. The amount of diffusion varies depending on the construction of the filter.

Mark L. Straubinger

243

You can use a star-effect filter to create rays from the setting sun, which can make a sunset picture even more appealing.

Neil Montanus

A star-effect filter is particularly effective for outdoor night scenes. Usually no exposure increase is required with this filter.

With star-effect filter

Michael Fuller

A star-effect filter can also create star-ray images from specular reflections in the scene.

Steve Kelly

With star-effect and diffusion filters

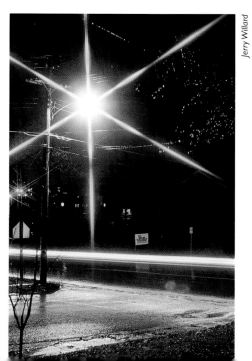

Jerry Willard

A star-effect filter creates star-like images of point-light sources.

For a different avenue to exciting and spectacular pictures, experiment with multi-image lenses. These lenses with multifaceted surfaces fit on the front of your camera lens. The facets produce multi-images of the scene, repeated in a straight row or arranged in a circular pattern. The number of images transmitted to your film may be 3, 5, or 6. These variations in pattern and number of images produced depend on the construction of the multi-image lens. You can rotate these lenses to obtain the most pleasing arrangement of the images in the picture. Since details surrounding the subject are also repeated, multi-image lenses work best with subjects against plain backgrounds like the sky, water, or a dark background with little detail.

Also, if you are using an autofocus camera, keep in mind that since multiple-image or other optical-distortion filters distort the light entering the lens, they will probably interfere with the ability of the camera to focus correctly. Therefore, you may find that both the camera and the visual effect are more easily controlled if you switch to manual focusing.

Creative uses of filters and lens attachments to make intriguing pictures are limited only by your imagination. When you take creative pictures, there are no definite rules. Anything you find pleasing can be a rewarding picture. For more complete information on the availability of filters, contact a filter manufacturer such as Tiffen, or explore the selection of filters available at a local camera store.

If you want to learn more about the subject, pick up a copy of the KODAK Workshop Series book, *Using Filters* (ISBN 0-87985-751-X).

Keith Boas

A multi-image lens repeats the image of the scene in a circular or straight-line pattern. The design of the lens determines the shape of the pattern.

Neil Montanus

To avoid confusing clutter, use a subject with a plain background.

Keith Boas

247

Close-Up Photography

Many 35mm cameras will focus on subjects as close as 1-1/2 to 2 feet without any special equipment. Although this is close enough for most subjects, you can find a whole new world of fascinating and unusual picture opportunities at closer distances. With close-up equipment, you can take compelling photos of flowers, bonsai, insects, coins, stamps, scale models, and more. You can take tabletop pictures of craft projects, floral still lifes, and copies of artwork or documents. The world of close-up photography is limited only by your imagination.

CLOSE-UP LENSES

You can get into the close-up league with any 35mm camera simply by using close-up lenses. These are positive supplementary lenses that let you take sharp pictures at distances closer than those at which your lens would normally focus. Close-up lenses fit over your camera lens like a filter. They're available in various powers such as +1, +2, and +3. Each close-up lens is good for a limited range of close-up distances. The higher the number, the stronger the close-up lens and the closer

you can get to your subject. The instructions that come with the lenses tell you what your subject distances should be at various focus settings and what area you'll be photographing at those distances.

You can use two close-up lenses together to get even closer to your subject. For example, a +2 lens and a +3 lens equals a +5 lens. Always use the stronger close-up lens next to the camera lens. Never use more than two close-up lenses together as this may affect the sharpness of your picture.

No exposure compensation is necessary with close-up lenses. Just expose as you would if you were photographing the same subject without a close-up lens.

An easy way to get into close-up photography is to use close-up lenses. You can use them with both rangefinder and single-lens-reflex cameras. Close-up lenses fit on the front of the camera lens in the same way as a filter. Photo by Louise A. Ritchie.

The world of close-up photography lets you isolate and enhance the beauty, color, and shape of small subjects. Still life—roses in carbonated water. Photo by Carole L. Hagaman.

When pictured close up with a shallow depth of field, tiny objects of nature can be portrayed in artistic, innovative ways. Crocuses silhouetted against the rising sun.

Barbara Widger

A close-focusing camera lens lets you take close-up pictures without using close-up lenses or lens-extension devices. Close-focusing lenses focus at shorter camera-to-subject distances than normal lenses.

Roscoe Dabney

CLOSE-FOCUSING LENSES

Some lenses, called macro or micro lenses, are designed for close-up photography. They let you focus at distances as close as 4 or 5 inches from the subject and obtain life-size images on your film without using a supplementary close-up lens. Macro lenses typically come in focal lengths of 50mm and 100mm. The longer focal length allows you to focus on small subjects from farther away—you don't have to get right on top of your subject, where you might block existing light or frighten it if it's an animal. Macro lenses are convenient because you can use them for close-ups one moment and for distant subjects the next without special attachments.

Most manufacturers of autofocusing SLR cameras also make at least one auto-focusing macro lens. Some compact auto-focus cameras have a close-up switch that allows you to work at closer distance than the normal close-focusing distance.

Autofocus cameras are an ideal tool for close-up work because they let you choose your point of focus very precisely. Simply center the area that you want in sharp focus in the viewfinder and then use your focus lock to hold that focus. If you work in the single-shot autofocus mode, you'll always be guaranteed a sharp image, since in this mode most autofocus cameras won't allow you to trip the shutter unless the image is sharp.

A zoom lens that includes a telephoto range usually has a "macro" setting that allows you to take close-ups as well. With most of these zooms, the macro range functions at the telephoto end of the zoom, which means you can be fairly far away from your subject and still get a close-up image.

Because of the added lens extension required for close-up focusing, macro lenses may require an exposure increase at close subject distances. If you use a macro lens on a camera with a through-the-lens meter, the meter will make the exposure compensation automatically. But if you are using a handheld meter or working with a manual flash unit, you will have to make the exposure compensation yourself.

LENS-EXTENSION DEVICES

Another method of taking close-up pictures involves extension tubes or a bellows. Such a device fits between the lens and the camera body to let you make sharp pictures at close distances. Because an extension device sits between the lens and the camera body, you can use it only on a camera that accepts interchangeable lenses, which includes most SLR cameras.

Since the tubes or a bellows moves the lens farther from the film than it would be for normal picture taking, you must compensate for the light loss by using a larger lens opening or a slower shutter speed. Cameras with built-in meters do this automatically.

If you have a camera that lacks a built-in meter, you can use the table to determine how much to increase the exposure. To use the table:

1. Measure the field size—long dimension for 35mm—at the subject distance you've focused upon.

2. Increase the lens opening by the amount shown, or

3. If you want to keep the lens opening constant, multiply the exposure time by the amount shown.

EXPOSURE INCREASE FOR EXTENDED LENS—35MM CAMERAS WITH LENS OF ANY FOCAL LENGTH

Field Size Long Dimension (inches)	11	5-1/8	3-1/4	2-1/4	2	1-3/4	1-3/8	1
Open Lens by (f-stops)	1/3	2/3	1	1-1/3	1-1/2	1-2/3	2	2-1/2
Or Multiply Exposure Time by	1.3	1.6	2	2.5	2.8	3.2	4	5.7

The requirements for a steady camera for sharp close-up photography are similar to those for telephoto lenses. Since the image is magnified in close-ups, so is any unsharpness caused by an unsteady camera. You should use a shutter speed of at least 1/125 second or faster for sharp pictures with a hand-held camera. A fast shutter speed is also beneficial for stopping subject motion such as life subjects or plants disturbed by a breeze.

Adam J. Cogan

DEPTH OF FIELD IN CLOSE-UPS

No matter what method you use to make your close-up pictures, you'll find that depth of field is very shallow. Since small lens openings increase depth of field, it's a good idea to use the smallest lens opening that the lighting conditions will allow. For optical as well as depth-of-field considerations, it's wise not to use lens openings larger than $f/8$ with +1, +2, and +3 close-up lenses, or larger than $f/11$ with more powerful lenses. You can compute depth of field for +1, +2, and +3 close-up lenses with the Depth-of-Field Computer in the KODAK Pocket Photoguide.

Programmed-exposure cameras that have depth-of-field modes are useful in close-up work since they will automatically give preference to small apertures. Similarly, auto-exposure cameras with an aperture-priority mode allow you to pick a small aperture to increase depth of field in close-ups.

Marina De Dipp

Depth of field is very limited in close-up photography. Even with a small aperture such f/16, depth of field will seldom exceed a few inches and for extreme close-ups may be less than an inch. By positioning the camera so its back is parallel to the subject, you can align the plane of focus to the subject plane, thereby making the whole subject sharp.

252

Angel Del Gado Hipolito

There are many varied subjects that make good close-up pictures. Learn to look at small segments of the overall scene for storytelling objects and eye-catching compositions. All of the pictures on this page were taken outdoors under natural-lighting conditions.

Byron C. Tinkey

Keith Boas

Keith Boas

253

LIGHTING FOR CLOSE-UPS OUTDOORS

For most of your outdoor close-ups, you'll probably use the natural lighting on the subject. If part of your subject is in sunlight and part in shadow, you can use a reflector, such as crumpled aluminum foil or white cardboard, to reflect the sunlight into the shadow areas.

Backlighting and sidelighting can be quite effective for making close-ups of subjects such as flowers and foliage. These types of lighting bring out the texture and emphasize the translucency and delicate qualities of such subjects.

Many advanced photographers like to use flash for their outdoor close-ups. Flash close to the subject allows you to use small lens openings to get the depth of field you need for close-ups. When using flash, it's a good idea to use the fastest sync speed available on your camera. Using a combination of a fast shutter speed and small lens opening with flash lets the background go very dark because there is so little exposure from the daylight. You can use this technique to tone down a distracting background or to make a bright, colorful subject stand out against a dark background. Shooting at fast shutter speeds also minimizes subject movement, such as the swaying of flowers on a windy day.

When you make extreme close-ups with flash, it simplifies exposure calculation if you can use your flash off the camera, always at the same distance from the subject. Then, regardless of your subject

Keith Boas

Direct sunlight is not always the best illumination for close-ups outdoors. The diffused illumination of an overcast day eliminates the often-distracting presence of deep shadows.

distance, your basic flash exposure with a specific film/flash combination will always be the same. Keep in mind, however, that a dark subject, such as a black woolly caterpillar, requires more exposure than a light subject, like a white moth.

If you can't use an extension flash to move the flash farther away from the subject, don't use regular guide numbers to calculate exposure for close-ups. The inverse-square law, on which guide numbers are based, doesn't work when you use flash at extreme close-up distances. You

LENS OPENINGS FOR CLOSE-UPS WITH FLASH

Electronic Flash with One Layer of Handkerchief		Lens Opening for ISO-100 Color Print Films*	
		Subject Distance 10—20 inches	Subject Distance 30 inches
For manual units	700—1000 BCPS	*f*/11	*f*/8
and automatic units	1400—2000 BCPS	*f*/16	*f*/11
set on manual	2800—4000 BCPS	*f*/22	*f*/16
	5600—8000 BCPS	*f*/22 with two layers of handkerchief	*f*/22

* For very light subjects, use 1 stop less exposure or place two layers of handkerchief over the flash.

For color slide film, set the lens opening 1 stop smaller or add an extra layer of handkerchief.

can use the table here as a guide in determining exposure. Or you may want to run your own exposure tests to determine the best exposure setting for your film and flash combination at various subject distances. Make exposures at half-stop increments from *f*/8 to *f*/22. Use one layer of white handkerchief over the flash to diffuse the light and to reduce its intensity. Keep a record of your exposures so that you can determine which lens opening produced the best exposure. Use that lens opening for any close-up pictures taken from the same subject distance.

If you are using an automatic electronic flash for close-up pictures, you may be able to let it determine the exposure automatically, or you may have to set it on manual, depending on the flash-to-subject distance. See your flash instruction manual. To use the flash unit on automatic, it may help to cover the flash reflector with one layer of handkerchief, but make sure that the handkerchief does not cover the light-sensitive cell in the flash unit. Take some trial pictures to see if your automatic electronic flash will produce good exposure for close-ups. If the trial pictures are too light—overexposed—use a smaller lens opening; if they are too dark—underexposed—use a larger lens opening.

Keith Boas

Jessica C. Thompson

Light not only reflects off objects, it can—with some subjects—transmit and illuminate from within. Here strong backlighting gave a glow to these slender blades of grass.

Viewpoint is also important. Here the photographer chose a low camera angle to capture the blue sky behind the zinnia. A small f-stop for a shallow depth of field softened the other background elements into blurs of harmonizing tones and colors.

Rainy days are great for photography, especially if you want to capture a feeling of freshness and life in your flower pictures. In this scene, the rain added richness to the green, brown, and yellow hues.

Keith Boas

Another way to use automatic flash effectively, even at very close distances, is to bounce the flash onto a white card held above the subject. This diffuses the light to create softer illumination. Some flash manufacturers sell bounce-card brackets for this purpose. Exposure will remain automatic provided the flash sensor is pointing at the subject.

Dedicated flash/camera combinations that measure the light through the lens or off the film plane are the ideal source for close-up flash. Dedicated flash will provide accurate exposure regardless of what type of close-up device you are using, and regardless of whether you are using the flash on- or off-camera.

When shooting at close distances, you may need to diffuse the light from your flash unit in some way so your subject is not overexposed. Bouncing the light off of a white card can be an effective way to reduce the flash output.

LIGHTING FOR CLOSE-UPS INDOORS

Although your outdoor close-up pictures might be of moving subjects, such as butterflies or buttercups swaying in the breeze, chances are that indoors you will be photographing tabletop/still-life objects such as coins, model cars, glassware, floral arrangements, or wood carvings. Since you don't need to be concerned with stopping action with this type of subject, short exposure times and bright flash aren't necessary. Consequently, you can use floodlights, photolamps, or just the lighting already existing in the room.

If you're using color slide film balanced for tungsten illumination, use 3200 K tungsten lamps to get accurate color balance.

With color print films and daylight color slide films, you can use 3200 K tungsten lamps and a No. 80A conversion filter. When you want to take black-and-white pictures, you can use any light source with no filter.

Robert E. Willis, Jr.

Photolamps are convenient to use for indoor close-up subjects because you can see the lighting effects before you release the shutter. Another benefit is that you can use your light meter to determine the exposure.

When you want to emphasize the contours and shape of a subject, you can photograph the subject against a relatively dark background and rim-light it by placing lights slightly behind the subject. When you do this, make sure the camera lens is shielded from the direct light of the lamps. You can emphasize surface textures by skimming the light across the surface of the subject.

Diffused, overhead lighting often works best for natural-looking indoor close-up photos.

Wingtat Yu

Use the standard two-light copying setup to create titles for slide programs. This subject was an inkjet print from a digital file created on a personal computer using a basic graphics software program.

Keith Boas

The lighting setup in the accompanying illustration was used to make this copy of a painting. For even lighting, be sure that both lights are the same brightness and are at the same distance from the subject. Place lights at 45-degree angles to avoid reflections from the surface of the subject. Original oil painting by Michael Boas.

Use a copystand to photograph flat objects such as stamps, coins, or paintings.

EXPOSURES FOR CLOSE-UPS USING A REFLECTED-LIGHT METER

When you make a reflected-light meter reading of a small subject, the meter reading may be influenced by a bright or dark background. That's because the meter assumes all subjects have tones that average a medium gray. So if the subject you're photographing is much lighter or darker than a medium gray, you may need to correct the meter's recommendation to get a properly exposed picture. One way to calculate proper exposure is to take a meter reading of the light reflecting off a KODAK Gray Card*, which has the same medium gray tone as a scene with average brightness. Place or hold the gray card as close to your subject as possible with the gray side facing the camera. Make sure the card is receiving the same angle and intensity of illumination as the subject. Hold your meter, or camera with built-in meter, about 6 to 12 inches away, and measure the light reflecting off the card. Be careful not to cast a shadow on the card.

When taking color slides, if your subject is very dark, **increase** your calculated exposure by 1/2 to 1 *f*-stop. If your subject is very light, **decrease** your calculated exposure by 1/2 to 1 stop.

Or you can use an incident-light meter to make a reading from the subject position.

You can purchase a KODAK Gray Card from your photo dealer.

Keith Boas

This indoor close-up photo was taken in the existing lighting of a kitchen. Most of the lighting was daylight from a large bay window to the left of the subject. A little extra light from a nearby tungsten chandelier gave gentle radiance to the copper surfaces.

This keepsake of Native American pottery was photographed outdoors in the shade. A scrap piece of aging canvas, draped over a chair, formed the background.

To emphasize textures and warm the scene, the photographer placed a gold-surfaced reflector on the right to bounce a bit of sunlight into the scene. Photos by Keith Boas.

Keith Boas

A patch collection can make a colorful and storytelling subject for a close-up picture. You can take a photo like this one in bright sun outdoors or with a standard copy-light setup indoors. Since the mixture of tones in this scene equal average brightness, a reflected-light meter reading would give you a normally exposed picture.

Christy Hobaugh

In this instance, a close-up reflected-light meter reading would be affected by the black subject. To get a properly exposed picture, you should increase exposure by at least 1 f-stop. Technically, the use of a gray card to calculate exposure would be appropriate; however, you'd probably miss this fleeting photo opportunity.

Norm Kerr

To achieve this soft natural daylight effect, you can use diffused flash (soft-box lighting) positioned high and slightly behind the props.

Linda M. Heim

Simplicity, color, design, and lighting—each enhancing the other in this beautiful close-up photo, taken by natural daylight indoors. The exposure was made on 100-speed daylight color slide film.

CHAPTER 12

Digital Imaging

One of the most important aspects of contemporary photography is the impact that digital imaging is having on 35mm camera photographers. The simple truth is that while you can capture images using a digital camera, digital images can originate from many different sources, including the pictures you take with your 35mm camera or your existing collection of slides, negatives, and prints. In this chapter, you'll learn how 35mm film can become part of digital imaging's three major processes: acquisition, manipulation, and output.

IMAGE ACQUISITION

For 35mm camera users, acquisition can be defined as the process of turning existing silver-based photos into digital images. Users can then manipulate these images on a computer or e-mail them anywhere on the planet. Before learning how to convert photos into digital form, you'll need to add a few new words to your photo-imaging vocabulary.

FROM PIX TO PIXELS

A digital image's resolution refers to how sharp (or clear) an image looks on a computer monitor or when it's printed using a desktop printer. There are two critical components that affect the resolution of a digital image: bits and pixels.

Let's start with bits. A bit is the smallest unit of information a computer can process. Computers are called digital devices because they represent all data, including photos, using digits. For images that appear on a computer monitor, these digits are measured in bits. Each electronic signal traveling through your computer is one bit, but to symbolize more complex numbers or images, computers combine these signals into 8-bit groups called bytes. 1,024 bytes make up a kilobyte (KB). When you combine 1,024 kilobytes, you get one megabyte (MB).

Digital imaging has expanded photography in new and creative directions. Turn your favorite snapshot into a masterpiece with just a few clicks of the mouse. This image was created from the photograph by Angelica Alba Gomez on page 92.

Resolution is sometimes referred to as color depth, because it's measured by the number of bits of information an image stores and determines how many colors can be displayed at once. Digital images can be created at many different color depths, from 8-, 16-, 24-bit color depth, and even higher. These terms will be familiar to video game players who recognize that 16-bit video games have more detailed graphics than 8-bit games. The same is true for digital images: The higher the number of bits, the more colors and color shadings you'll be able to see. For example, an 8-bit image can show 256 different colors, while a 16-bit image increases the number of possible colors to 64,000. 24-bit digital images can be called truly photographic and display more than 16 million different colors.

While a 35mm slide is measured by dimensions such as 24 x 36mm and a print by dimensions such as 3 x 5 or 4 x 6 inches, digital images are measured by width and height in pixels, which is short for "picture element." If you look closely at a photo on a computer screen, you see the digital equivalent of film grain. These are pixels. On the screen, combinations of pixels produce all of the colors you see. Pixels appear in clusters or triads. A triad is a combination of three colored dots (red, green, and blue) placed close together. In a typical monitor, three electronic "guns" fire three separate signals (one for each color) at the screen. If all three guns hit a single pixel's location, it will appear white on the screen. If none of the guns hit a target pixel, it will be black. Your computer also controls the location and color of each pixel.

Images can be digitized (turned into pixels) at various sizes. For example, a 2048 x 3072 image has more pixels than the same image digitized at 128 x 192 pixels. At these smaller sizes, images have a grainy appearance. Much like in conventional photography, the more pixels an image has, the better its visual quality will be.

Besides size, photos can be digitized at different resolutions. The resolution of most digitizing devices, such as scanners, are rated not in pixels but by dots per inch (dpi). If an image has a resolution of 300 dpi, it means that there are 300 dots across and 300 dots down. The tighter this cluster of dots is, the smaller the size of the dot becomes. The higher the number of dots, the finer the resolution and the more photographic the image will appear.

DIGITIZING YOUR PRINTS

While there are several methods that can be used to acquire digital images, scanners may be the most practical because they allow you to create computer-ready images using the same cameras and film you already own. What's more, scanners can be used to digitize all of the images in your existing photographic library of images. Not too long ago, scanners were so expensive that only large ad agencies, service bureaus, and printers could afford them. Now scanners are available in a wide range of prices that can fit everyone from casual snapshooter to professional photographer.

Scanners convert photographic images into digital form by passing a light-emitting element across the original photograph, transforming its analog form into a

collection of pixels that can be stored as a digital file. The first scanning devices, which were used in the publishing industry, were called drum scanners. This type of scanner focuses a light source onto an original transparency mounted on a rotating drum. That light is directed onto mirrors and then through red, green, and blue filters that act as optical amplifiers.

The more commonly available scanners use a lens to produce a digital image. Located behind that lens is an image sensor, usually a charge-coupled device (CCD), which converts light reflected off the print image into an electrical signal. As in a drum scanner, analog signals are converted into digital form.

Scanners can be evaluated by their color depth, resolution, and dynamic range specifications. As mentioned before, color depth refers to the number of bits assigned to each pixel in the scan. Popularly priced color scanners have color depths ranging from 24- to 36-bit color depth, with professional-quality models providing even higher color depths. A 30-bit color depth, for example, assigns 10 bits for each red, blue, or green pixel. The more bits you have for each color, the more photo-realistic the final, scanned image will be.

A scanner's resolution is determined by the maximum number of dots or pixels per inch that it can read. It's often specified by both optical as well as interpolated resolution, referred to as enhanced resolution. The optical resolution of a scanner is the raw resolution that is inherently produced by the scanner's hardware. When the resolution requested by the user exceeds the optical resolution, software interpolates the data and, by using algorithms, fills in the spaces between existing pixels. This does not mean that using interpolated resolutions for your scans is bad—far from it. Enlarging an image to twice the optical resolution would show no noticeable change in quality.

Some manufacturers refer to dynamic range as dMax, much like film, and there are similarities in how it's measured practically. (In photographic terms, dMin is the brightest possible level and dMax represents the darkest possible level for the same image.) Dynamic range can liberally be interpreted as the range of *f*-stops that can be captured from a print or slide and is rated on a narrow scale from 0.0 (pure white) up to 4.0 (pure black).

Scanners. Scanners that can be used to digitize your prints are available in three types, with some variations on those themes: flatbed, handheld, and snapshot.

Flatbed scanners look like small copy machines and work similarly. They use a CCD array consisting of several thousand elements arranged in a row on a single chip to digitize images. When a scanner's light source passes over a print, the CCDs

Some flatbed scanners, such as the Agfa SnapScan 1212U model, have 36-bit color depth and can scan at 600 x 1200 dpi.

interpret the color and intensity of the reflected light and convert the data into a digital signal. Depending on design, flatbeds make one or three passes across an original photograph lying on a flat piece of glass. Grayscale-only scanners read this light once, while color scanners take three readings-one each for red, green, and blue (RGB). Three-pass color scanners typically use a single linear array and rotate an RGB color wheel in front of a lens before each of the three passes are made. A single-pass color scanner uses three linear arrays, which are individually coated to filter red, green, and blue light. The same image data is focused onto each array simultaneously.

Handheld scanners, such as this ScanMan Color Scanner from Logitech, provide an inexpensive way to digitize prints-especially snapshot-size images.

Handheld scanners let you do all of the work of digitizing an image by letting you physically roll the scanning element across the face of an original print. Handheld scanners have the advantage of being inexpensive but the disadvantage of being limited by the width of the scanner's head. Some handheld scanners include software that allows you to stitch separate scans together. How well this process works depends on the steadiness of your scan and the software itself. Handheld scanners used to be the most plentiful type of scanner available, but as the price of desktop scanners dropped, the number of handheld scanner models available has greatly decreased. As this trend continues, the category may disappear, to be replaced by the snapshot scanner.

Snapshot scanners are a variation of document scanners, which use a sheetfed approach to scan letters and forms for optical character recognition (OCR) pur-

poses. This newest class of scanner combines elements of both sheetfed and handheld scanners to produce a compact desktop device specifically designed to scan snapshot-size photos. To make a scan, you simply insert the print and press a button.

Since the types of scanners available can be bewildering to the new digital imager, the biggest problem may be deciding which one is right for your needs. Shopping for a scanner is a matter of setting your goals for the type of images you will be starting with and what form your output will take. First ask yourself what the maximum size of your original images is. This tells you how big the scanning area must be. Next ask what the resolution of the output will be. If you are printing your images on a 720 dpi inkjet printer, you don't need a scanner that will produce a digitized image at 2700 dpi. If you do, the printer will merely discard the unused information.

Image File Formats. When your image has been digitized, you will need to save it in an image file format that can be used for manipulation and output. There are several popular formats in widespread use. Here's an overview of the most popular ones in alphabetical order:

BMP. The term "bitmap" refers to any graphic image that is composed of a collection of individual pixels-one for every point or dot on a computer screen. Often pronounced "bump," this acronym is a file extension for a specific kind of Windows-based graphics file.

FlashPix. This format represents bitmapped photos, image-broken into manageable pieces. FlashPix technology increases the amount of color information available to improve color quality output of a large variety of printers and maximizes the resources available on more modest computers. For more information, visit www.flashpix.com on the Web.

GIF. The Graphics Interchange Format (pronounced "jif") was originally developed by CompuServe Information Services and is completely platform-independent. The same bitmapped file created on a Macintosh computer is readable by a Windows graphics program. A GIF file is automatically compressed and, consequently, takes up less space on your hard disk.

JPEG. Joint Photographic Experts Group is designed to be a universal format, since files can be read on both Windows and Macintosh OS computers. JPEG uses technology that compresses images so that they can be stored in less space. This allows more images to be stored on devices lacking ample storage space, such as floppy disks.

PCX. This is a bitmapped file format originally developed for the popular program PC Paintbrush. Most popular Windows graphics programs read and write PCX files. (The letters don't stand for anything specific.)

PSD. Adobe Photoshop image-editing software (PSD) has its own proprietary file format.

PICT. This file format can contain bitmapped or vector information. Vector images save data as points, lines, and mathematical formulas. (PICT is an acronym with no strict definition.)

TARGA. TrueVision Advanced Raster Graphics Adapter, a bitmapped graphics file format developed by TrueVision, Inc. for its original line of PC-based video graphics boards used for high-resolution digital imaging. TARGA files handle 16-, 24-, and 32-bit color information.

TIFF. Tagged Image File Format is a bitmapped file format developed by Microsoft and Aldus. A TIFF file can be any resolution in black and white or color. TIFFs are supposed to be platform-independent files, so a Windows graphics program can (almost) always read files created on a Macintosh computer.

If you would like to know more about image file formats and digital imaging acronyms in general, pick up a copy of *The Digital Imaging Dictionary* by Joe Farace.

DIGITIZING FILM

There are many tools and techniques that you can use to turn your silver-based film into digital form. There are digitizing services from Kodak. Or to do it yourself, you'll need a film scanner.

KODAK Picture Disk. The KODAK Picture Disk gives you an economical way to digitize images from 35mm film. To get your images delivered on Picture Disk, just check the box for "KODAK Picture Disk" when bringing your film in for processing. After processing, you'll get prints, negatives, and a floppy disk containing your pictures stored as digital images at 400 x 600 pixels.

The image files stored on a Picture Disk are created using industry-standard JPEG compression. Each picture contains 24 bits of color information, and the pictures are 720 KB when uncompressed. Image files vary in size depending on the number of pictures stored on the disk. All of the pictures use about 900 KB of disk

The KODAK Picture Disk provides digitized images from your film, along with Microsoft Windows-based software that can be used to enhance them.

space, and each picture gets roughly the same amount of that space. The more pictures you have on the disk, the smaller each picture will be; conversely, the fewer pictures you have on the disk, the larger or less compressed each will be.

KODAK Picture Disk Plus contains digital images that are higher resolution, with a maximum size of 1024 x 1536 pixels. As a result, you typically receive only one picture per Picture Disk Plus instead of up to 28 pictures. This higher resolution gives better results when making large prints or when editing your pictures in your computer. With Picture Disk Plus, you can request pictures in one of two file formats: JPEG or FlashPix. Additional Picture Disk software (See "Software to Go" later in the chapter) is not supplied on the Picture Disk Plus. Viewer software for pictures in JPEG format is available on the Internet from Kodak's Web site at *www.kodak.com/global/en/consumer/ consDigital/pictureDisk/download.shtml.* Viewer software for pictures in FlashPix format is available from the PictureWorks Media Center Web site at *www.picture-works.com/download.*

Since KODAK Picture Disk images are stored in the JPEG format, you can use Picture Disk as an image source for most Mac OS software programs, as long as your operating system is 7.0 or later. These later versions include Apple's PC Exchange software that allows Macintosh computers to read PC-formatted disks.

KODAK Picture Disks are available in the United States through retail locations that offer KODAK Premium Processing Services.

KODAK PHOTO CD Process. The KODAK PHOTO CD Process has been around for some time. One of its best features is that someone else does all the work of "acquiring" the images from your 35mm slides and negatives. To make your own PHOTO CD disc, take your exposed, unprocessed film to a photofinisher that offers the service of turning your analog film images into digitized images. If you take in exposed slide film, you'll receive a box of slides along with a PHOTO CD disc containing all the images on the film. If you shoot print film, you'll get a stack of prints along with the disc. Facilities that process PHOTO CD discs can also digitize images from existing color slides and black-and-white or color negatives.

To produce a finished disc, a PHOTO CD Transfer Station converts your analog images into digital form using a high-resolution film scanner (more about film scanners later), a computer, image-processing software, a disc writer, and a color thermal printer. Each image is pre-scanned and displayed on the monitor. The operator checks the orientation (portrait or landscape) of the image and begins a final, high-resolution scan. The digital image is adjusted for color and density and then written to the CD. A thermal printer creates an index sheet showing the images transferred to disc, which is inserted into the cover of the CD's jewel case.

Originally there were six different kinds of Photo CD discs, but now a more flexible strategy has simplified the number of kinds of discs into two: the PHOTO CD disc and Pro PHOTO CD disc.

The PHOTO CD disc format is specifically designed for 35mm film; each disc can hold 100 images. The image files use KODAK Image Pac format, which contains five different scans at five different resolutions. This is often referred to as a five-res scan. On a PHOTO CD disc, you will find images in the following resolutions:

Base/16 - 128 x 192 pixels
Base/4 -256 x 348 pixels
Base - 512 x 768 pixels
Base*4 - 1024 x 1536 pixels
Base*16 - 2048 x 3072 pixels

The Pro PHOTO CD Disc was originally designed for professionals, but anyone, whether amateur or professional, can use it. Besides 35mm, these discs accept images from 120 and 70mm rolls as well as 4 x 5-inch sheet film. Discs include the same five-res scans included in the standard PHOTO CD disc and offer an optional sixth, Base*64 resolution image, that produces a size of 4096 x 6144 pixels.

KODAK PHOTO CD Acquire Module. The KODAK PHOTO CD Acquire Module software allows image-manipulation programs to open images from PHOTO CD discs. Since most image-editing programs, such as Adobe Photoshop, are already compatible with the KODAK PHOTO CD file format, you may wonder why you would need another way to open this type of image file. The answer depends on how you plan to use the images on your PHOTO CD discs. If you plan on just opening a PHOTO CD file and working on it inside your image-editing application, you should use the program's standard Open command.

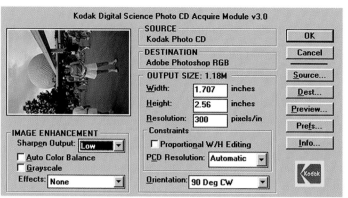

Kodak Digital Science Photo CD Acquire Module v3.0

SOURCE
Kodak Photo CD

DESTINATION
Adobe Photoshop RGB

OUTPUT SIZE: 1.18M
Width: 1.707 inches
Height: 2.56 inches
Resolution: 300 pixels/in

Constraints
☐ Proportional W/H Editing
PCD Resolution: Automatic

IMAGE ENHANCEMENT
Sharpen Output: Low
☐ Auto Color Balance
☐ Grayscale
Effects: None

Orientation: 90 Deg CW

OK
Cancel
Source...
Dest...
Preview...
Prefs...
Info...

The KODAK PHOTO CD Acquire Module offers options including changing color mode, sharpening, and cropping.

Joe Farace

The advantage of using PHOTO CD Acquire Module software to open a PHOTO CD file is that it lets you manipulate an image before it's opened. For example, you can save time by converting an image to black and white, cropping, and sharpening it — all before the image is actually opened.

The PHOTO CD Acquire Module dialog box also allows you to change the image's color mode. If the image is in color but you need it in black and white, you can open it that way. You can also use the controls to change the photo's size and do some image cropping.

PHOTO CD Acquire Module software is available free for both Windows and Macintosh OS-based computers; you can download the latest version from *www.kodak.com*.

KODAK Picture CD. Much as PHOTO CD discs and Pro PHOTO CD discs might be the choice of experienced users, the Picture CD can be considered an entry-level approach. Images from any standard 35mm or Advanced Photo System film can be stored as high-resolution digitized

images. KODAK Picture CD is an all-in-one, autoloading CD-ROM disc for storing, enhancing, sharing, and printing pictures using your computer.

Each Picture CD typically holds one roll of film. Ordering is as simple as checking a box on the film-processing envelope provided by your photofinisher. After the film is processed, you receive your prints and a Picture CD, with an index print in the CD's sleeve, all in the same envelope.

Unlike a PHOTO CD disc, the Picture CD includes image-manipulation software on the same CD-ROM disc as the images.

Consumers who don't own a computer also can enjoy the benefits of the Picture CD. KODAK Picture Maker units, installed at many photo retailers, are now compatible with the KODAK Picture CD. Consumers can use the kiosks to perform many of the same imaging functions possible on a computer.

Film Scanners. By digitizing the original film instead of a print, film scanners eliminate one generation. Besides removing the print phase from the process, you save the cost and time associated with having a print made. Because they scan small items, film scanners take less desktop space than flatbed scanners.

The typical 35mm film scanner has a slot in the front panel for inserting a slide or negative. When the scanner starts working, it pulls the slide inside for scanning. For 35mm negatives, film scanners typically require the use of an enlarger-style carrier to hold the filmstrip.

Keeping your negatives and slides clean is much more important with film scanners than with flatbed scanners. Even the smallest dust speck can be an obvious, objectionable spot in the final scan.

When selecting a film scanner, you'll want to know what film formats it can scan. If you shoot only 35mm film, don't spend more money for a larger, more expensive scanner that can also handle larger film sizes.

The resolution of your scanner depends on the resolution of the output device-the printer. All you get when scanning 35mm film at higher-than-necessary resolutions is a larger file, not better image quality.

The Epson Perfection flatbed scanner includes an optional film adapter that lets digital photographers scan film from 35mm up to 4 x 5-inch sheet sizes.

Flatbed Scanners. If your scanning needs are occasional, an inexpensive flatbed scanner with a 35mm film adapter may be the best solution. Some flatbed scanners are now sold with the film adapter included. Others may provide the adapter as an option. Typically, these hybrid scanners provide an optical resolution of 600 dpi and an interpolated resolution of up to 9600 dpi. They usually include drivers for both Macintosh OS and Windows computers.

IMAGE MANIPULATION

As a digital imager, you can use image-enhancement and manipulation software to improve and change your "acquired" images much as you would produce similar effects in a traditional darkroom. The big advantage of working in a digital darkroom is that you don't have to work in the dark or get your hands wet. Also, you'll find that achieving dramatic effects is easier to accomplish digitally than using light-sensitive paper and photographic chemicals.

DIGITAL TOOLS OF THE TRADE

Regardless of computer type and software used, all image-enhancement programs accomplish the same goal: They let you manipulate an image's pixels to produce a desired effect. The techniques used are similar to a photographer working in a darkroom where silver grains in film and paper are manipulated to produce a finished print.

Because most image-enhancement programs have similar functions, many of the basic tools are similar in name and purpose. Here's an overview of some typical digital imaging tools. While the examples shown are demonstrated using Adobe Photoshop, most photo-manipulation software have similar tools.

Crop. Using a digital cropping tool, you can eliminate distractions in an image and direct attention to the subject. You can also fix mistakes in composition and even change the shape of the image from portrait to landscape orientation.

This horizontal- (landscape) shaped photograph was made on 35mm color print film and digitized as a FlashPix file.

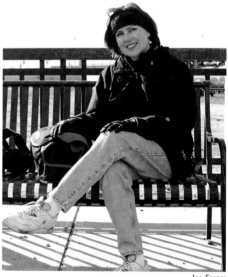

Joe Farace

Here the resulting portrait-shaped image eliminates extraneous background material.

The cropping tool lets you draw a rectangle around the image, which you can then convert into a vertical (portrait) shape.

Rotate. The rotate tool can change the shape of the image from portrait to landscape orientation by simply flipping the image on end. One of the most practical uses for this tool is to rotate an image very slightly to straighten a lopsided horizon line.

The original image is not quite level and could use some adjustment.

After rotating, you can crop the image into a conventional shape or leave it this way.

The first part of the process is to use the Rotate tool, which lets you rotate the image by as little as a fraction of a degree in either clockwise or counterclockwise direction.

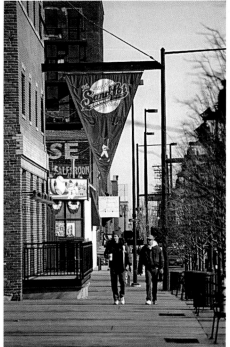

Joe Farace

Here the final image is more upright.

Change Color. Changing an image from color to black and white or vice versa is much easier digitally than in a traditional darkroom. Working in a darkroom requires using special paper and total darkness, while a digital conversion requires only a menu pull.

Change Brightness and Contrast. These tools let you reduce or increase contrast or brightness in a scanned image so that it can actually look better than the original photo. Making these kinds of changes is significantly easier to do digitally than using variable contrast or graded photographic paper in a darkroom.

Brightness/Contrast		✕
Brightness:	15	OK
Contrast:	20	Cancel
		✓ Preview

The brightness/contrast controls allow you to improve a digital image more than you might imagine.

Lighten/Darken. You can use image-enhancement tools to produce traditional photographic techniques such as burning and dodging. For new photographers, or those not familiar with darkroom work, burning is a term for selectively darkening part of an image to hide a distracting element or bring out something hidden by highlights. Dodging is the reverse process: It selectively lightens part of an image.

Paint. If the original image is not in good condition, you can use image-manipulation techniques to eliminate scratches, cracks, and creases. All of these techniques can be combined to rescue old and not-

so-old photos from being lost forever. Some programs even have a built-in command that eliminates dust and scratches. But many of them accomplish this by softening your image, an effect which you may not want.

Sharpen. If there's one tool that is unique to digital imaging, it's the ability to actually sharpen an image. There are two ways that this is accomplished. Most often this effect is produced by increasing the contrast of adjacent pixels and can be applied to an entire image by using sharpen filters or selectively by using sharpen tools. Some programs, including Photoshop, offer an Unsharp Mask command. This oddly named function is a digital implementation of a traditional darkroom technique in which a blurred film negative is combined with the original to highlight a photo's edges. In digital form, it's a more controllable method for sharpening an image.

The Unsharp Mask dialog box in Photoshop includes a preview window that allows you to see how the sharpness of the finished image would look.

SOFTWARE TO GO

Along with your digital pictures, the KODAK Picture Disk service includes image-manipulation software which makes it easy for you to:

* View, rename, rotate, and crop your pictures.
* Copy and paste pictures into other software.
* View the "thumbnail" index which shows each image in a smaller version.
* View pictures individually or in a full-screen slide show. The slide show feature allows you to view your photos on the screen in sequential order, as slowly or as fast as you choose.
* Export pictures as BMP, PCX, Photoshop, PICT, TARGA, and TIFF formats, enabling you to use your pictures in other programs, such as Microsoft Word or PowerPoint.
* Import pictures from other sources in these formats: BMP, JPEG, PCX, Photoshop, PICT, TARGA, TIFF, and PHOTO CD.

* Organize pictures into albums or collections on your hard drive.
* Make prints in standard snapshot sizes using any printer supported by the software.
* Access on-line help via the Internet to take advantage of Kodak's scan ning technology, color management science, and technical support.

The KODAK Picture CD incorporates pictures and software in one place. When you insert the disc into a CD-ROM drive, pictures will appear automatically on your monitor. You can view, organize, enhance, print, and e-mail the pictures from your desktop. With KODAK PHOTONET™ Online (see page 286), your pictures can be uploaded to the Internet.

The KODAK Picture CD disc combines your digitized images along with image-manipulation software that lets you enhance and improve your photographs, as well as add special effects.

SPECIAL EFFECTS

One of the joys of digital imaging is that it allows you to "play" with your images in ways that would have taken much too long using traditional darkroom techniques. Digital imaging allows you to have fun with photography. For example, in a few steps you can make an image look older than the person who made it.

To make the photo appear old and weathered, image "noise" was added using the Add Noise dialog box.

Next a sepia tone was added by selecting Duotone from the Image menu.

The starting point for this example is an image from a PHOTO CD disc of a locomotive taken at the Colorado Railroad Museum using 200-speed color print film. The effects were achieved using Photoshop software.

Finally, to give the photo a soft-edged look, a vignette effect was added, using the Vignette Action button.

Joe Farace

Plug-ins. The digital imaging equivalent of camera filters are called "plug-ins," and some plug-ins are even called "filters." Plug-ins are small software programs that add a feature to your image-editing program that wasn't originally there. After installation, they are, in effect, plugged into the program. One of the advantages of using plug-ins is that they can be used to create filter-like effects after the image has been created.

Next, Photoshop's Watercolor plug-in was used to manipulate the digital photo to give it a more artistic appearance.

The original is a FlashPix image, which was opened with Adobe Photoshop.

The Extensis Intellihance Pro plug-in was used to improve the image before applying any manipulations. This plug-in automatically adjusts contrast, brightness, saturation, sharpness, or color cast.

The final result.

Joe Farace

279

IMAGE OUTPUT

Although it's already become a cliché to say it, we are in the era of the "digital darkroom" where images can be manipulated and printed using completely digital techniques. In this section, you'll learn about some of the desktop printing technologies that can be used to print digital images with your computer. You'll also discover that you don't even need to have a computer to output digital prints. The KODAK Picture Maker makes it possible to enhance and output images at your local photo retailer. Or you may not even want to make a print. As the Internet becomes part of daily life, you may find that some of your digital images will not even exist as photographic prints, but will have the capability to be viewed anywhere in the world as pixels in cyberspace.

DESKTOP PRINTING

Color Printers. With digital imaging, technological change is often difficult to keep up with and can be unpredictable. For example, if you ask an expert what the best photo-quality printer is today, you might get a different answer than if you had asked the same question to the same person a week ago. Several manufacturers are bringing printer improvements to market on an ongoing basis. The result is that if today a company claims that its printer will produce photo-quality output, chances are it will. The challenge now is this: How inexpensively can they produce a photo-quality printer? Manufacturers have plunged into this competition with as much vigor as they did making the printers capable of photo quality in the first place.

Kodak Professional 8670 PS Thermal Printer.

The piezoelectric technology used by the Epson Stylus Photo 750 printer provides high resolution, 1,400-dpi printing.

One of the least expensive ways to get photo-quality output is to save your image file on some kind of removable disk, then take it to a service bureau where a print can be made for you. Most service bureaus offer more than one form of photo-quality color output, and even the most expensive options are less costly than purchasing a printer. The KODAK Picture Maker provides one of these same options in a hands-on environment at your photo retailer.

There are so many kinds of desktop color printers available, it's easy to get confused about which one is best for you. When shopping for a photo-quality printer, you can choose from a menu that includes inkjet, electrostatic, laser, and thermal dye sublimation devices.

At the present time, inkjet printers dominate the market. The reasons for their popularity are simple: low price and high quality. In an inkjet printer, a print head sprays one or more colors of ink onto paper to produce output. The methods used to accomplish this have an effect on output quality. Piezoelectric technology, for example, is based on the property of crystals to oscillate when subjected to electrical voltage. This vibration fires ink droplets onto the paper. The method allows printers to deliver output at up to 1,440 dots per inch (dpi) resolution. Another method, called drop-on-demand, uses a set of independently controlled injection chambers — the newest of which use solid ink which liquifies when heated and solidifies when it hits paper. A third method is the continuous stream method, which produces droplets aimed onto the paper by electrical field deflectors.

Consumables. When considering purchasing a photo-quality printer, don't forget consumables. They can have a considerable effect on the total cost of ownership of any color printer.

The most obvious consumables are the ink cartridges. It's difficult to say how long cartridges last because much depends on how you use the printer. If you print lots of large color photos, the cartridges won't last as long as if you print just a few, small photos. Cartridge capacity and age are also factors. Inks can dry out sitting in the cartridge or on the shelf waiting to be used. Ink life for many cartridges is about two years from production date — if unopened. Otherwise, the ink may last only six months (at room temperature) after the package is opened.

Another important consumable is paper. When it comes to photo-quality printers, the paper you use can be as important as the printer design. For best reproduction, use deluxe photo papers designed specifically for inkjet printers. KODAK Inkjet Photo Papers and KODAK micro-perforated Photo Papers are true photographic papers, designed to give you arrestingly sharp, vivid color pictures. The patented coating reduces ink puddling, which means less beading and banding.

YOU DON'T NEED A COMPUTER

The KODAK Picture Maker enables you to make digital prints without even owning a computer! Available at over 19,000 retail locations around the world, Picture Maker lets consumers add text to their prints for special occasions as well as produce borderless prints and enlargements-without negatives. You can create high-quality images from digital sources such as KODAK Picture Disks, KODAK Picture CDs, or even KODAK Digital Cameras. The kiosk or countertop models let you perform cropping, correct red-eye problems, and even add up to 40 different graphic borders to your prints, including a 120-month calendar. If you have an older, slightly faded color print, the Color Vibrancy tool lets you restore color brightness to the image. Images can be output on the same page in print sizes of 3-1/2 x 5, 4 x 6, and 5 x 7 inches.

Picture Maker software also provides access to KODAK PHOTONET Online. Once images are scanned by the retailer and uploaded to the Internet, the user can share them on-line or order prints from them.

PIXELS IN CYBERSPACE

One of the most popular ways to use images on the Internet is to e-mail photos to friends and family as attachments to messages. Preparing images for e-mail or placement in a Web site introduces variables. Some of the factors that affect images on the Internet are the quality of the viewers' computer display system, the speed of their modem, and their Internet service provider (ISP) connection. As you have no control over any of these variables, all you can do is prepare your images to minimize download time and display well on most computers.

There is some controversy over which graphic file type is best to use: JPEG or GIF. As in everything else in digital imaging, there are trade-offs over which file format will produce the best results. A GIF image file works best when there are fewer colors in the image. If your image contains less than 64 colors, a GIF file will be smaller than a JPEG file. It's a good idea to use a JPEG file when saving photo files. JPEG files allow the use of more colors but can take longer to display because the files tend to be larger than GIF files. GIF files may have less on-screen quality but usually display faster.

Interlaced GIF vs Progressive JPEG files. Unlike other compression systems, GIF was designed specifically for on-line viewing. If your image was stored in non-interlaced form, when half of the image download time was complete, you would see 50 percent of the image. At the same time, during the downloading of an interlaced GIF, the entire contents of the image would be visible — even though only one half of the image data would be displayed.

An alternative to using interlaced GIF is progressive JPEG. This file format rearranges stored data into a series of scans of increasing quality. When a pro-